Lia Perjovschi

Behind the Line: the Art of Dan and Lia Perjovschi

with an essay by
David Crowley

University of Plymouth Press

Contents

making tools of knowledge 5
 Performances 16
 Newspaper 20

installations, 1999-2010 22
 Diagrams, Mind maps 24
 Endless Globe Collection 26
 States of Mind 28
'Knowledge Museum', Sketch for Kunstmuseum, Liechtenstein 30
'Knowledge Museum', Kunstmuseum, Liechtenstein 32
Mind Maps and souvenir objects from the world's museum shops 38
The Archive and the Knowledge Museum – Kit 40
'Knowledge Museum', Espai d'art contemporani de Castelló, Castelló, Spain 42

timelines 44
'20 Romanian Culture 45
Timeline on General Culture, From Dinosaurs to Google Going China 46
Romanian Culture 46
Timeline *Dada Legacy/Anti Art* Cabaret Voltaire, Zürich, Switzerland 48
Knowledge Museum Map, Künstlerhaus, Vienna 50
General Culture, Subjective Art History from Modernism Today 52
My Subjective Art History from Modernism Today 54
General Culture and My Subjective Art History 56
General Culture, From Dinosaurs to Google Going China 57

mind maps 58

35 Mind Maps 59

Diagram/Mind Maps 60

CAA kit 70

In the Shadow of the Monument 71

Mindmuseum 72

Global Warming Mind Map 73

The Rich People of the World 74

Top Art Collectors 76

The Rich People of East Europe 77

'70 Romania, Mind Map 78

'90 Romania, Mind Map 79

2000 Romania, Mind Map 80

Statement 81

Immobiliare, Mind Map 82

Mass Media, The Owners, Mind Map 83

centre for art analysis 84

Sens newspaper 85

CAA/CAA space, poster 86

Austrian, German and Romanian Curators 87

CAA/CAA Space, Berthelot 12 88

CAA/CAA, official end 89

CAA/CAA publications/newspapers, No 1–12 90

The Archive and the Knowledge Museum – Kit 95

CAA/CAA new space, Sibiu 96 96

Romanian Culture, Timeline, Detail, 1997–2006

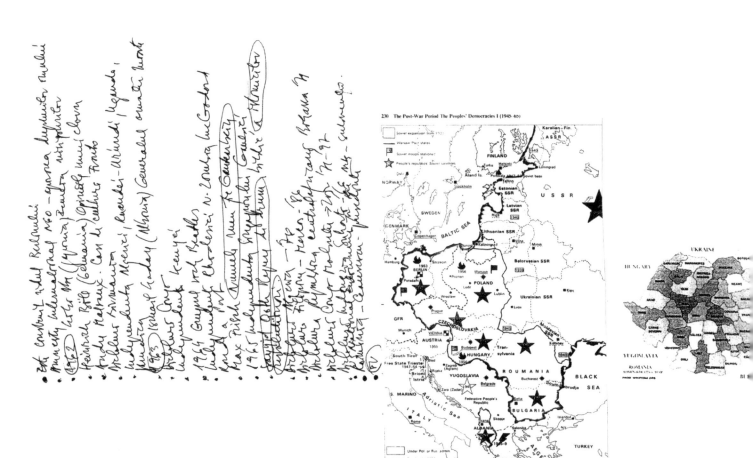

Romanian Culture, Timeline, Detail, 1997–2006

lia perjovschi

When, in the mid-1970s, the Romanian security forces intercepted a handful of letters criticising President Nicolae Ceauşescu addressed to Radio Free Europe in Munich, the dictator issued one of his many bizarre demands. "I'll give you three months to get handwriting samples for the whole Romanian population, starting with children in the first grade," he barked at his underlings. "No exceptions... In three months you ought to be able to catch every anonymous letter writer and put him in jail."[1] According to one eyewitness, the Deputy Minister of the Interior coolly responded by saying that the state already possessed this autographic archive. Marinated in paranoia, it is perhaps not surprising that the Romanian state acquired a reputation as "the most cruel and dark dictatorship".[2]

Lia Perjovschi began her career as an artist producing mail art and performances.[3] Her early works testify to the mute condition of Romanian society in the 1980s. In 'The Test of Sleep', a performance in her own apartment – a small state of freedom – in Oradea in 1988, Lia Perjovschi marked her own body with hypergraphics, a system of letters, symbols and images that both suggested and denied meaning. Evidently these inscriptions constituted a language, but not one which could be easily interpreted. Describing this work, Lia Perjovschi said "Everyone in Romania silently calls out loudly. I wanted to draw attention to that inner life, to make it possible for people to understand it without words."[4]

[1] Ion Michai Pacepa, Red Horizons: *The True Story of Nicolae and Elena Ceauşescu's Crimes, Lifestyle and Corruption* (Washington, 1997), 199.

[2] Norman Manea, *On Clowns: The Dictator and the Artist* (New York, 1992), 4.

[3] Kristine Stiles has written an authoritative account of Lia Perjovschi's art and career: see *States of Mind. Dan and Lia Perjovschi* (Durham, NC., 2007).

[4] Lia Perjovschi cited by Kristine Stiles, 'On Shaven Heads and marked Bodies. Representations from Cultures of Trauma' in Bruce B. Lawrence, Aisha Karim, eds., *On violence: a reader* (Durham, NC, 2007), 537.

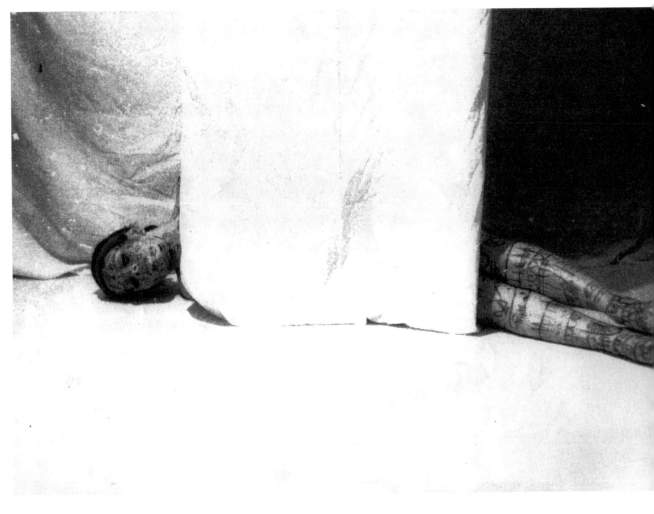

In the photographs recording this event, Lia Perjovschi is framed by examples of the mail art that she and her husband, Dan Perjovschi, were making at the time. Using the postal service, artists around the world exchanged postcard-sized works of art. Lia Perjovschi's mail art and small sculptures from the late 1980s were fashioned from strips of printed paper, some sliced from a French travel guide. Cutting the pages vertically, she produced texts which – like 'The Test of Sleep' – denied reading. (One wonders how many hours were spent by Ceaușescu's cryptographers trying to make sense of Lia Perjovschi's cut-ups?) In such works she testified bravely to the strong sense of captivity felt by many in Romania before the dramatic Revolution of December 1989 which toppled Ceaușescu.

The Test of Sleep
Oradea, Romania, June 1988

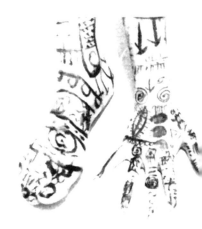

Our Withheld Silences, 1989

Lia Perjovschi has lived in two strikingly different information economies. When she began her career, Romania was a world in which too little knowledge circulated. The state exercised a monopoly on what could be written and said. From April 1983, for instance, all typewriters and duplicating machines in Romania had to be registered in the form of a sample page deposited with the police. In this way, anti-regime publicity could be identified and punishment meted out to its authors.[5] Only licensed sentences found their way into print. Even single words carried dangerous, inflammatory associations, according to the censors, and so had to be struck from the manuscripts that passed through their hands. In his essay 'Censor's Report' Norman Manea offers a glossary of these treacherous words, amongst them 'cold', 'dark', 'coffee', 'breasts' and 'God'.[6]

Arguably, our globalised and interconnected age suffers from too much information. Alex Wright sounds the alarm in his book, *Glut. Mastering Information Through the Ages*: "Today we stand on a precipice between the near-limitless capacity of computer networks and the real physical limits of human comprehension."[7] We have, of course, been driven to this edge by the exponential growth of the Internet. Our number one archive of knowledge is – according to the doomsayers – under the threat of collapse from the activities of spammers, YouTubers, pornographers and media corporations.

For almost two decades Lia Perjovschi has been obsessed with gathering and organising knowledge, light-heartedly describing herself as a 'real Google'. This desire to know represents a strategy for coming to terms with both too little and too much information. Aware of the intellectual

[5] Anneli Ute Gabanyi, *The Ceauşescu cult: propaganda and power policy in communist Romania* (2000), 397. Interviewed by Hou Hanru in 2010, Dan Perjovschi recalled the irony of this situation for the exchange of mail art '... we had no copy machines, because they were forbidden in a Communist country. So artists sent us a Xerox, we sent them original drawings.' http://www.artpractical. com/feature/interview_with_dan_and_lia_perjovschi/ – accessed July 2010.
[6] Manea, *On Clowns*, 70.
[7] Alex Wright, *Glut. Mastering Information Through the Ages* (2007), 230.

deprivation that was forced on her during the Ceauşescu years, her 'Research Files' and 'Mind Maps' – combinations of notes and images on historic and scientific themes – represent her desire to catch up on lost time. Looking back to before the 1989 Revolution, Lia Perjovschi has said 'I started in 1987, doing performances similar to people in the West in the '60s. I really had the impression that I invented it, not knowing the history'.[8] The idea of hypergraphics had, for instance, been conceived by the Romanian exile Isidore Isou in Paris in the 1940s.[9] With titles that demonstrate her personal motivation to know, 'research files' on the 'Subjective History of Romanian Culture in the Frame of Eastern Europe and the Balkans, from Modernism to the European Union' and 'Subjective Art History from Modernism to the Present' are her attempts to fill in gaps in knowledge. Yet these works were produced between 1997 and 2006, a time when such intellectual in-filling was strictly unnecessary. The world's knowledge is little more than a click way, or so it seems. But too much knowledge is almost as problematic as too little. Willem van Weelden puts this dilemma in stark terms: "For the curious layman… relying heavily on Google and Wikipedia in the quest to make sense of that world, it is easy to fall into a state of utter indiscernibility and total confusion. How much 'multiplicity' can an average curious layman bear, being confronted with the horrifying complexity of a labyrinthine matrix of disinformation, veiled propaganda, sponsored links, cookies, spy ware and commercial messages?"[10]

Lia Perjovschi turns to a set of low-tech tools – the filing 'card', the pen and the timeline – to make her own annotations on history, science and art. With their hand-rendered hesitations and crossed-out lines, they have a value because they seem to say "this is what I know… now.

State of mind without a title
Timișoara, Romania, 1991

[8] Interview with Hou Hanru, http://www.artpractical.com/feature/interview_with_dan_and_lia_perjovschi/ – accessed July 2010.

[9] Jean-Paul Curtay, *Letterism and hypergraphics: the unknown avant-garde, 1945–1985*, exhibition catalogue (New York, 1985).

[10] Willem van Weelden, 'Ideas on the politics of designing the singular' in Gerlinde Schuller, *Designing Universal Knowledge* (Lars Müller Publishers, 2009), 264.

Perhaps I will know something different later." The straight confident lines of history are combined with the looping and oblique lines of autobiography. Moreover, when Lia Perjovschi's research files are exhibited or reproduced in publications, she goes to some lengths to suppress their intelligibility. Refusing to give up precise details or to cohere into a neatly packaged thesis like a product of a professional historian, they remain resolutely subjective histories.

In Western Europe and North America there has been a creeping, widespread realisation over the last couple of decades that the media produces history. This is not just a matter of editorial control (i.e. determining what is and what is not newsworthy). Viewers and readers have been prepared for events – most notably in the Gulf wars – by reporting that announces the outcome of events which have yet to happen. As readers and viewers, we seem to be growing increasingly suspicious of what Noam Chomsky calls the 'management of consent'. The spin doctor looking out for good days to bury bad news has become a new kind of folk devil. Nevertheless this cycle of simulation and disavowal continues, not least in the protracted 'War on Terror'.

Not surprisingly, those who lived through the 'dictatorship of the people', as communist governments liked to call their regimes, are less surprised by the idea that history can be written in advance. After all, Marxism-Leninism – the governing doctrine of communist states – saw history as a 'science' which could explain all events. This notion was given a special spin in Romania. In 1977 Ceauşescu seized the idea of 'Protochronism', a nationalist philosophy which promoted the superiority of Romania over other nations. The task of historians was to order the past to demonstrate national genius.[11] This was little more than chauvinism but it had the effect of increasing ignorance of the wider world. What is striking about many of the images in Lia Perjovschi's timelines is the way in which they now

[11] Katherine Verdery, *National ideology under socialism: identity and cultural politics in Ceauşescu's Romania* (Berkeley, Cal, 1995), 167–209.

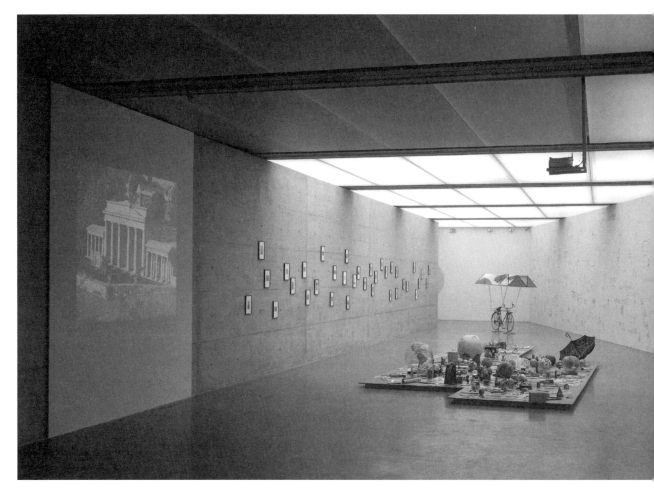

constitute an international commonwealth of knowledge. The iconic status of many of these images has much to do with the way that the Internet has already accelerated their circulation. Of course, what gets written into our global histories and what gets written out is hardly objective or neutral. When phrases like 'the invention of printing', 'the discovery of America' and 'the liberation of Iraq' are spoken, their meaning depends on who is speaking and who is listening. As if to emphasise this effect, Lia Perjovschi occasionally interjects unfamiliar images and subjects into her diagrams and timelines that perhaps only she can indentify. To what extent are our histories our histories?

Key chapters in the modern history of globalisation include the collapse of communism in Eastern Europe at the end of the 1980s and the rise of the Internet. The rapid spread and deep penetration of consumerism around the world presents another, far more equivocal face of this process. Lia Perjovschi has been collecting commodities in the shape of, or imprinted with, the image of Earth since 1990, sometimes exhibiting them as small universes under the title of the 'Endless Globe Collection'. In Chicago in 2003, she showed her collection as two panels, each containing 100 photographs

Endless Globe Collection
1990–present, *New Europe*, Generali
Foundation, Vienna, Austria, 2005

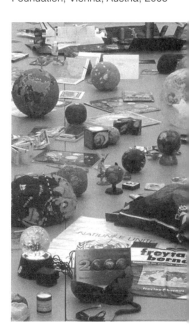

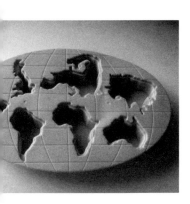

Globe Collection
Global warming, cool it down with these little frozen land mass ice cube tray, 2009

of globes. She invited visitors to bring other objects featuring globes to the opening to extend the installation. For the Bucharest Biennale in 2008, Lia Perjovschi installed 1,500 of these kitsch goods – key rings, pencils, napkins and soft toys – in the city's Geological Museum alongside dusty samples of the rocks and stones which literally form our world.

The image of the globe has distinctly autobiographical associations for Lia Perjovschi. It symbolises the period before 1989 when the opportunity to travel abroad was an impossible, yet much desired, dream. Lia Perjovschi is by no means alone in once finding high hopes in this image. When cameras were put into orbit in the mid-1960s, the resulting images of the blue planet wrapped in wisps of clouds channelled tremendous hopes and fears. For the counter-culture in the USA, for instance, the image would, it was hoped, kindle a benign spirit of internationalism: "National boundaries are simply not a motivating image when we have photographs of the Whole Earth," claimed one writer.[12] Today borders are demolished not by ideals but by the voracious spread of global capitalism armed with what Zygmunt Bauman calls "awesome weapons of extraterritoriality". Consumer goods carry an imperative to the societies which demand them: open up to global free trade.[13]

Many of the goods which have overrun Romania since the country 'opened up' in the 1990s, bear such images on their shiny surfaces. As Lia notes, the image of the globe which was created over centuries as "a knowledge tool" has become a "diminished object".[14] This emblem on children's sweets and disposable fast-food packaging is an unintended, but entirely accurate, reference to the process of globalisation in which these goods play their part. The idea of the 'Endless Globe' is now a forlorn hope

[12] Michael Shamberg and the Raindance Corporation, *Guerrilla Television* (New York: Holt, Reinhart and Winston, 1971), 3n.

[13] Zygmunt Bauman, *Liquid Modernity* (OUP, 2000), 186.

[14] 'De la un instrument de cunoaștere la un obiect minimizat', by Lia Perjovschi in 'Being Here. Mapping the Contemporary', a special issue of *Pavilion* magazine published in association with the Bucharest Biennale, May–June 2008, p. 7.

Mind Maps, Detail
Lia Perjovschi: Plan (for Knowledge Museum), Dorottya Gallery, Budapest, Hungary, within the framework of the *Interval* exhibition series, organised by Mücsarnok, Budapest, Hungary, 2009
Curator: Judit Angel

when the resources of the planet are being leeched at a disturbing rate by the over-production of throwaway products. Our encounters with images of the globe swing between the entirely trivial (like the cartoon images on packaging) and the frightening (like the digital projections of the immense hole in the ozone layer over the South Pole regularly issued by NASA). We cannot look on Lia Perjovschi's 'Endless Globe Collection' with equanimity.

Lia Perjovschi's art has been described as a herculean intellectual effort, the product of hours spent in the library.[15] The spirit behind these projects is not Hercules but Sisyphus. The idea of complete, or universal, knowledge is wrapped in hubris and, in an age wracked with conflicting fundamentalisms and accelerated communication, is destined to fail. This Lia Perjovschi knows well. In fact, she has often exhibited her research as a 'Knowledge Museum', an imaginary institution with impressively titled departments ('The Body', 'Art', 'Culture', 'The Earth', 'Knowledge and Education', 'The Universe', and 'Science'). Lia Perjovschi's project seems – at least on first impression – to belong to the Enlightenment dream of perfect knowledge. From Denis Diderot's *Encyclopédie* (1751–1772) and Paul Otlet's *Mundaneum*, an 1895 project to organise all the world's knowledge into a single indexing system, to Google Book's Library Project and the Wayback Machine archiving the internet today, Western intellectuals have sought out tools to perfect information. But Lia Perjovschi's 'Knowledge Museum', when exhibited, is strikingly low-key and modest. Her research materials are pinned to the gallery wall or cast on the floor in an unspectacular and seemingly casual fashion. Less a grand project for universal humanity, this is evidently one person's vision (though she is keen to stress that one day it could be built). As Lia Perjovschi says, "… everyone has a kind of museum in his or her head, a collection of what we like, what we saw, what we read and, in time, can begin to make a selection. This knowledge is the museum."[16]

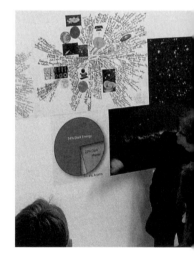

Guided tour
Lia Perjovschi: Plan (for Knowledge Museum), Dorottya Gallery, Budapest, Hungary, within the framework of the *Interval* exhibition series, organised by Mücsarnok, Budapest, Hungary, 2009
Curator: Judit Angel

[15] Amy White, 'Romanian artists Dan and Lia Perjovschi open the vaults', www.indyweek.com (September 2007) – accessed July 2010.

[16] Lia Perjovschi interviewed by Nicoleta Zaharia in Adevărul (22 December 2009) – on-line edition.

CAA Kit
The Map: Navigating the Present
Bildmuseet, Umeå University,
Sweden, October 12, 2008 –
February 8, 2009

One conclusion that could be drawn from Lia Perjovschi's art is that it forms a kind of closed world in which public knowledge is rendered personal, only meaningful to its diligent archivist. In fact, the reverse is true: in early actions reflecting on the limits of expression in 'Ceauşescu's Romania' and in revealing her process of self-education in 'research files' like 'Timeline: Romanian Culture from 500 BC until Today' (2006), Lia Perjovschi seems to be committed to what Roland Barthes called the "publicity of the private", i.e. the practice of sharing subjective experiences and views with others.[17] Even when working with systematic ways of organising information like timelines, her own handwriting and other devices emphasise subjectivity and presence and, as such, belong to the conception of performance as testimonial (a crucial tradition in Eastern European art in the 1970s[18]). Moreover, she is committed to a notion of the public as an active and informed social body (a view which, of course, can be contrasted with her anger at the passivity and ignorance imposed on Romanians before 1989). In the early 1990s – little more than months after the Revolution – Dan and Lia Perjovschi opened the Contemporary Art Archive (renamed the Centre for Art Analysis in 2000), an independent institution offering readers access to articles, books, images and other hard-to-come-by materials.[19] It also issued its own publications. Combining both international materials and material dating back to the nonconformist 1980s in Romania, the archive contains rich seams of material for others to create their own subjective histories.

Their studio – home to the archive until 2010 – has long operated as a public space, hosting lectures, meetings and occasionally television

http://www.adevarul.ro/cultura/literar_si_artistic/Lia_Perjovschi-Imi_place_sa_
creez_spatii_jucause_0_175782814.html – accessed July 2010.

[17] Roland Barthes, *Camera Lucida* (New York, 1981), 98.

[18] See Zdenka Badinovac, *Body and the East From the 1960s to the Present* (Boston, MA, 1999).

[19] Lia Perjovschi, Contemporary Art Archive/Centre for Art Analysis 1985–2007 (Köln, 2007).

broadcasts.[20] Anthony Gardner and Charles Green connect its prehistory as Lia and Dan Perjovschi's own apartment in Oradea with the post-communist present: "once-frozen gestures from art's history become thawed and remobilised in new contexts and new histories through shared sessions of dialogue between the Centre's participants".[21]

Lia Perjovschi's practice as a curator continues today. In 2009, she helped shape a new art centre in Bucharest, Pavilion Unicredit (a building that, designed as a housing block during the Ceauşescu era, became a bank in 1993). She curated its first show, 'Statement', preparing a rationale which describes not only a group exhibition but a philosophy which underpins the CAA and her conception of the 'Knowledge Museum' and, ultimately, her practice as an artist, curator, researcher, teacher and publisher:

> *STATEMENT is an expositional plan. A route. A process. The storyboard of a contemporary art centre nowadays. A conceptual expression for the lines of force structuring the intellectual life and the life in general. A multidisciplinary programme created with modesty (books, newspapers, quotations). A data bank and a possibilities bank. Art is not alone. Art is positioned in a cultural, political and scientific framework. Works of art admired and then given away as gifts, replicas more interesting than the original, hundreds of artists in texts, images, postcards. Institutional history in bags. A map of ideas that may go wild or may structure itself peacefully. A laboratory where the spectators become researchers.*

Written in 2009, this mission statement describes a philosophy of art which has been shaped by 25 years of practice.

[20] In 2000, Dan and Lia Perjovschi were part of a team that created 'Everything on View', a series of three-hour television programmes on a national channel exploring different faces of culture and politics.

[21] Charles Green and Anthony Gardner, 'The Second Self: A Hostage of Cultural Memory' at www.aprior.org/articles/36 – accessed July 2010.

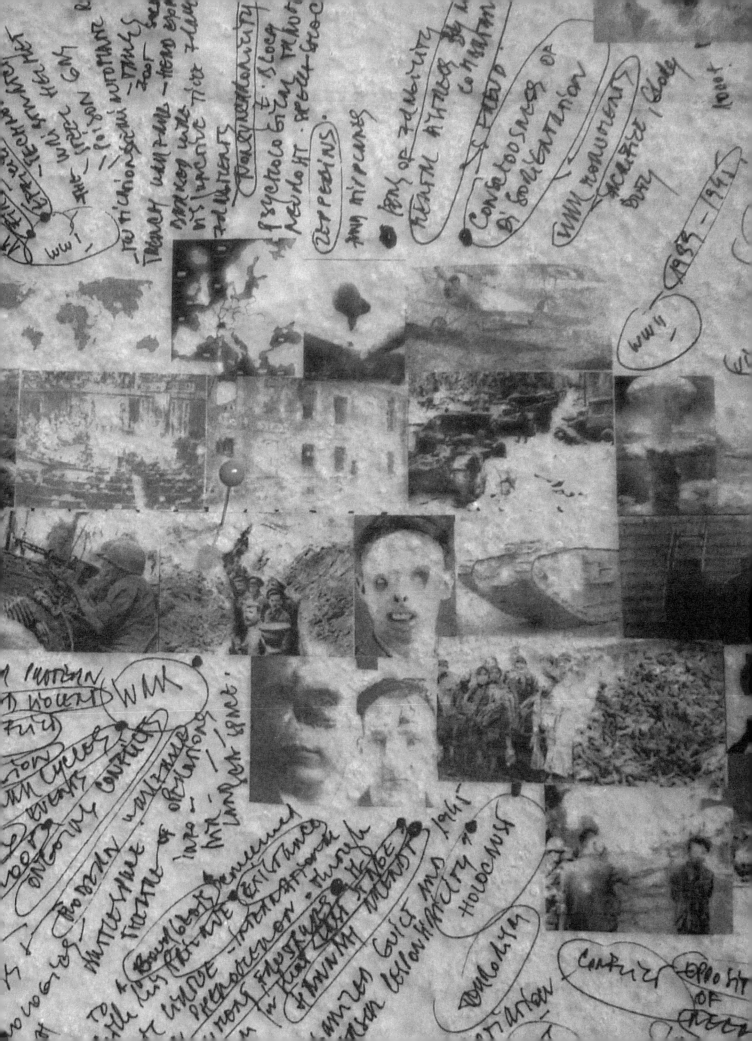

Lia Perjovschi: Performances 1987–2007, installation view Wilkinson Gallery, London, UK, May 22 – June 29, 2008

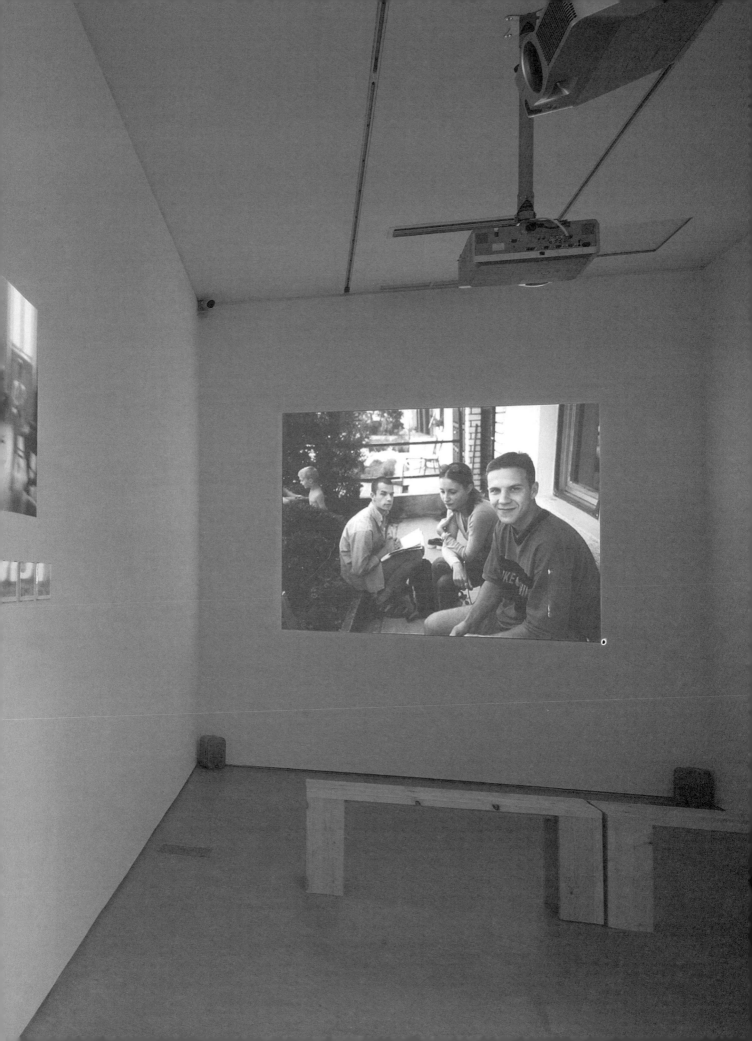

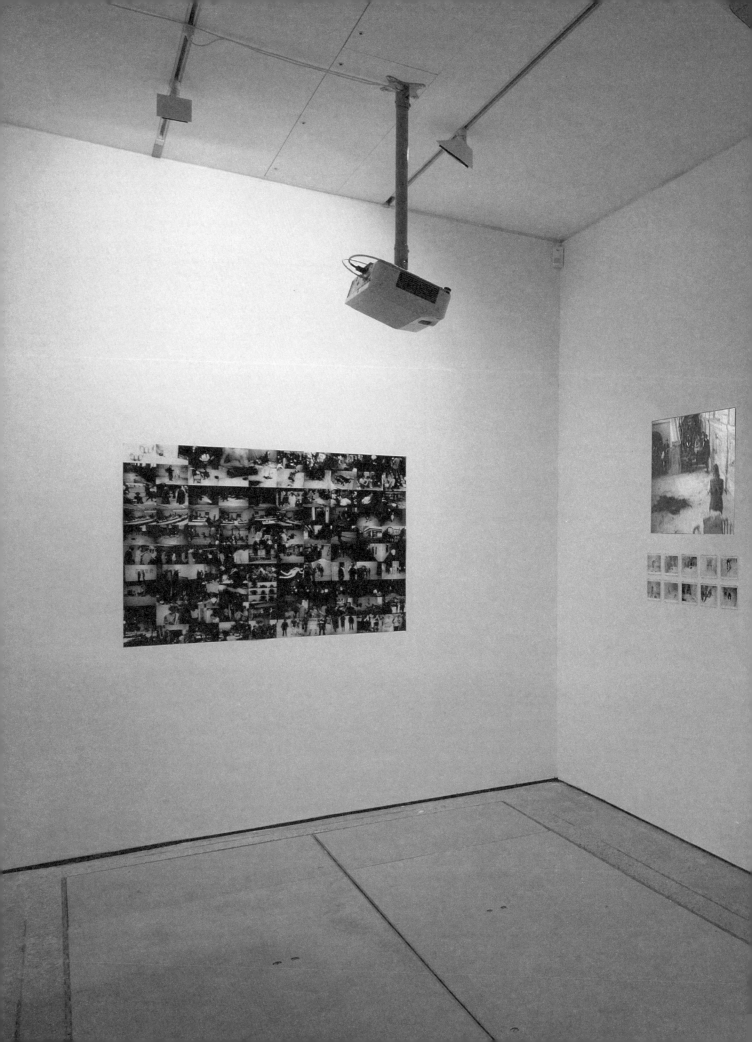

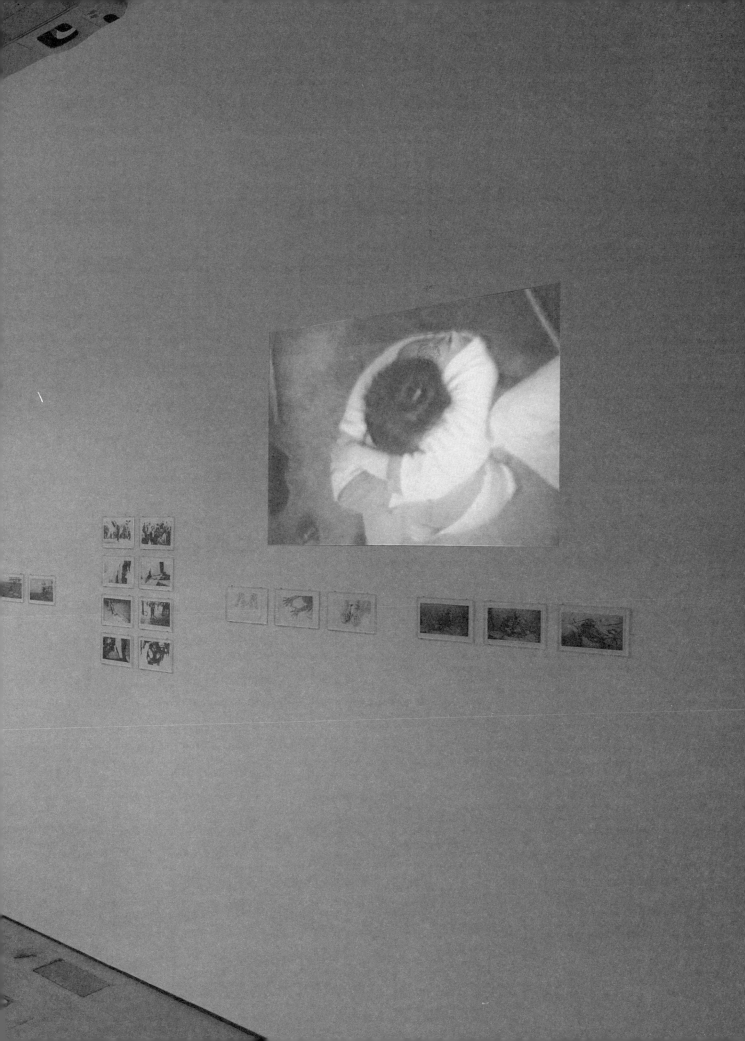

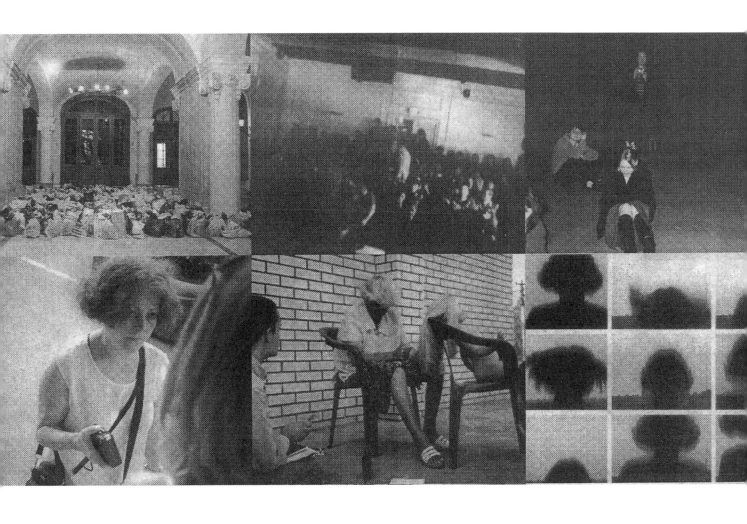

Working Title, Short guide- Position Rumanien, newspaper-projects

KulturKontakt, Vienna, Austria, September 13, 2002 – October 22, 2002

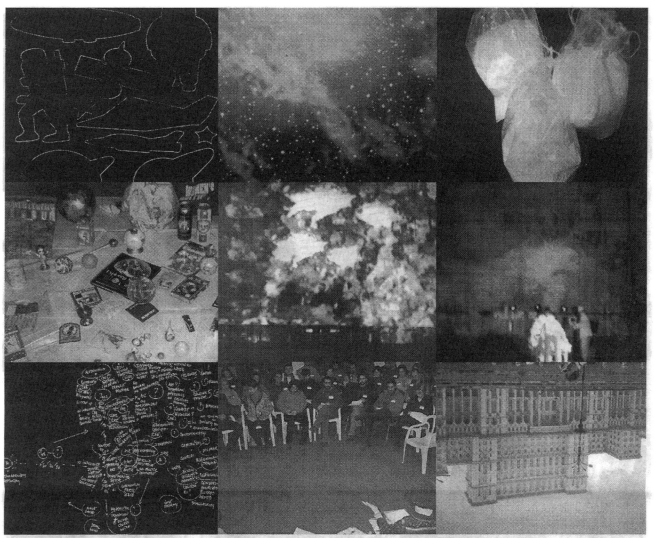

from left to right • first line: *project 200*0 • second line: globe collection 1990 - today (e.u., u.s.); *wit* (margaret edson) directed by catalina buzoianu, stage design "mic theatre" bucharest • third line: *sense* diagrame; workshop at oradea art academy; *dizzydent* programe project (against the national museum of contemporary art in the ceausescu palace/actual parliament

lia perjovschi born 1961 sibiu romania;1997 founder of **caa** (contemporary art archive) active under diferent names since 1985; 1985-1987 open apartment oradea, 1987 - 1991 experimental studio, bucharest art academy; 1991- today, open studio; 1997 money nation (curator marion von osten) shedhalle zurich; 1998 **caa** in public space; 2000 **caa** on tv, channel1, live show. Artist In Residence/Fellowship; 2002 KunstlerHaus Worpswede; 2001 Le Saline Royale d'Arc et Senans, Institute Claude Nicolas Ledoux; 2001 Schloss Pluschow, Germany; 1999 IASPIS Stockholm; 1997 Artist in Residency / Visiting Professor Duke University, Durham, NK; 1996 ArtsLink, New York; 1994 KulturKontakt / Christine Konig Gallery, Wien; 1994 Academia di Brera, Milano;

Dr. Kristine Stiles, Duke University: Amalia (or Lia) Perjovschi for her husband's surname. In various professional activities, she has called herself "V", Max Pacurar, and amaLIA perjovschi. But she describes herself as an "alien and a dreamer"(...) Lia's strategy as an artist is both to link and to critique various social antagonisms. She conflates her own interior states with political conditions within her own historical experience and maps them onto the larger global picture of nationality and identity in the post – communist period. (...) Lia's art emerged in a very precise historical moment – a political statement that destroyed the will to live, to act, to think independently in such conditions and in order to survive as a whole person she styled herself as an "amaLIA perjovschi", Bucharest 1995)

Zdenka Badovinac, director Moderna Galerija Lublijana: Her various works- performances, drawings and objects- have a common feature: silence and absence. This is not evident only in atmosphere, which is often created through whiteness and weightlessness; her work also contains more direct and obvious signs, titles. Restricted communication, isolation and loneliness come both from Amalia's personal history and the collective experience of the Romanian nation, generated in the austerity of social and political life during Ceausescu's regime. Communication was not restricted only through the censorship of public media, the regime was most effective in generating general mistrust and self-censorship. The psychological deformations, which resulted from this, cannot disappear in a few transitional years, during which artists face new topics (from "2000+ Arteast Collection", Oranjerie Innsbruck)

Dan Perjovschi: Years ago the artist started a project-as-an-institution. She employs the recent history of art as material for building up relations, dialogue. Her works are neither instal-lations nor performances. They look like offices for individual research, reading rooms or places for debates. The focus is the body of art. She cares less if one calls it art or not. From simple lectures in her studio to series of public debates, from radical interviews to a 3-hour live program on national TV, from exhibitions to workshops, her "institution" has become a practice of independent attitude. **caa** (Contemporary Art Archive) is a "context in motion" a "museum in files" Based on a 12-years meticulous documentation of the international art scene (exhibitions, fellowships, catalogues, books,slides, videos, texts, networks etc) CAA has the mission to enlarge the contemporary art scene, to preserve independent positions and to empower promising institutions and individuals (from *Voice Activated Installation*, Praesens no 2, Budapest, 2002)

Judit Angel, curator Budapest Kunsthalle: Lia Perjovschi's art is characterized by the urge to live, act and think independently. She wants to assert the right of the individual to be dif-ferent and to legitimate a personal value system. However, her attitude is not authoritarian at all, but driven by a strong sense of empathy and the desire for communication (from Einladung, Kunsthalle Essen, 2001)

Pavel Susara, art critic: When traditional languages are used by inert minds, incapable of adapting to the spirit of time, traditionalism becomes a dogma. Lia Perjovschi organized an exhibition exclusively dedicated to contemporary art, called diaPOZITIV. This project tries to reconsider a theoretical problem and a practical activity, seriously muddled by confusions, inadequacies and imitations. (...) All its components, from the static to the dynamic, have an explicit artistic message. The spectators, as well as the functional inventory, coagulate in a single discourse. The exhibition reminds us of a Borgesian scenario, in which the labyrinth takes shape as it is described and inhabited. (from *An applied course*, Romania Literara, May, 1998)

Gheorghe Craciun, writter: I know Lia and Dan Perjovschi and in a way, I worry about them. They are too spontaneous, demanding, well informed; they live too much in the avant-garde, at a different speed than we. (...) The images from exhibitions and museums, the scenes from movies, the live performances, made me wish I had been a stenographer so that I could have remembered important details. (from *Hard&Soft*, Observator cultural, October 2000)

Marius Stefanescu, columnist: The viewer is introduced to another way of thinking and consequently, to a new way of regarding the artist, who, now, is perceived as an awkward individual. (...) Can this exhibition be considered a demonstration of the fact that we can create an Internet without computer inside the gallery? (from *An Internet gallery without computer*, Cotidianul, November 28, 2001)

©lia perjovschi po.box 17, 70700 bucharest working title 13.9 bis 22.10. 2002
romania tel/fax + (40 21)310 01 17 quartier 21/ piroschka museumsquartier wien
perjovschi@yahoo.com printed at fed s.a. bucharest

installations
1999 − 2010

Lia Perjovschi's approach to exhibiting her work belongs to a tradition which can be traced to the Dadaists who emerged in Central Europe during the First World War. Eschewing the conventional techniques of the gallery – pictures in frames and the even spacing of exhibits – the First International Dada Fair in Berlin in 1920 featured artworks which seemed to have been torn from everyday life. Some exhibits were laid over one another, whilst visitors had to crane their necks to look at others hung at ground and ceiling height. Dada artists set out to disturb their audiences.

No longer shocking, Perjovschi's decision to lay her mind maps on the floor or to arrange her collections of mass-produced objects like globes in seemingly chaotic ways shares an essentially Dadaist view of value or craftsmanship. Her work is never precious. As she says, "If you enter the market, you are pushed here, there, and further, but without you having too much say about it. So I am for the thinker artists, and not for the maker artists".[1]

Souvenir objects from the world's museums
Lia Perjovschi: Plan
(for Knowledge Museum),
Dorottya Gallery, Budapest,
Hungary, within the framework
of the *Interval* exhibition series,
organised by Mücsarnok,
Budapest, Hungary, 2009
Curator: Judit Angel

[1] Lia Perjovschi interviewed by Hou Hanru in 2010 at http://www.artpractical.com.

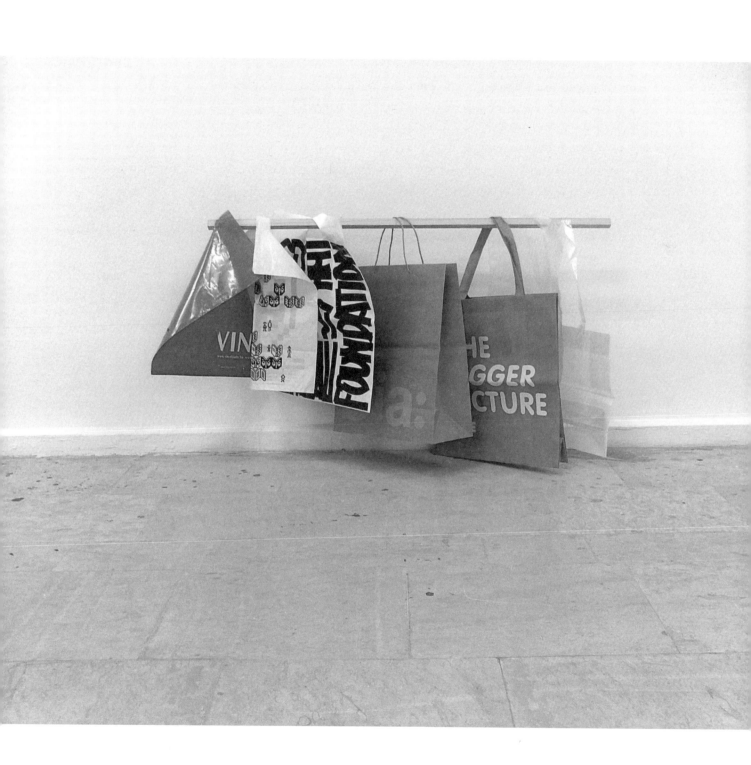

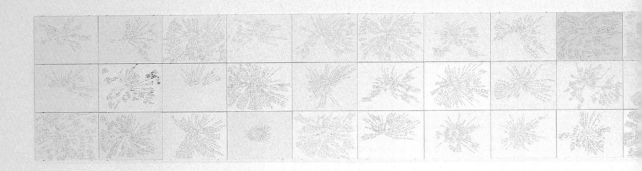

Diagrams, Mind maps 1999–2005

60 drawings, fineliner on paper

framed, 21 x 29.7 cm

New Europe, Generali Foundation, Vienna, Austria, 2005

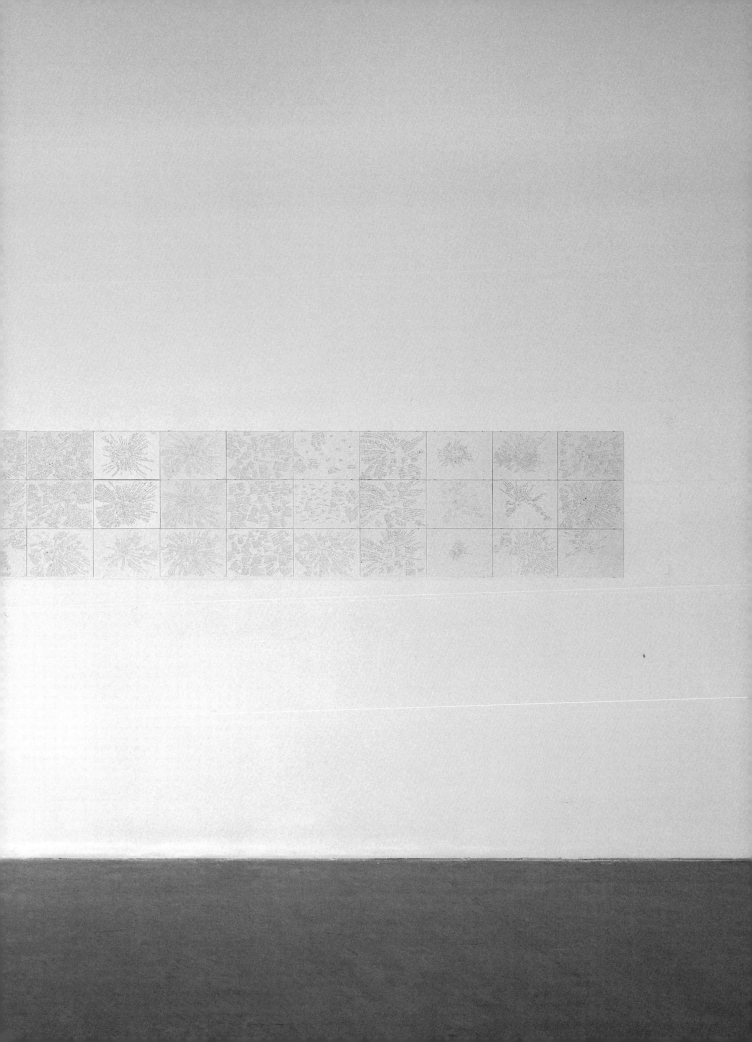

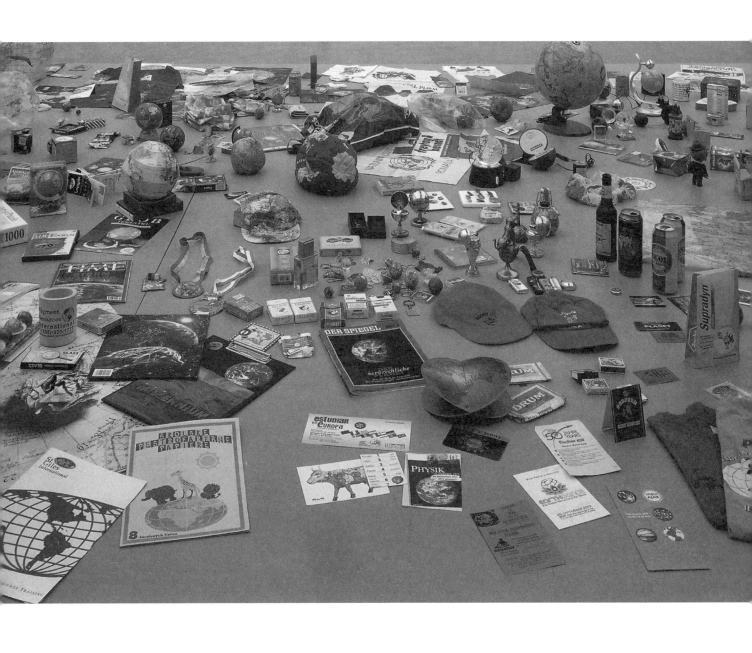

Endless Globe Collection 1990-present

New Europe, Generali Foundation, Vienna, Austria, 2005

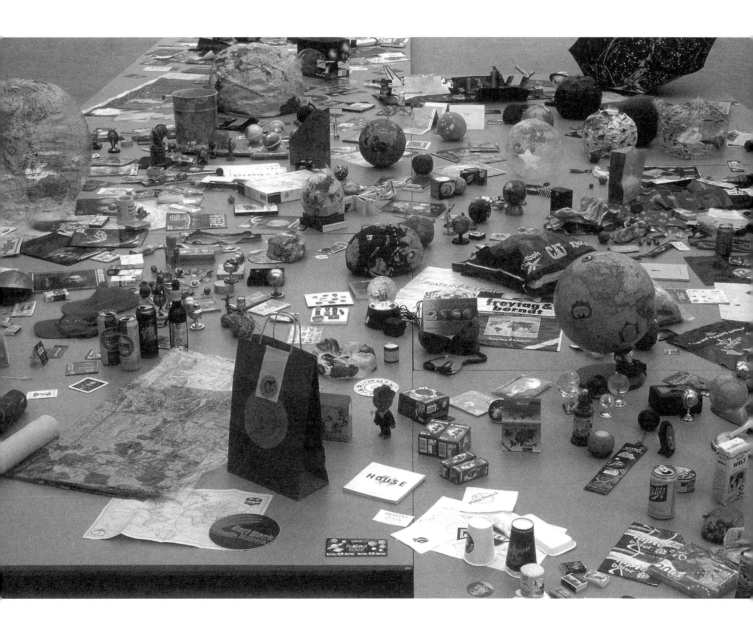

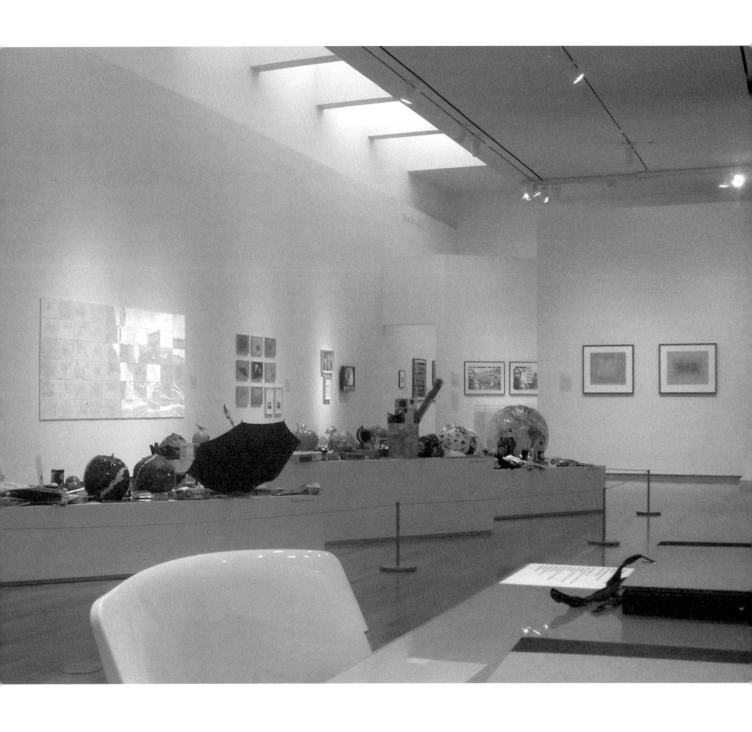

States of Mind: Dan and Lia Perjovschi, Nasher Museum of Art, Duke University, Durham, USA, August 23, 2007 – January 6, 2008

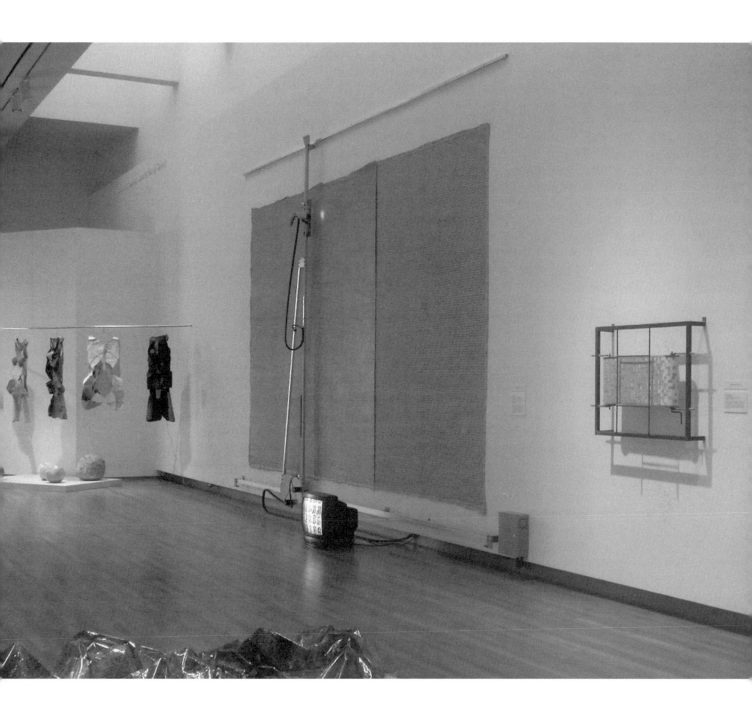

Knowledge Museum, 1999–2007

Sketch for Kunstmuseum, Liechtenstein

series of 3 works

ink, collage, felt pen on various cardboards

21 x 29.7 cm each

lia PERJOVSCHI/PERJOVSCHI dan, Christine Koenig Galerie, Vienna,

Austria, 2007

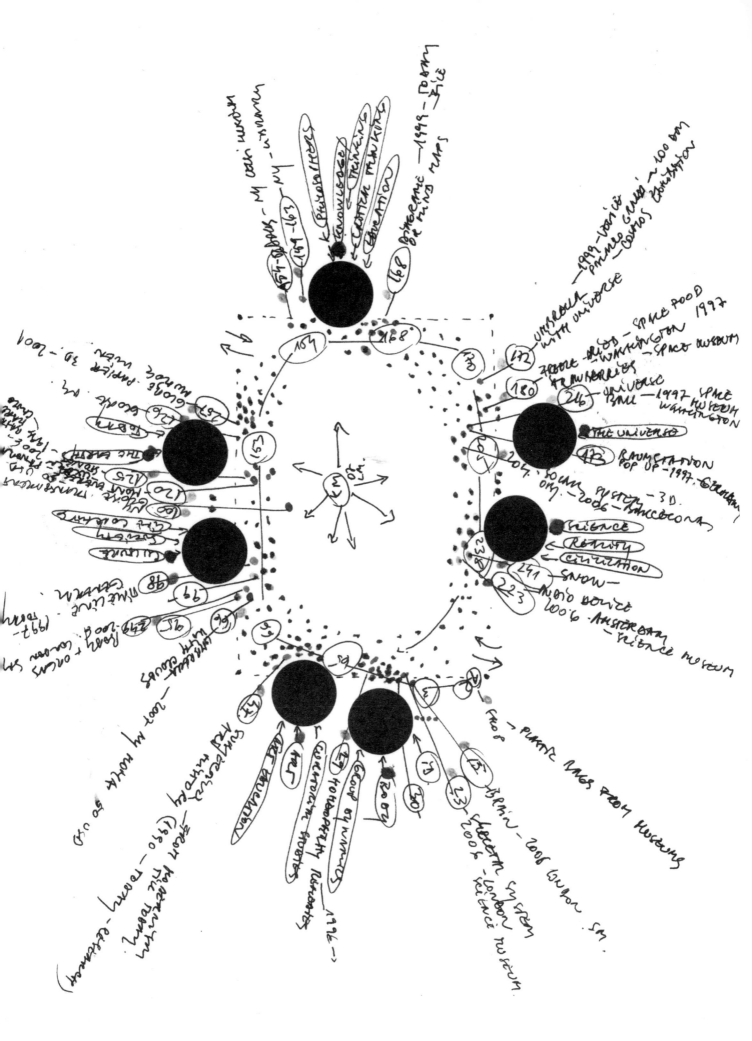

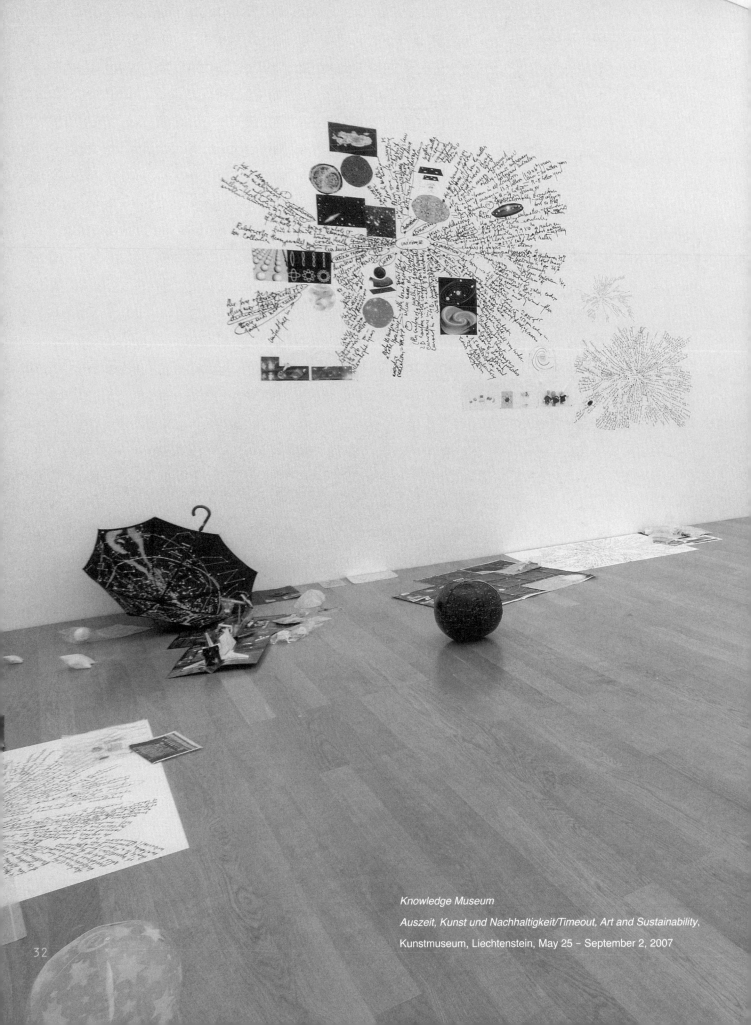

Knowledge Museum

Auszeit, Kunst und Nachhaltigkeit/Timeout, Art and Sustainability,

Kunstmuseum, Liechtenstein, May 25 – September 2, 2007

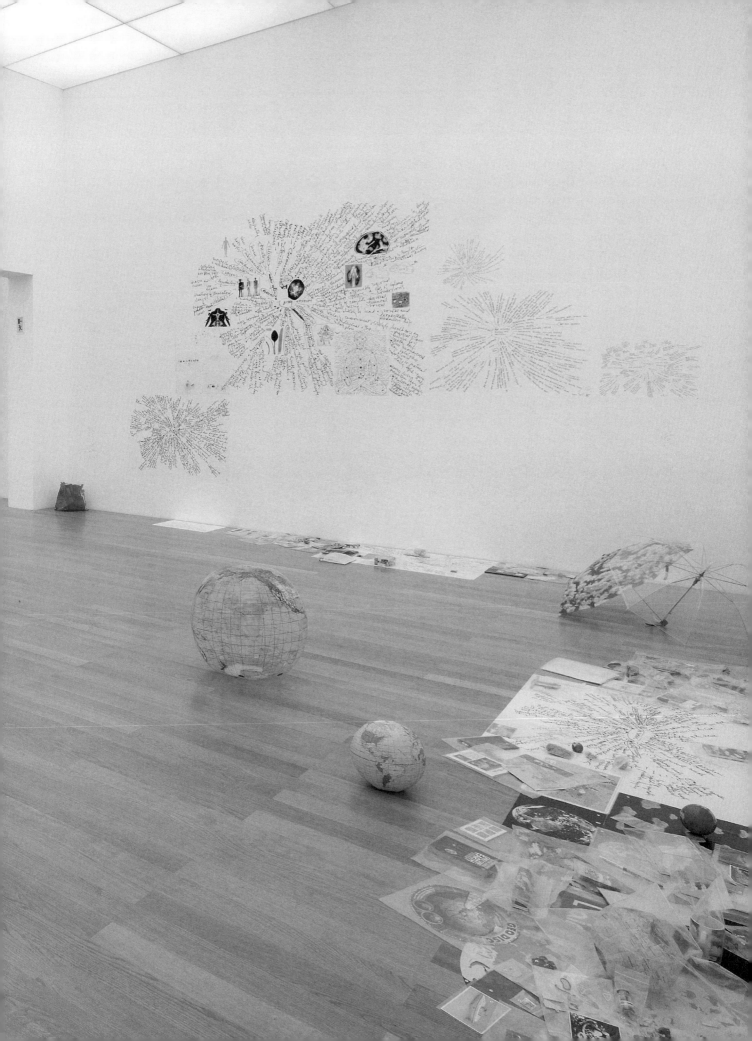

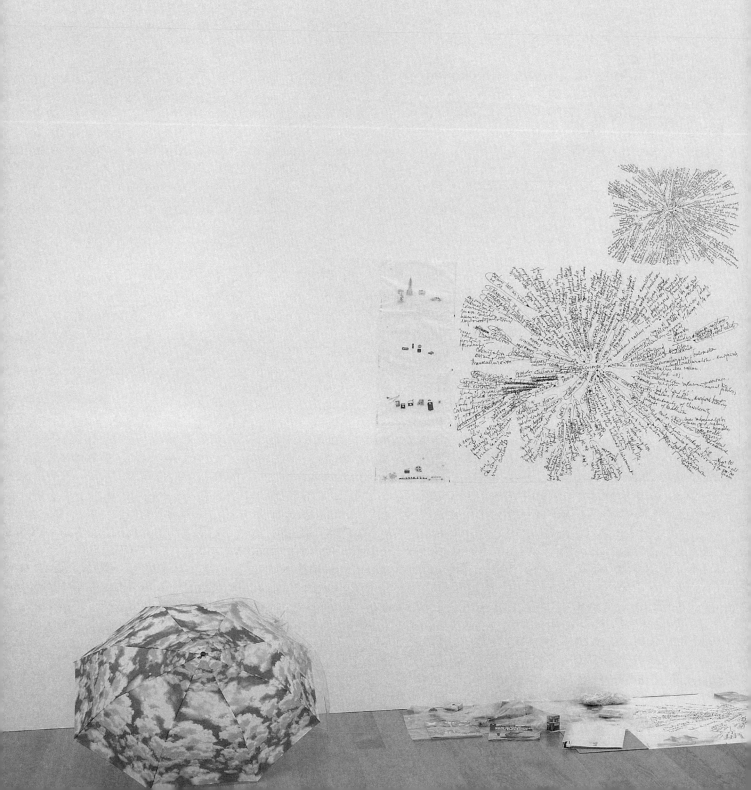

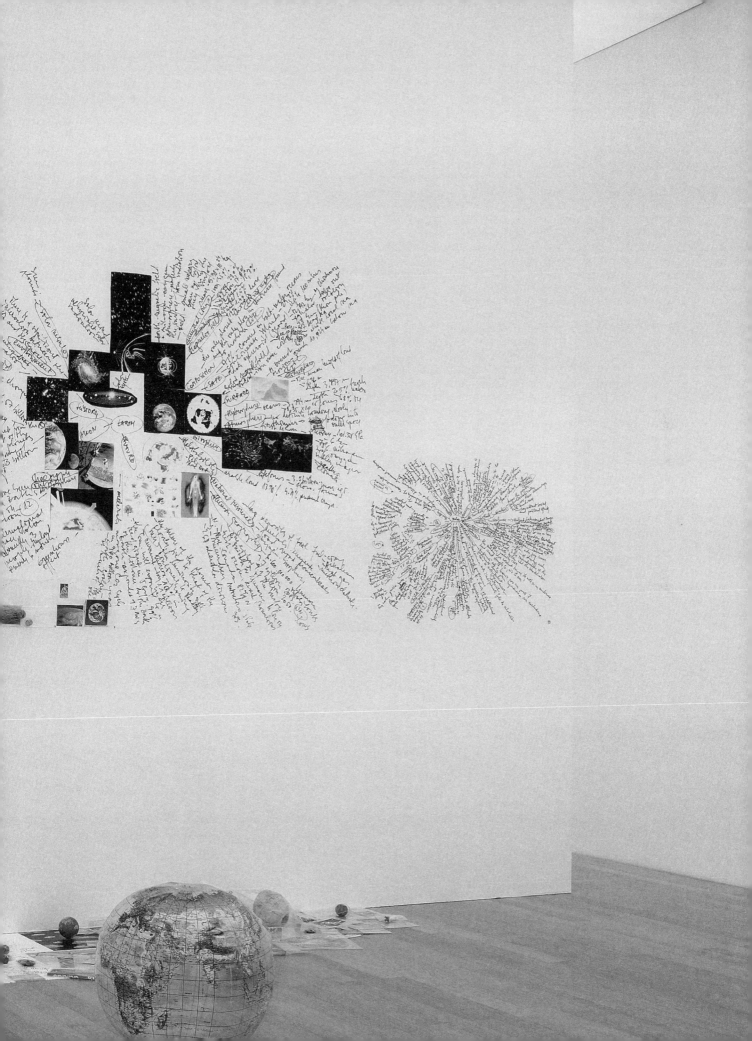

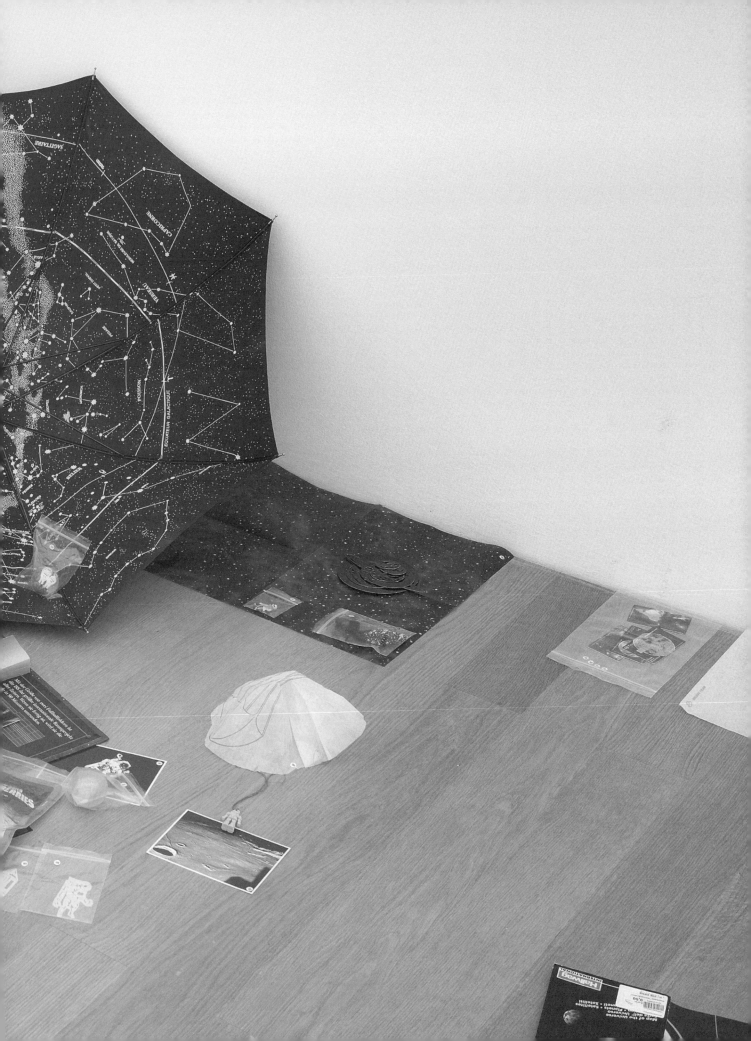

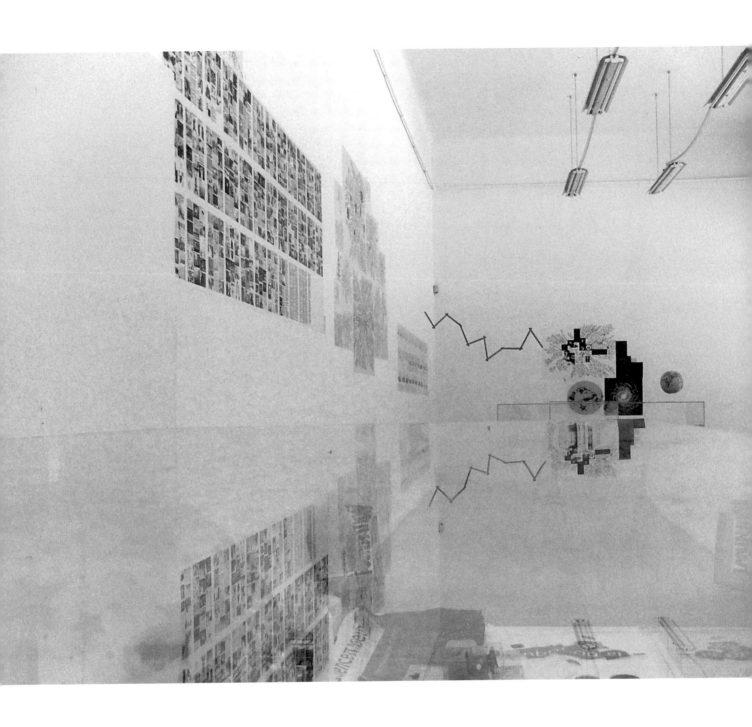

Mind Maps and souvenir objects from the world's museums
Lia Perjovschi: Plan (for Knowledge Museum), Dorottya Gallery, Budapest,
Hungary, within the framework of the *Interval* exhibition series, organised by
Mücsarnok, Budapest, Hungary, 2009
Curator: Judit Angel

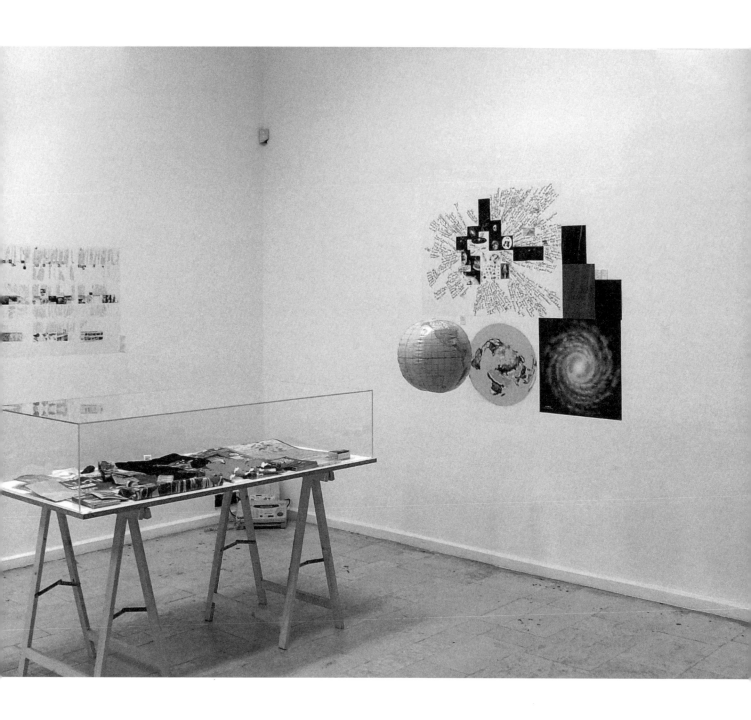

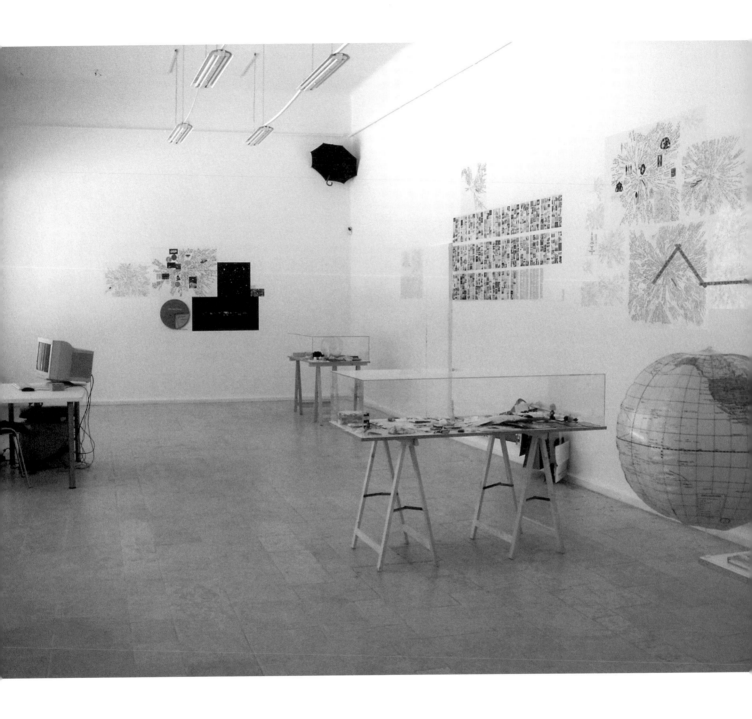

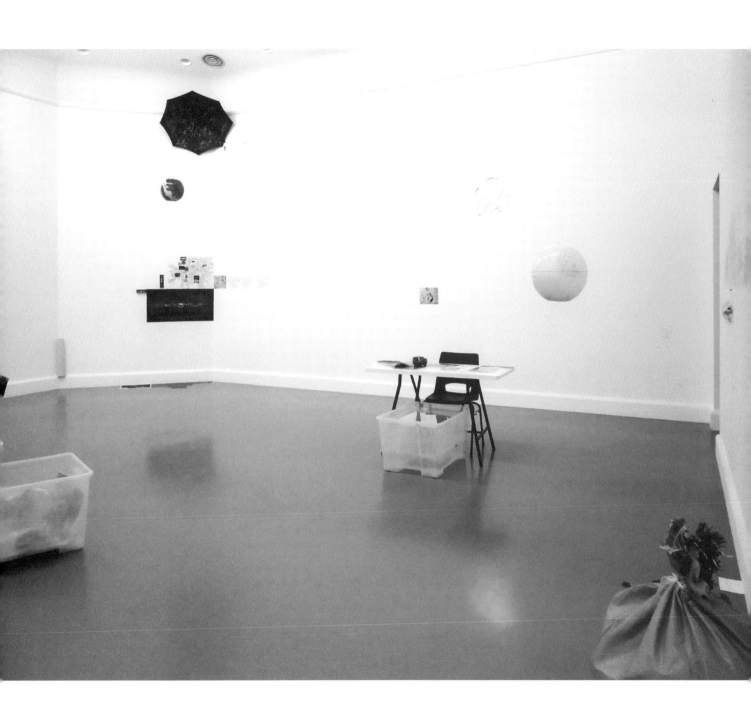

The Archive and the Knowledge Museum – Kit, 1985–present

Play Van Abbe Deel 3: De principes van verzamelen, het verzamelen van principes/Play Van Abbe – Part 3:

The Politics of Collecting – The Collecting of Politics

Van Abbemuseum, Eindhoven, The Netherlands, September 25, 2010 –

January 30, 2011

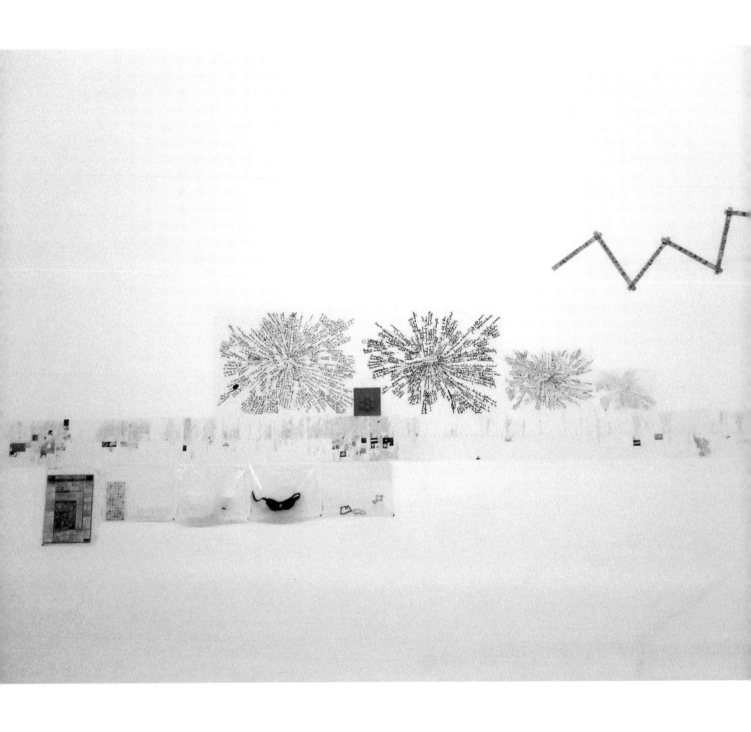

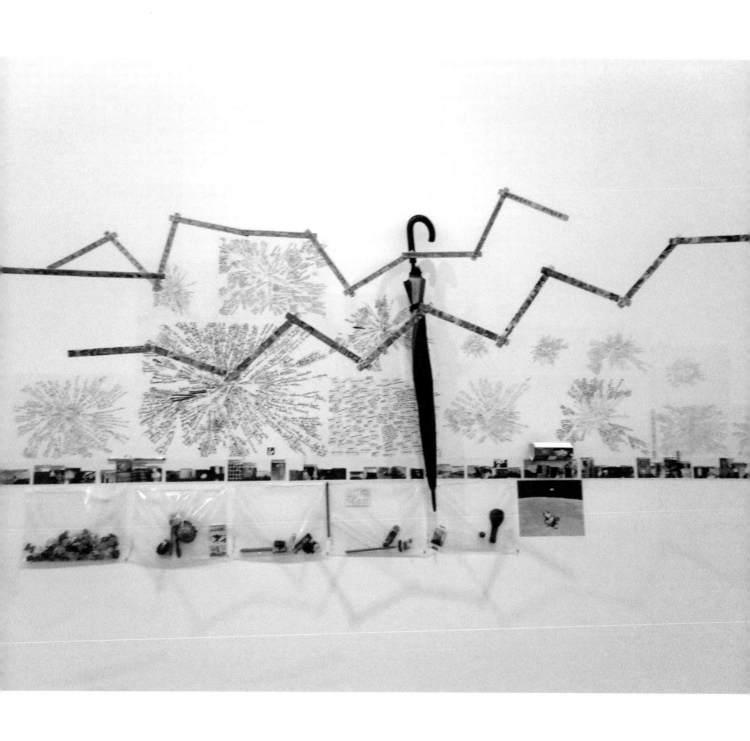

Time Specific by Dan Perjovschi and *Knowledge Museum* by Lia Perjovschi,
October 15 – December 26, 2010, Espai d'art contemporani de Castelló,
Castelló, Spain, 2010

t i m e l i n e s

Timelines have – appropriately – a long history. They can represent authority or challenge it. They were, for instance, first employed in charts mapping history in Ancient Egypt associating periods in history with the rule of pharaohs. By contrast, during the Enlightenment in Europe, timelines issued a challenge to the authority of the Church by extending the past beyond the biblical age of the Earth.

Carrying the aura of imperial comprehension, timelines allow the viewer to take in the long sweep of history at a glance. Lia Perjovschi's timelines operate differently. Using her own handwriting and taking on spiralling forms or gathered in the concertina format of the leporello, they are not so easy to comprehend. Lia Perjovschi has worked on a number of different histories, including the history of humanity from the Stone Age to the high-tech present. The extraordinary scale of these exercises in historical comprehension makes them like Sisyphus's mythic task; not only are they impossibly daunting, they are sometimes quite literally endless.

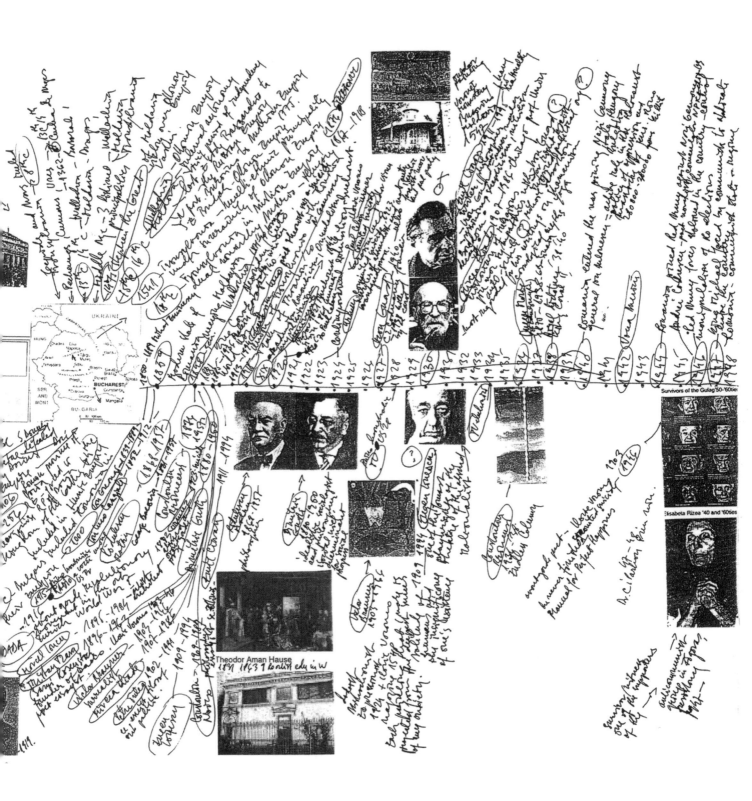

'20 Romanian Culture, Mind Map, Detail, 1997–2006

Timeline on General Culture, From Dinosaurs to Google Going China, Detail, 1997–2006

Romanian Culture, Timeline, 1997–2006

47

Timeline *Dada Legacy/Anti Art*

Cabaret Voltaire, Zürich, Switzerland, August 26, 2010 –

February 20, 2011

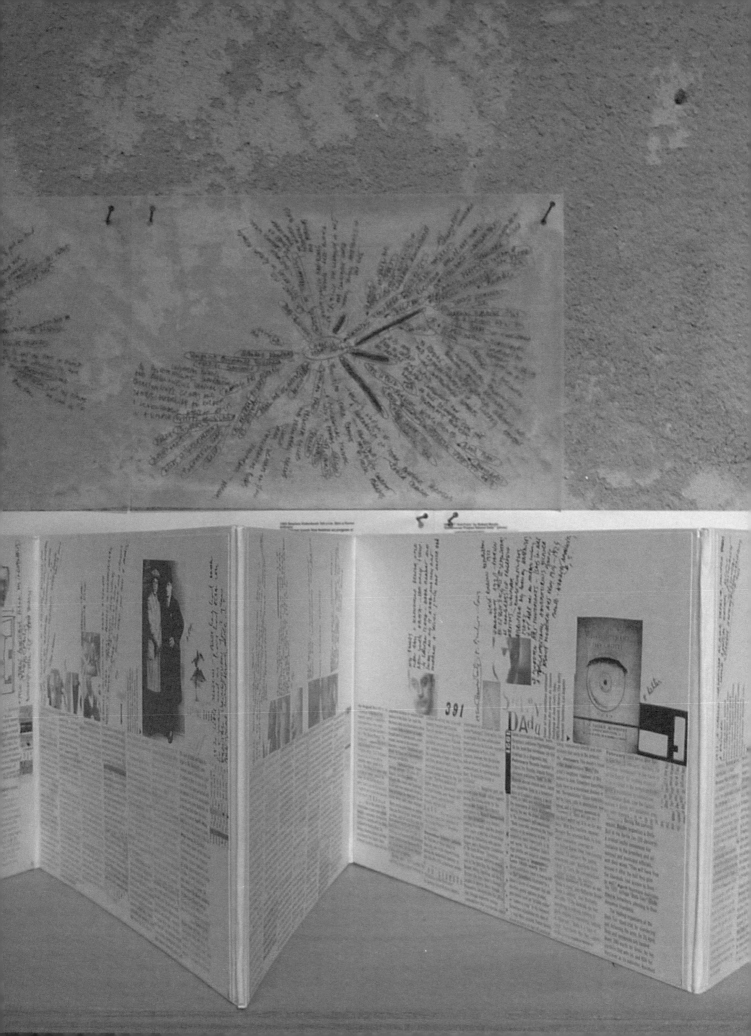

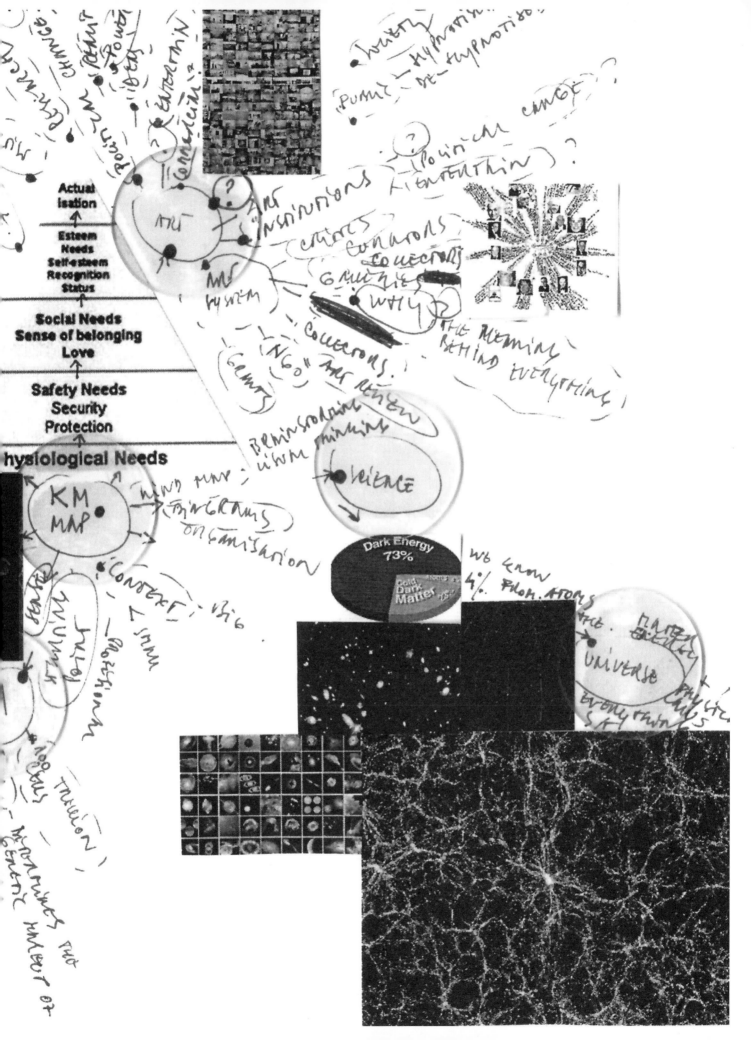

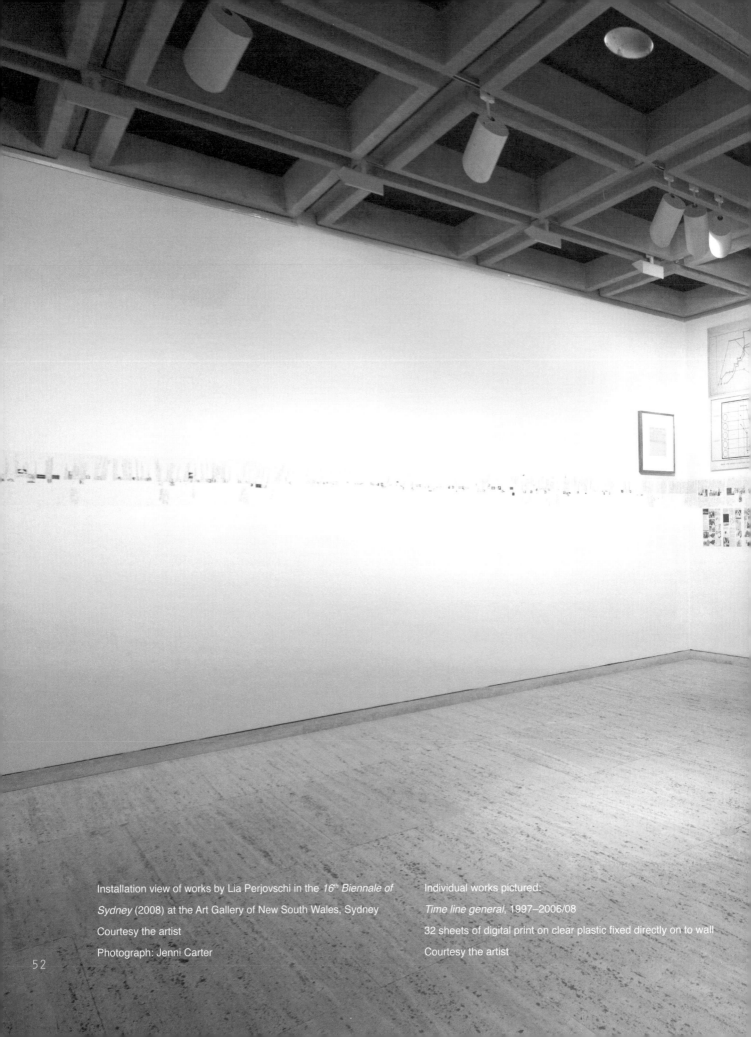

Installation view of works by Lia Perjovschi in the *16th Biennale of Sydney* (2008) at the Art Gallery of New South Wales, Sydney
Courtesy the artist
Photograph: Jenni Carter

Individual works pictured:
Time line general, 1997–2006/08
32 sheets of digital print on clear plastic fixed directly on to wall
Courtesy the artist

52

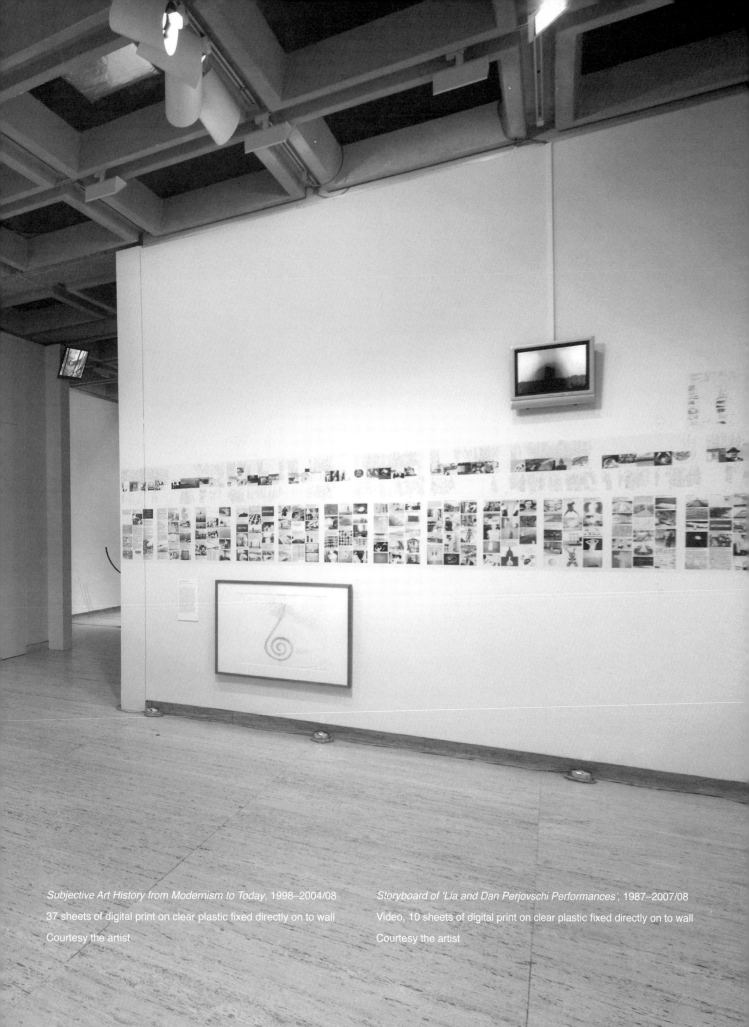

Subjective Art History from Modernism to Today, 1998–2004/08
37 sheets of digital print on clear plastic fixed directly on to wall
Courtesy the artist

Storyboard of 'Lia and Dan Perjovschi Performances', 1987–2007/08
Video, 10 sheets of digital print on clear plastic fixed directly on to wall
Courtesy the artist

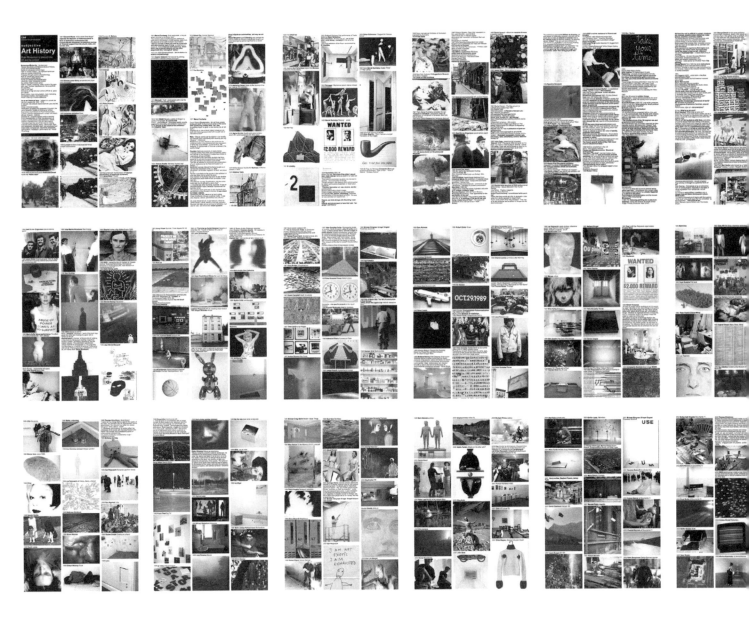

Timeline, My Subjective Art History from Modernism Today

1990–2004

Le nuage Magellan, Centre Pompidou, Paris, France, January 10 – April 9, 2007

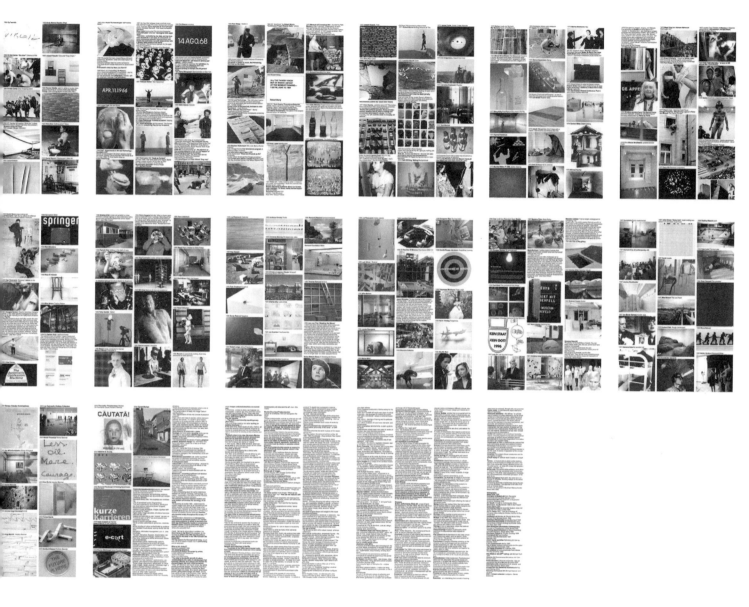

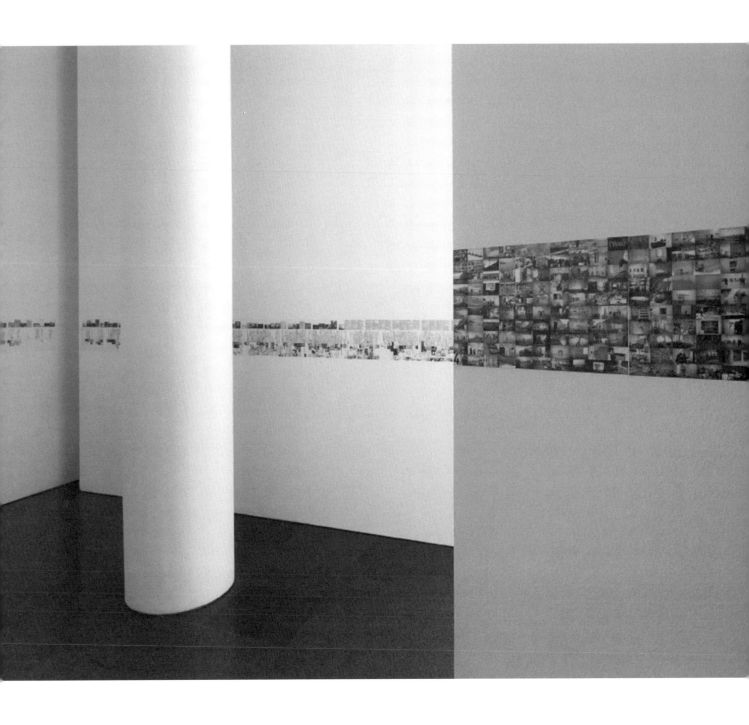

Timeline, General Culture and My Subjective Art History
Museum of Parallel Narrative, Museu d'Art Contemporani de Barcelona
(MACBA), Spain, May 14, 2011 – October 2, 2011

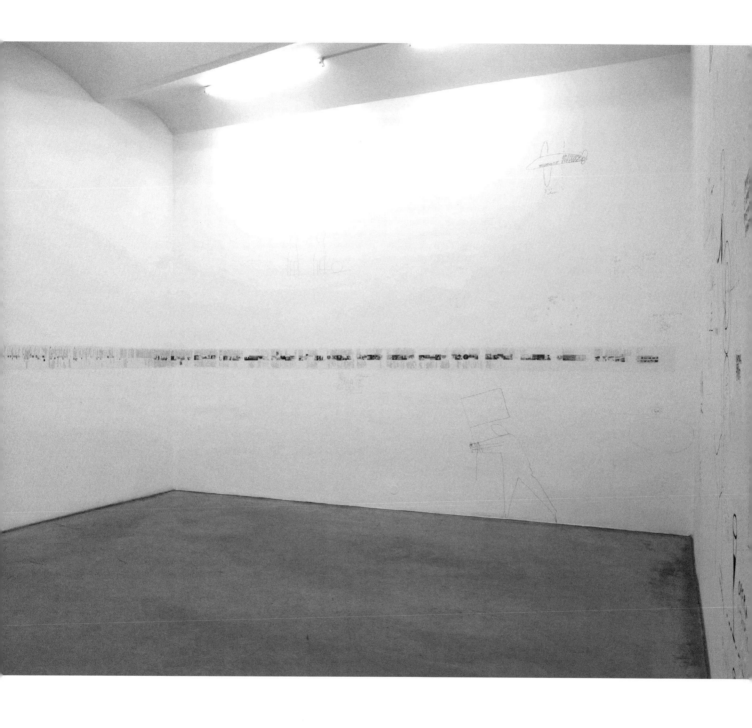

Timeline, General Culture, From Dinosaurs to Google Going China

lia PERJOVSCHI/PERJOVSCHI dan, Christine Koenig Galerie, Vienna, Austria, 2007

mind maps

A graphical technique used to organise or memorise information, mindmapping usually emphasise the connections between concepts or events. Unlike linear structures such as lists, mind maps allow a viewer to grasp an entire field of interconnections. Sometimes a central dominating concept has a hold over other ideas, like a star exercising a gravitational force on the planets in its orbit. Others take on rhizomatic forms which seem to eschew hierarchy or points of origin.

Lia Perjovschi has been making and exhibiting mind maps since the late 1990s. Some of the universes mapped in this fashion are realms of abstract thought; others set out to chart hidden knowledge like, for instance, the identities and interest of super-rich collectors of art. Her most enigmatic mind maps are often the most intriguing. Occasionally the central conceptual space around which all the other ideas and names have been gathered is just a question mark. Viewed as a body of work, Perjovschi's mind maps belong to her project to contest the enforced ignorance that accompanied communist rule in Romania before 1989.

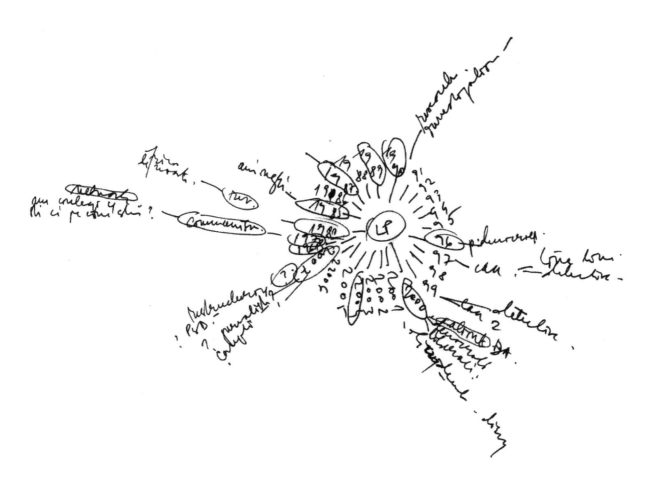

35 *Mind Maps*, 1999–2007

ink on paper, framed

21 x 29.7 cm

lia PERJOVSCHI/PERJOVSCHI dan, Christine Koenig Galerie, Vienna,

Austria, 2007

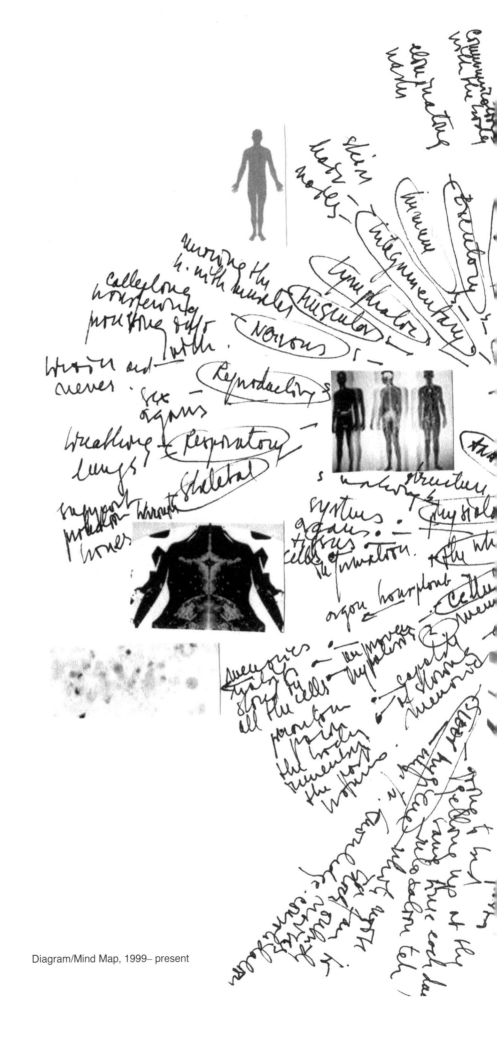

Diagram/Mind Map, 1999– present

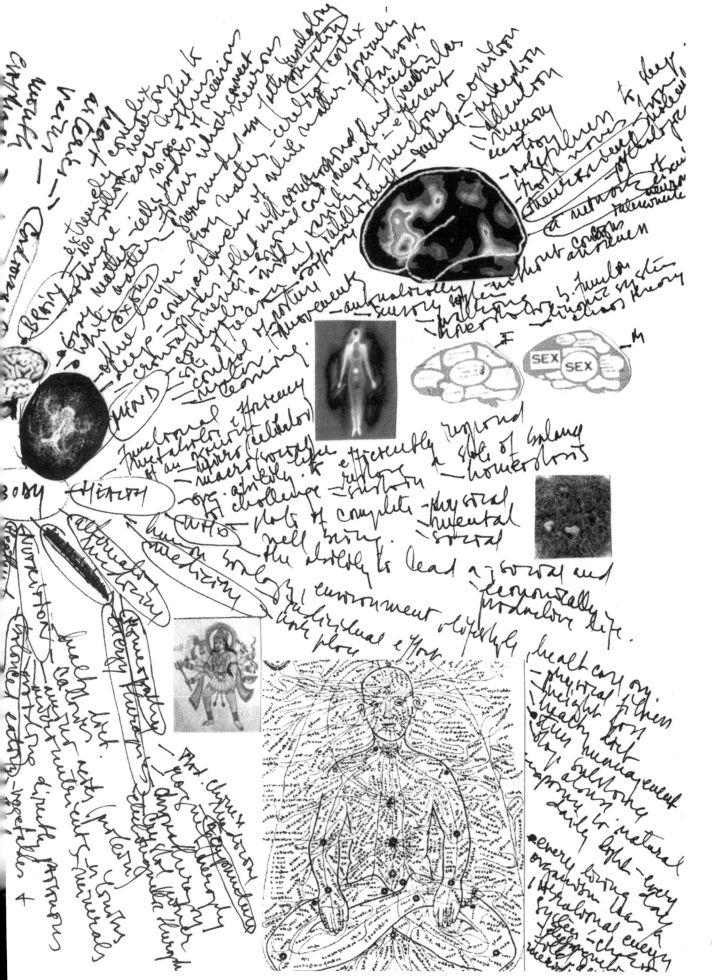

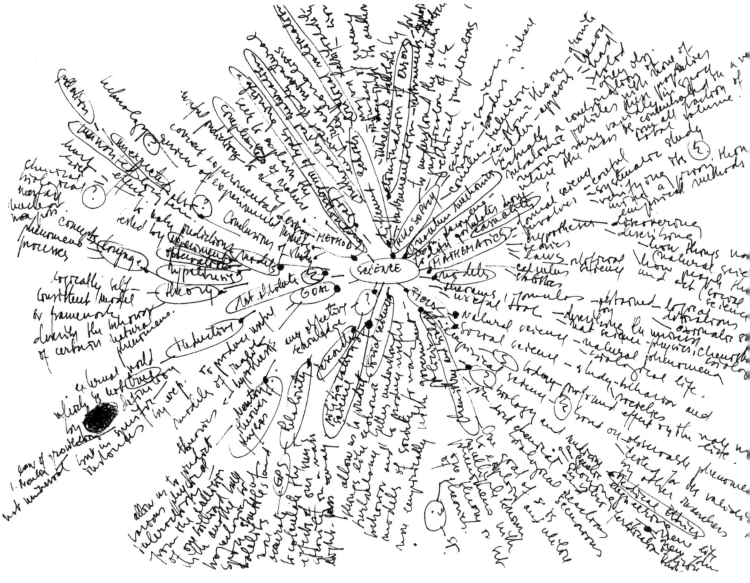

Diagram/Mind Map, 1999– present

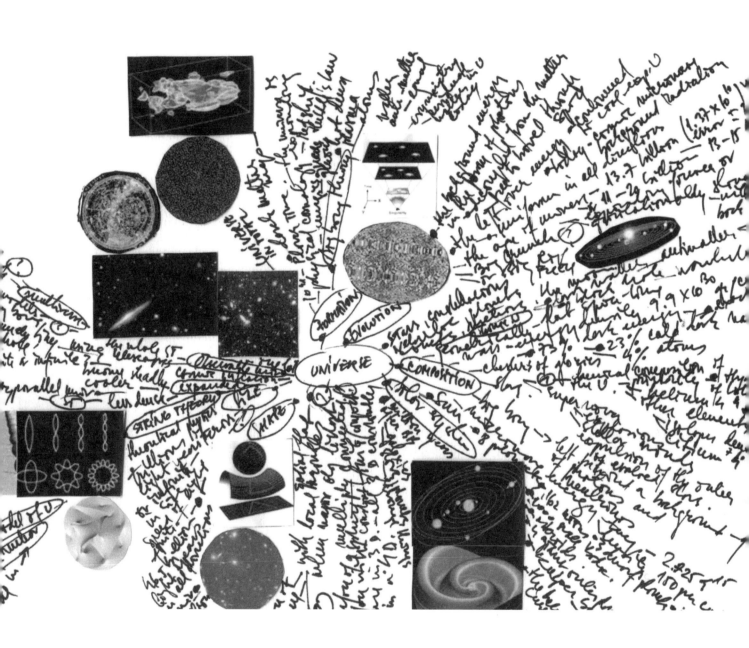

Diagram/Mind Map, 1999– present

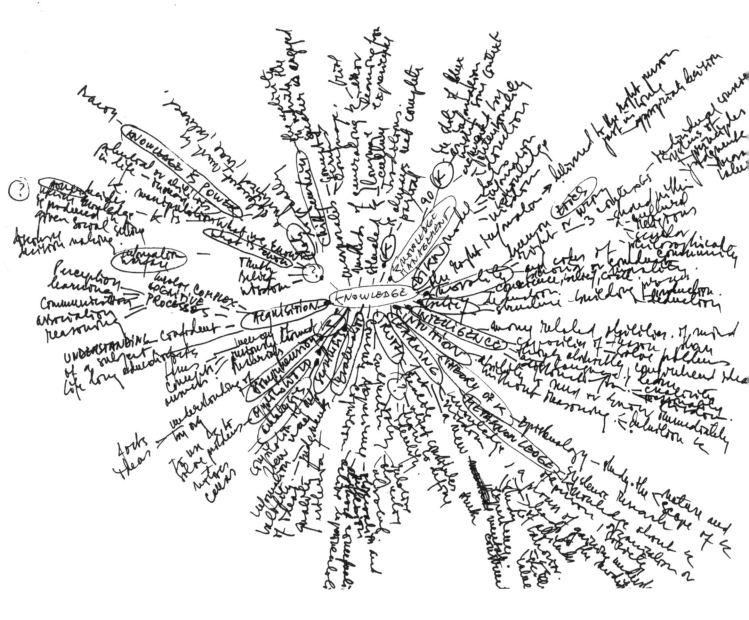

Diagram/Mind Map, 1999– present

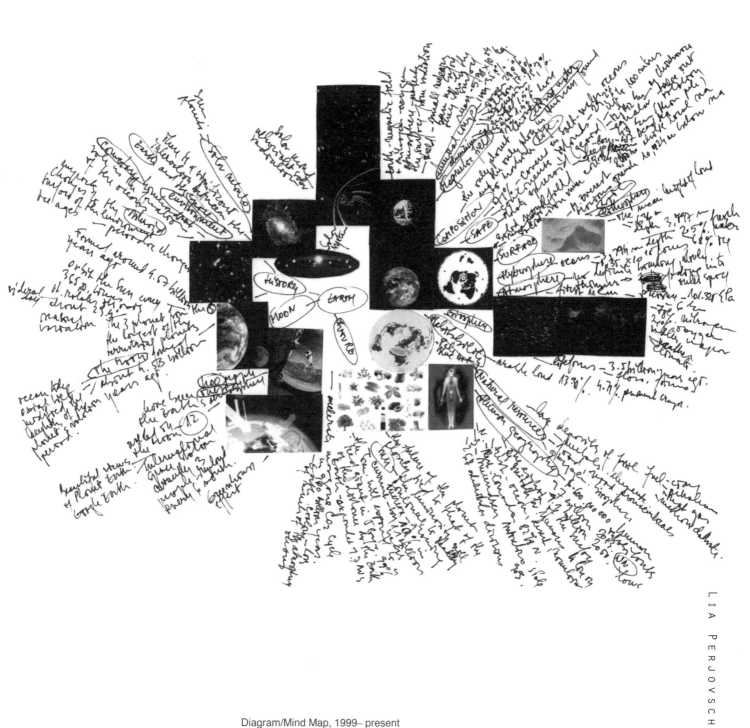

Diagram/Mind Map, 1999– present

Knowledge Museum

Auszeit. Kunst und Nachhaltigkeit / Timeout. Art and Sustainability, May 25

to September 2, 2007, Kunstmuseum Liechtenstein

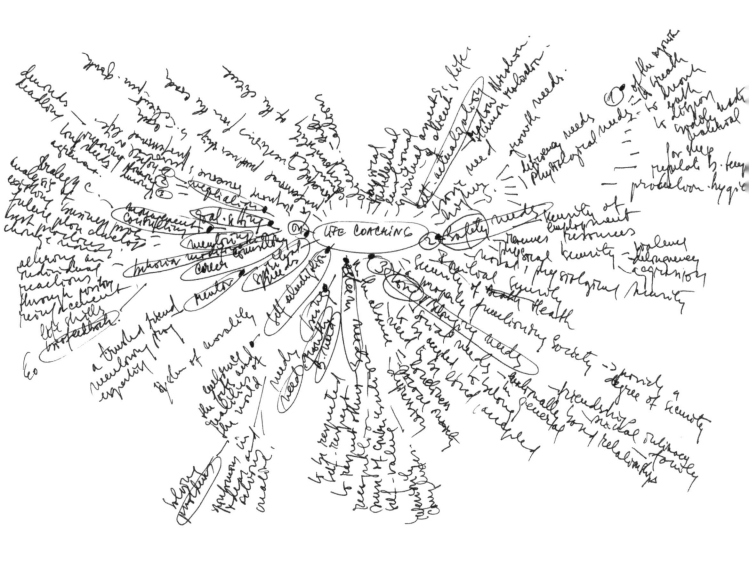

Diagram/Mind Map, 1999– present

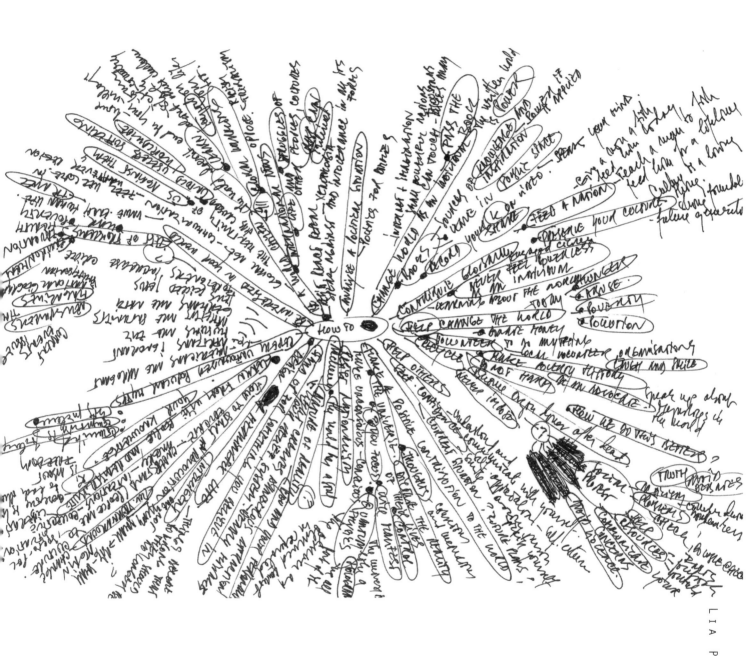

Diagram/Mind Map, 1999– present

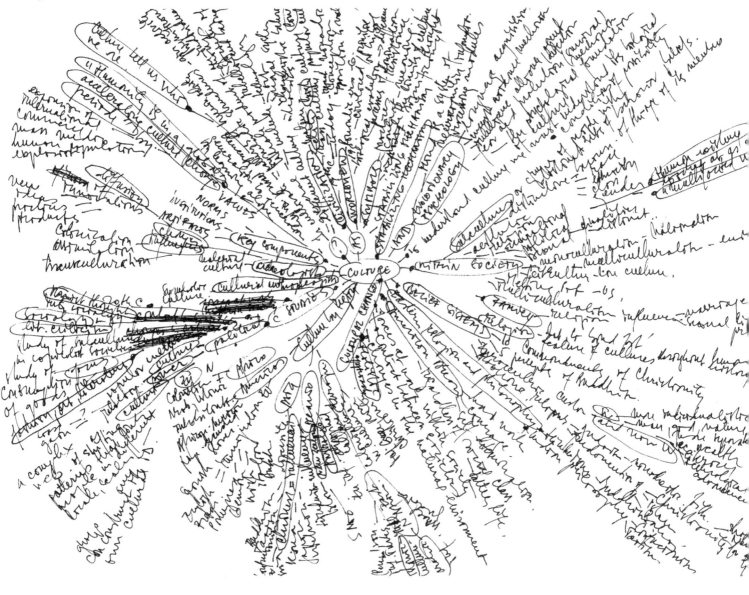

Diagram/Mind Map, 1999– present

Knowledge Museum

Auszeit. Kunst und Nachhaltigkeit / Timeout. Art and Sustainability,

May 25 to September 2, 2007, Kunstmuseum Liechtenstein

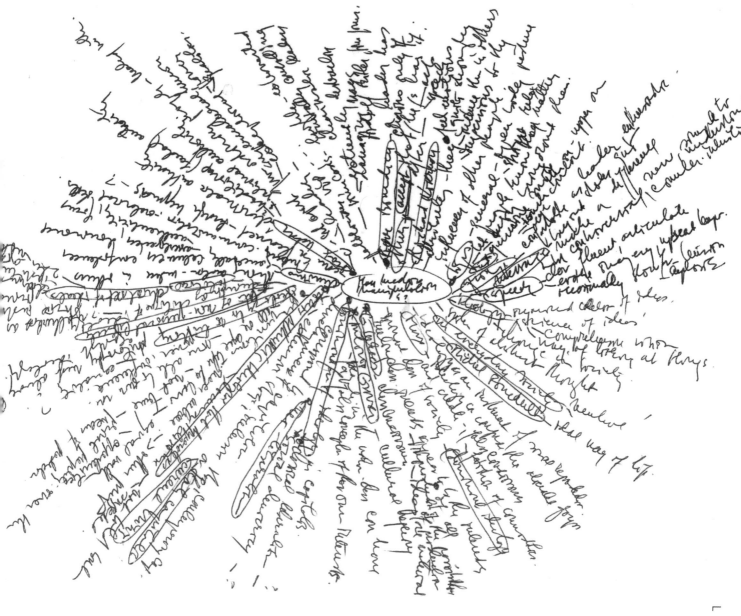

Diagram/Mind Map, 1999– present

35 Mind Maps, 1999–2007

ink on paper, framed 21 x 29.7 cm

lia PERJOVSCHI/PERJOVSCHI dan, Christine

Koenig Galerie, Vienna, Austria, 2007

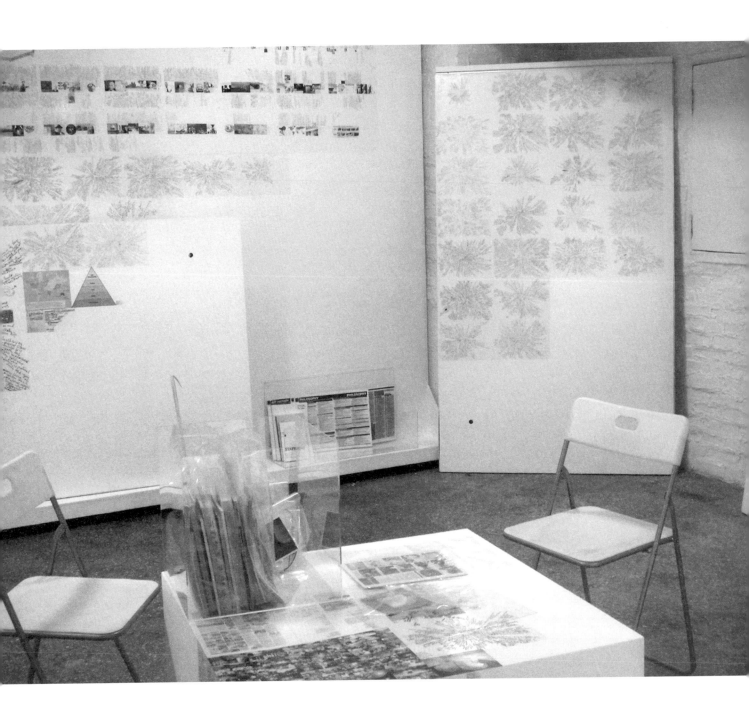

CAA kit, '*The 21st Century, The Feminine Century, and the Century of Diversity and Hope*, Incheon Women Artists' Biennale (IWAB), South Korea, 2009

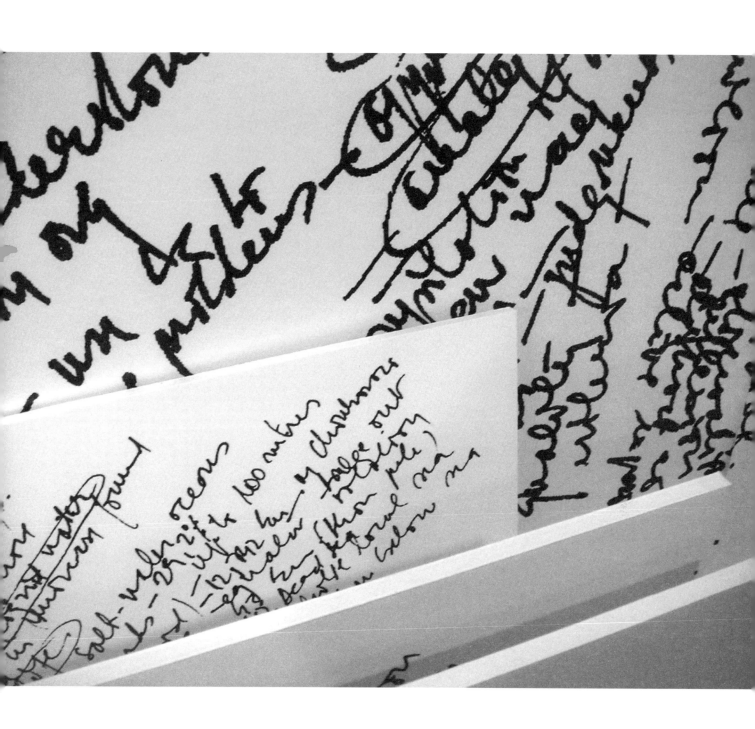

In the Shadow of the Monument, Gävle Konstcentrum, Sweden, 2009

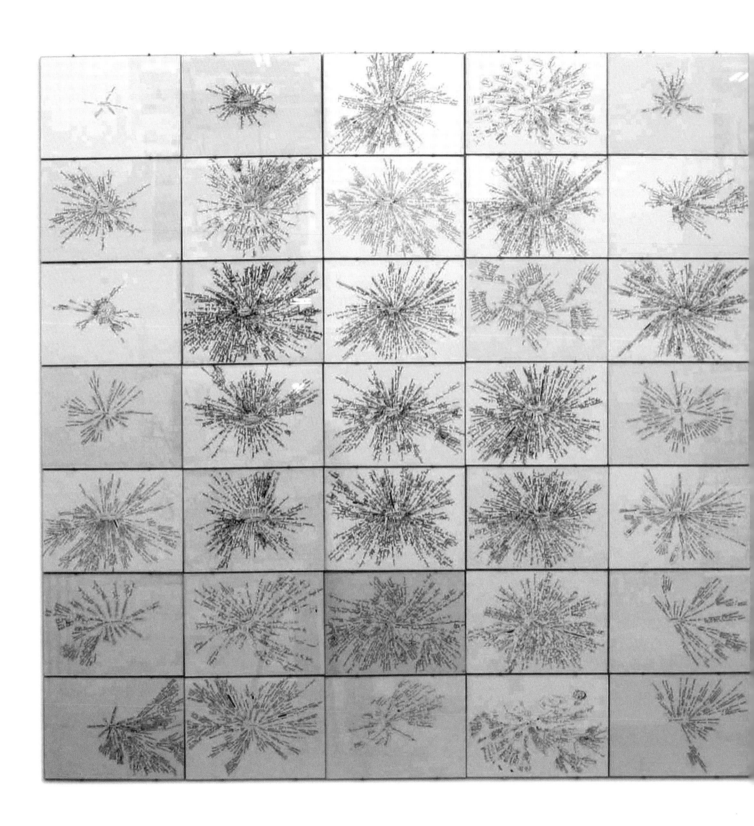

Mindmuseum

exhibition view *lia PERJOVSCHI/PERJOVSCHI dan*, Christine Koenig

Galerie, Vienna, Austria, 2007

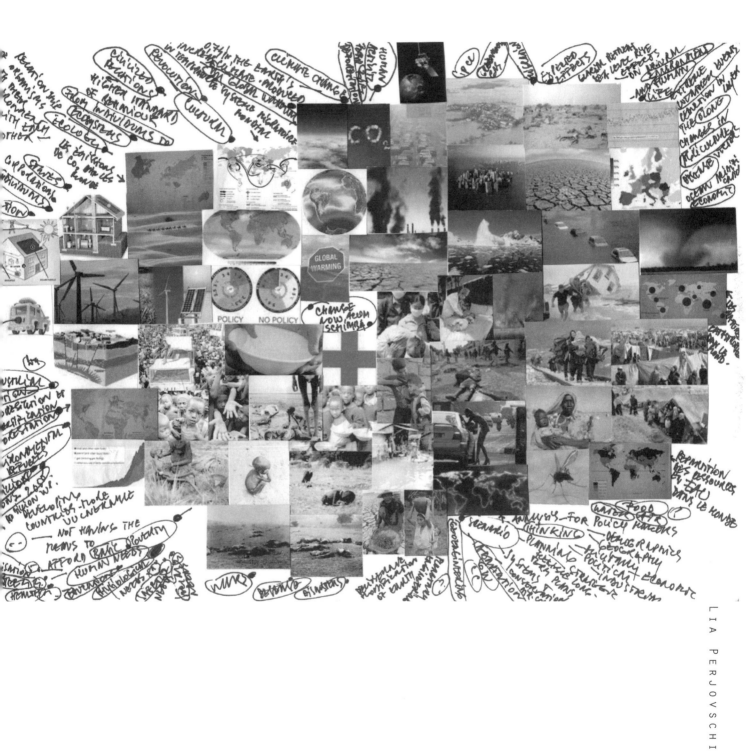

Global Warming Mind Map, 2009

L I A P E R J O V S C H I

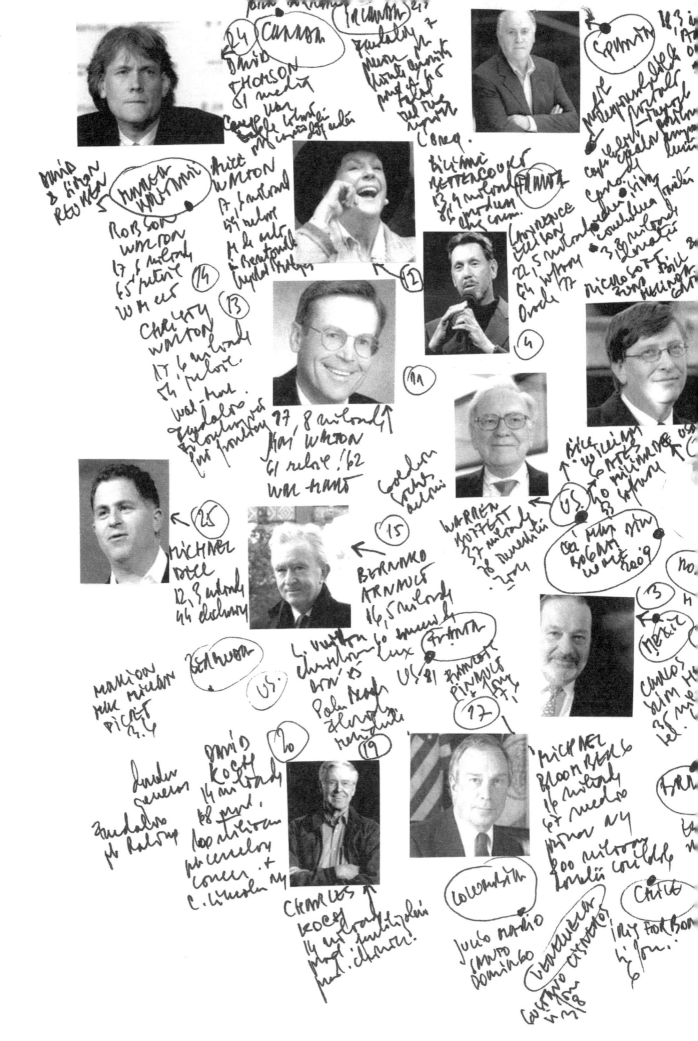

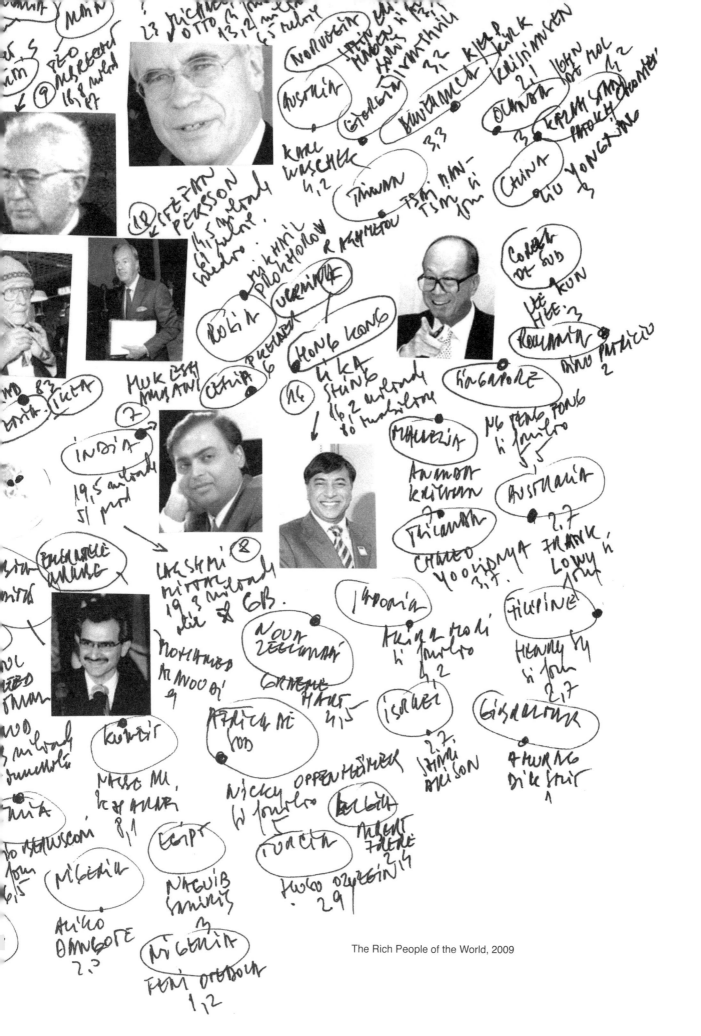

The Rich People of the World, 2009

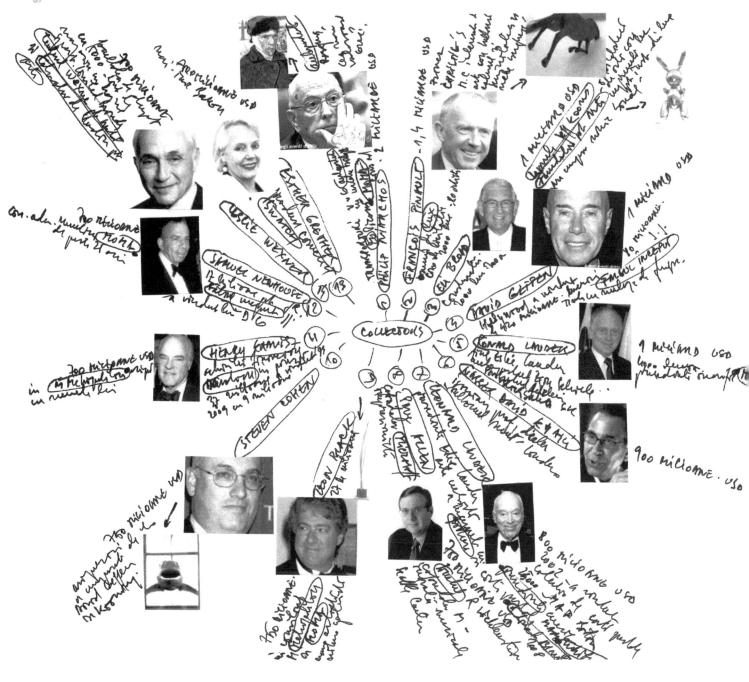

Top Art Collectors, 2009

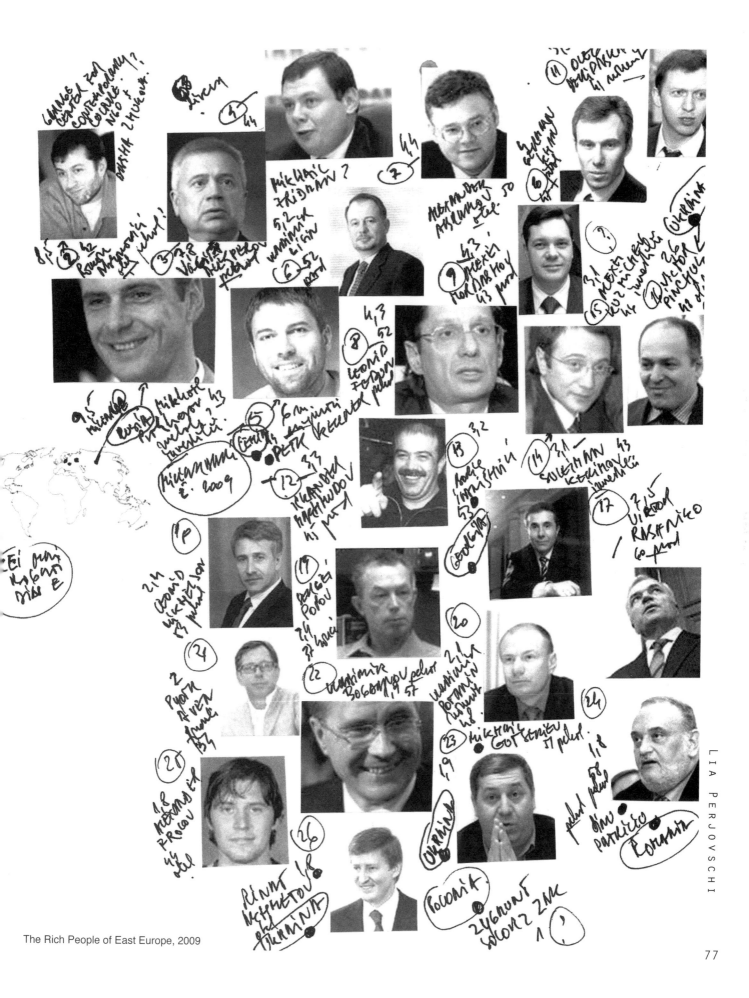

The Rich People of East Europe, 2009

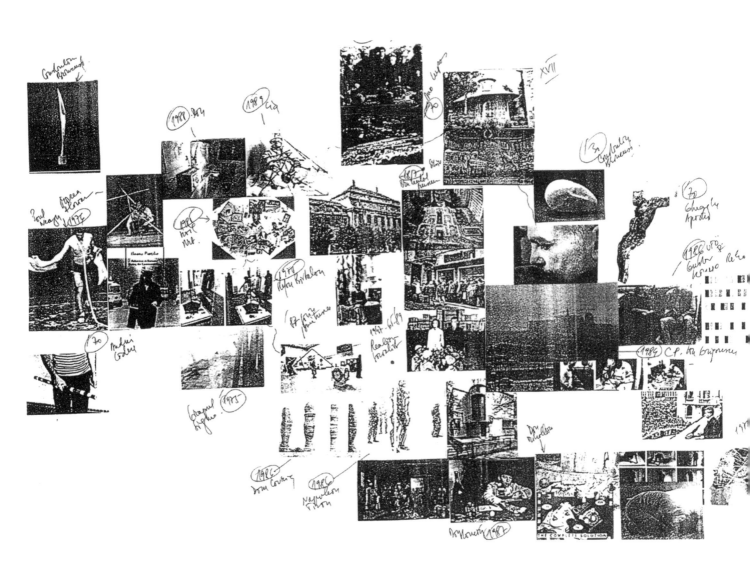

'70 Romania, Mind Map, 1997

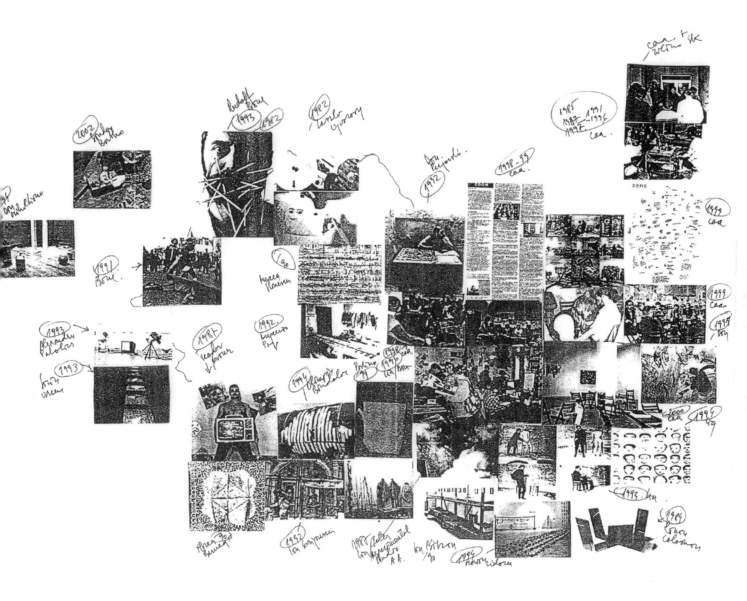

'90 Romania, Mind Map, 1997

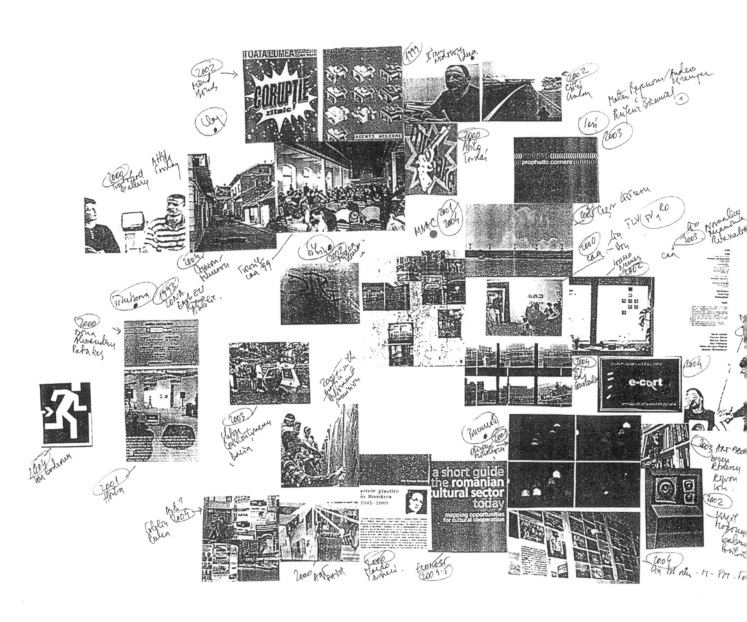

2000 Romania, Mind Map, 1997–2006

Statement, curated by Lia Perjovschi at PAVILION – Center for Contemporary

Art and Culture, Bucharest, Romania, 2009

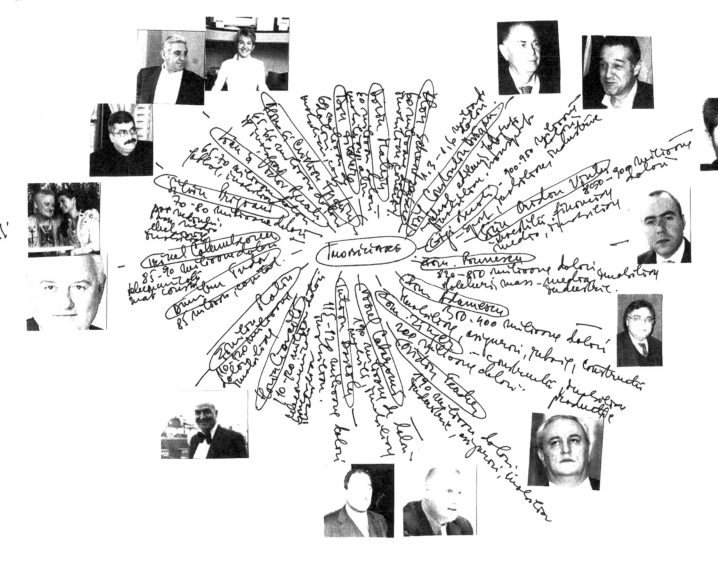

Immobiliare, Mind Map, Romania, 2009

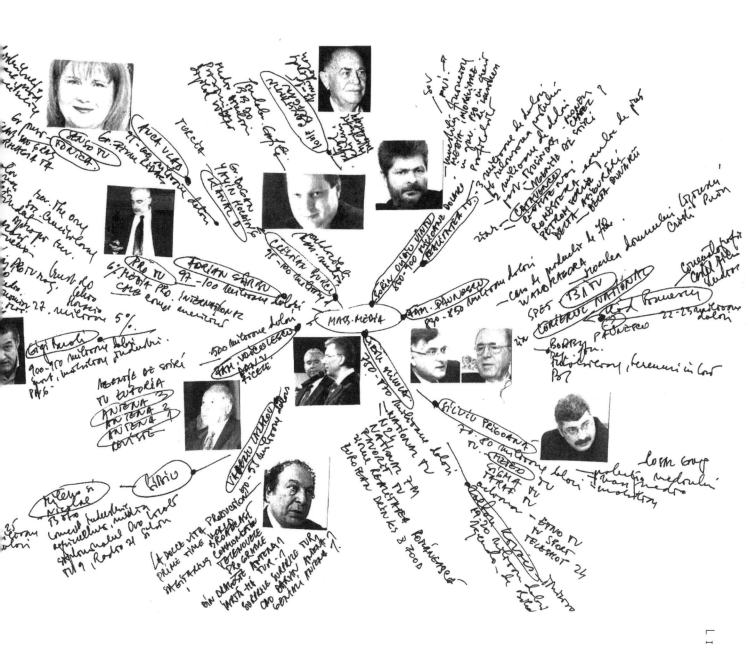

Mass Media, The Owners, Mind Map, Romania, 2009

centre for art analysis

Lia Perjovschi's entire output can be understood as a kind of extensive and unending archive. From her earliest days mounting performances and exhibitions in her apartment to her recent plans for a 'Knowledge Museum', she has been concerned with creating opportunities for intellectual exchange. In the early 1990s, Lia and Dan Perjovschi turned their studio into the *Contemporary Art Archive*, an unofficial setting where visitors could survey magazines, books and reproductions of works of art from around the world. The CAA also operated as a publisher, issuing inexpensive broadsheets, and a public forum organising events and talks. Keeping its acronym, in 2003 the CAA was renamed the Centre For Art Analysis, suggesting a more active role for Lia Perjovschi's archive. With the artists and theorists increasingly drawn to the archive as a space where knowledge is not fixed and where the mythical authority of the expert can be challenged, the CAA has moved from a marginal location in the context of Romanian culture to a central place in contemporary art.

Sens newspaper, 2002
States of Mind: Dan and Lia Perjovschi, Nasher Museum of Art, Duke University, Durham, USA, 2007

sens

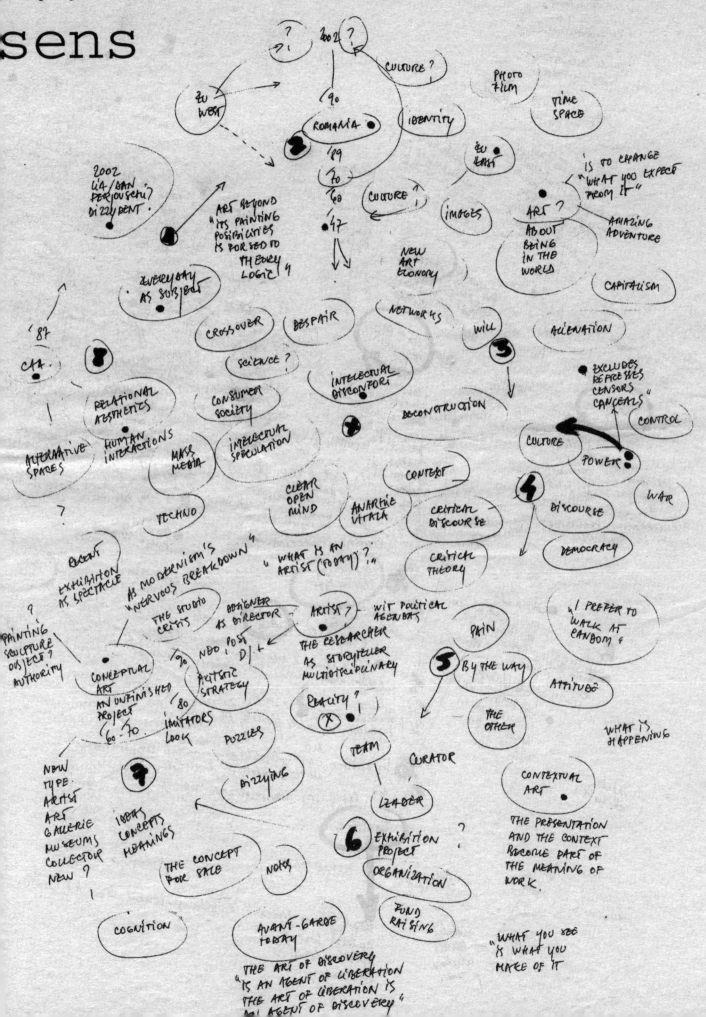

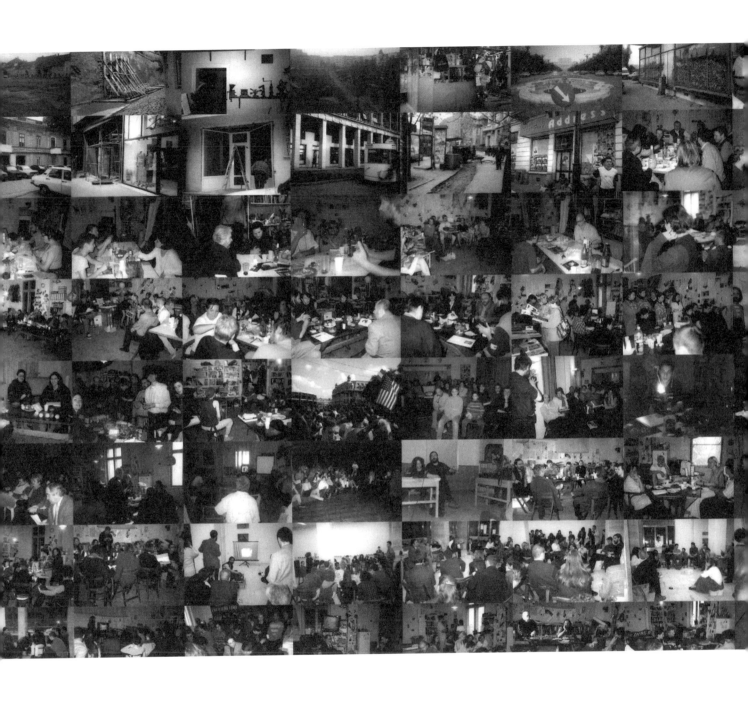

Lia and Dan Perjovschi's studio became the CAA/CAA space, poster, 1990–2000

Austrian, German and Romanian Curators, 2005

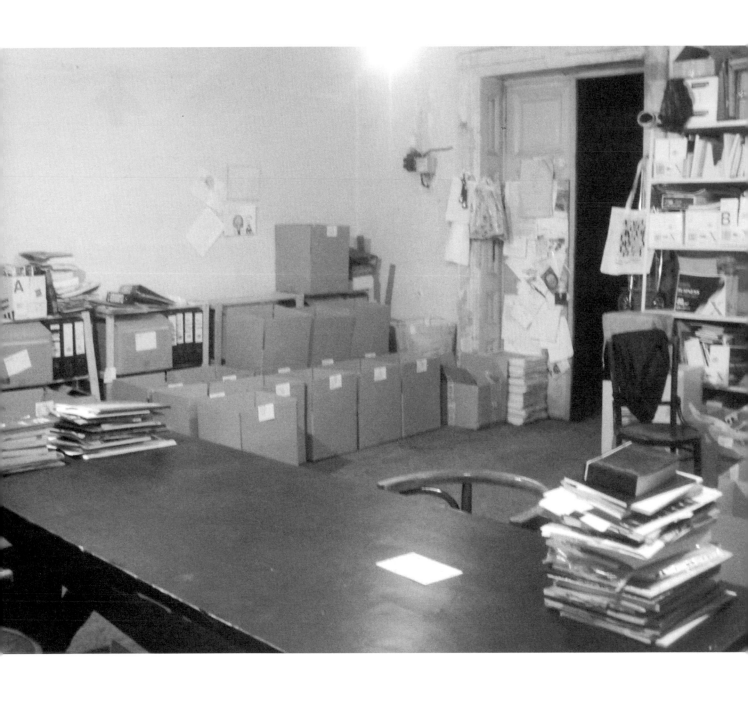

CAA/CAA Space, Berthelot 12, in the yard of the Art Academy,

Bucharest, Romania, 1990–2010

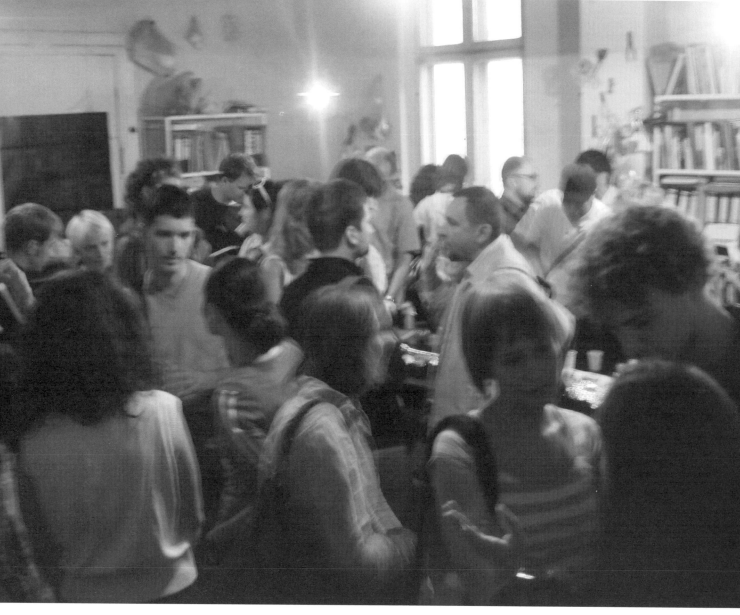

LIA PERJOVSCHI

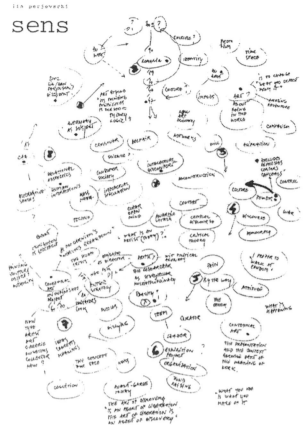

sens

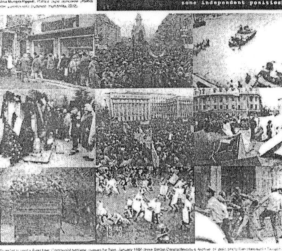

short guide
art in public space (ro)
some independent positions

left, CAA/CAA publications/newspapers,

no 1, 2, 3 and 4, 1998–2000

right, CAA/CAA publications/newspapers,

no 5, 6, 7 and 8, 2002–2003

p.92–93 CAA/CAA publications/newspapers,

detective draft, Detail, 2005

caa
caa
(center for art analyse)
lia dan perjovschi
12 berthelot street
p.o. box 17
70700 bucharest 1
romania
tel/fax: +421/310.01.17;
tel: +421/424.72.95
perjovschi@yahoo.com;
perjo@ong.ro

project in the frame of

"Profetic corners"
Curator:
Anders Kreuger
Iaşi Biennal 2003
"Periferic"

Normalcy
Meaning
Relaxation

caa:

1. Please try to outline a rough sketch of the context you/we are experiencing nowadays (an inventory of positive and negative things).
2. How would you draw a blueprint of building normalcy?
3. How do you see your personal future? What about that of Romania? (or about the future in general)
4. Please recall a few important things that had a great impact on you (your own, personal deposit of positive thoughts).
5. What projects did you fail to achieve? (and why)
6. What major projects did you succeed in achieving?
7. What are your projects for the future?

Sorin Antohi
Ciprian Mihali
Marius Oprea
Dan Petrescu
Alina Mungiu-Pippidi
Joanne Richardson

caa
caa

waiting
r o o m

in the frame of ECF
(European Cultural Foundation) action line

Enlargement of Minds
Crossing Perspectives
seminar
Theatre Instituut Nederland (TIN)
Amsterdam 16-18 June 2003

"In 2002 the ECF launched the action line "Enlargement of Minds". With the aim of exploring, analyzing and anticipating the cultural dimension and implication of EU Enlargement and beyond, it comprises a series of seminars, research, publications, artistic and cultural events that tackle the cultural aspects of EU Enlargement. It contains various viewpoints, and involves cultural operators, opinion leaders, policy makers, media professionals and artists debating the cultural challenges, opportunities and risks that enlargement brings to those "included" and those "excluded" from the process. EoM intends to stimulate proactive contribution to European cultural policy-making and advocate new forms of exchange and encounter. In terms of scope, EoM will address the challenges for the "cultural project Europe" after the first wave of accession in 2004 (Czech Republic, Cyprus, Estonia, Hungary, Latvia, Lithuania, Malta, Poland, Slovakia, Slovenia) and the second wave planned for 2007 (Romania, Bulgaria). But EoM extends beyond the present accession process. It seeks to draw attention to the larger European cultural area, including those countries that will not be part of these two accession."
Crossing Perspectives is a vital component of the series.

some art positions

Nevin Aladag
Matei Bejenaru
Pavel Brăila
Mircea Cantor
Daniel Knorr
Oliver Musovik
Rassim
Anri Sala

1971. Ceauşescu visits China and North Korea – a mini cultural revolution – a second destruction of the elites, shaping the 'new man' – a creature lacking an active conscience and a civic attitude. Civil society is atomised.
Resistance to the trends to return culture under ideological control and cult of personality, was to take place more by individual actions or in very small groups, quickly repressed by the Securitatea, by arrests, convictions, deportation, house arrest and breaking the entourage…informational block – excluding the possibility of solidarity and generalised protest.
The only sources of real information in Romania were the radio stations broadcasting in Romania – **Free Europe, BBC, Deutsche Welle, Voice of America** (A continuous form of protest and information - some say - was the cultural resistance by allusive and metaphorical language, managing to defeat censorship (a practice that is still in use today.)
1977. Attempts at solidarity with resistance movements in other countries (Paul) **Goma Movement**

Between 1964 and 1981, the Writers' Union was a barricade in the struggle against dictatorship, censorship, and the violation of human rights.
In the 1980s, a common form of protest was with open letters, manifestos, destroying communist monuments and symbols, illegal newspapers, open protest in public places, public suicides.
Illegal border crossing to Yugoslavia, Hungary, spectacular escapes to Austria, Turkey.
The massive departure of Germans and Jews… who were able to buy their freedom…
A chronology of civil society
1974-78 Victor Frunză writes a History of Stalinism in Romania – criticising the violation of human rights and of the cult of personality, forced to leave the country in 1980.
31 May 1977 after the earthquake of 4 March massive demolitions are started in the centre of Bucharest (for the House of the People)
2 August 1977 the strike of 10,000 miners started in Lupeni and extended to the entire Jiu valley (after that, Securitatea members were infiltrated to keep things under control – used in 1990)
1979. The Free Trade Union of Labourers was created by Ionel Cana and Gheorghe Braşoveanu.
Vasile Paraschiv of Ploieşti, a professor from the 60s, is arrested and subjected to psychiatric treatment.

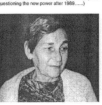

1982-89 and the 90s Doina Cornea addresses many open letters, criticising all the dictator's social, economic and cultural policies. (also questioning the new power after 1989……)

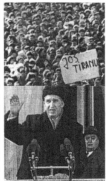

1982-83 Radu Filipescu distributes thousand of manifestos in the letterboxes. Sentenced to 10 years at Aiud prison.

1983 Dumitru Iuga, a TVR technician, organises the Movement for Freedom and Social Justice
80s manifestos: Ion Ilie of Piteşti, Florin Vlasceanu, Pavel Vechio, Victor Tottu – Tirgovişte, Gheorghe Gheorghina, Nicolae Ionel, Ion Drăghici Bucharest
17 November 1985 Gheorghe Ursu is killed in the holding cell of the Bucharest Securitate for his diary that he had written over his last 15 years.
18 February 1987 a protest movement at Nicolina Iaşi, followed by an action of the students in the city streets.
15 November 1987 a movement at the Steagul Roşu Braşov factory
1988-89 Radu Chesaru, Geo Asavei and other young people distribute manifestos in Bucharest
26 January 1989 editors of the Romania Liberă ("Free Romania"), Petre Mihai Băcanu, Mihai Creangă, Anton Uncu, typography worker Nicolae Chivoiu, had prepared an illegal publication with anticommunist articles.
2 March 1989 Liviu Babeş of Braşov sets himself on fire in a ski slope in Braşov, shouting anticommunist slogans.

1989 Dan Petrescu, Liviu Antonesei, Liviu Cangeopol of Iaşi and from Bucharest

Gabriel Andreescu are subject to inquiries
14 December anti-Ceauşescu movement in Iaşi - Casian Maria Spiridon, Ştefan Prutianu, Titi Iacob…arrested

16 December the revolution starts in Timişoara
20 December the revolution starts in Sibiu,

Proposals for change
Instead of MNAC, an institute studying the communist period (with a mixed team, consisting of specialists – anthropologists, sociologists, psychologists, artists, critics, theoreticians, historians…philosophers) responsible professionals – this framework might include, depending on the subject, even recent proposals from the contemporary art.
Recent history – some initiatives –
1999 Radu Filipescu – documentary exhibition – Ceauşescu's era at GDS
Museum about the private life in communism – Victims' Memorial Centre from Sighetul Marmaţiei – under the guidance of Ana Blandiana and Romulus Rusan, and Timişoara

Revolution Memorial (director Traian Orban) and The Hall of Black (Red) Death, created by Irina Nicolai at the Museum of the Romanian Peasant are the only initiatives of producing, by a museum intervention, the Romanian communism memory.
Gabriela Cristea "viaţa privată in comunism/ private life under communism" project.

2004
Bogdan Iancu
In the majority of the ex-communist block's countries, appeared a series of museums dedicated to the totalitarian regime, one of them focused on a memory of political terror, others, fewer – on the daily life.
Reversible thinking
The Romanian contemporary art lacks the theoretical background, the funds and production places, the professional

presentation places and the international networks.

Historical, political, cultural context
Romania
Lucian Boia
Romania Borderland of Europe London Reaktion Books 2001 / Romania Tară de frontieră a Europei, Bucureşti, Humanitas 2002
"Romania is a country at a crossroad between different geographies and civilisations, a space characterised by perpetual instability, by lack of discipline, perseverance, and a spirit of organization. European versus autochtonismous is a typical intellectual polarization for Romanian society. The past often looks more important than the future. The position of

Romanians towards their communist past remains opaque and equivocal."
Cartea neagră a comunismului/ The black book of communism
Crimes terror repression
Stephane Courtois, Nicolas Werth, Jean-Louis Panne, Andrzej Paczkowski, Karel Bartosek, Jean Louis Margolin, Edition Robert Laffont SA Paris 1997 Humanitas 1998

2000, Ştefan Constantinescu, Archive of pain (video by Cristi Puiu)

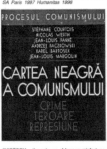

"HISTORY – the science of human misfortune (…) The COMMUNISM begins in 1914 …
Communist Repression in Romania and its official dimensions
1947. 30 December – the Romanian People's Republic is proclaimed – evolution to a social system that is similar to that imposed in the Soviet Union.
Structural changes in the economic and social life, accompanied by the elimination of every political opposition.
Approximately 2,000,000 persons have been in prisons and labour camps during the period 1948 to 1964.
The mass media came under the total control of the state.
Libraries and bookstores were 'cleansed' of titles that were politically inappropriate, the activity of journalists, writers and artists was controlled by the Agitation and Propaganda Section (Agitprop)

of the Communist Party.
Education: **1948.** The law for the education reform – cleansing among the teachers and students, renowned teachers being replaced by Stalinist indoctrinators.
Church: the last obstacle, the Greek Catholic church was dissolved, while the Roman-Catholic and Orthodox churches were controlled.
Protests
1950. Resistance movement in Făgăraş groups of anticommunist partisans (Elisabeta Rizea… one of the supporters of a group… survivor/witness)

international architecture contest – **"Bucharest 2000" – to redesign Bucharest's centre.** The contest was won by the German architecture office "Von Gerkan, Marg und partner".
The project accepted the axis and the palace as a historical heritage and tried to create new qualities, by gathering new urban elements (the axis remains with the memories of a lost historical structure and of the new democratic

design method…). All proposals, all solutions were ignored.
2001 - in the back, in section E4 the MNAC building begin.
2004 – a rooftop national flag – accounted for some 60,000 dollars – as part of government spending, the flag was widely regarded as a costly useless buy.
2005
Curierul naţional 23 February
Bogdan Costache
The sudden change of a hole in the Palace of Parliament basement into a luxurious swimming pool recreation complex … between 2001 and 2003, the area saw investments (3,5 billion lei), to complete the construction and to clean up.

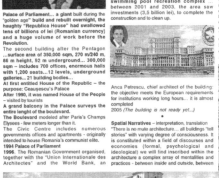

Palace of Parliament… a giant built during the "golden age" build and rebuilt overnight, the haughty "Republica House" had swallowed tens of billions of lei (Romanian currency) and a huge volume of work before the Revolution.
The second building after the Pentagon …surface area of 350,000 sqm, 270 m/240 m, 86 m height, 92 m underground… 300,000 sqm – includes 700 offices, enormous halls with 1,200 seats…12 levels, underground galleries… 21 building bodies…
At first entitled House of the Republic – the purpose: Ceauşescu's Palace
After 1990, it was named House of the People – visited by tourists
A grand balcony in the Palace surveys the entire lenght of the boulevard.
The Boulevard modeled after Paris's Champs Elysees - few meters longer than it.
The Civic Centre includes numerous governments offices and apartments - originally intended to house Romania's communist elite.
1994 Palace of Parliament
1996. The Romanian Government organised, together with the "Union Internationale des Architectes" and the World Bank, an

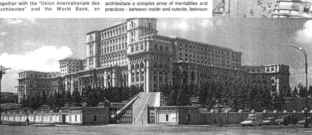

what is supposed to be seen and what is not. The space, size, location - defined by and give definition to the social and psychological narratives that influences the behaviors (encouraged, allowed, discouraged or forbidden). Architecture participates in the managing of subjects-in form of the organization, hierarchization and systematization of order, activities, behavior, movement and visibility. Foucault's micro-technologies of power – "the circulation of effects of power through progressively finer channels, gaining access to individuals themselves, to their bodies, their gestures and all their daily actions – architecture function both as and under authority – structure and is structured by institutions." (Mark Rakatansky)
"The Architecture of **Atmosphere** - Sigfried Giedion – "atmosphere starts where the construction stops". It surrounds a building – seems to emanate from the object – it is some kind of sensuous emission of sound, light, heat, smell, moisture…a strong spatial and emotional effect…"(Mark Wigley)
Distant, Big body, fence, and empty space around…
"**Optics** is a politics of positioning - Only those occupying the positions of the dominators are self-identical…knowledge from their point of view is truly fantastic, distorted, and irrational…
Positioning, is the key practice grounding knowledge…implies responsibility"(Donna Haraway)
"**Seaming** - The loss of ethical urgency is due to the disappearance of otherness or difference… which allows the cultivation of the space necessary for critical distance. This eclipse of otherness results either from difference becoming so different that it is indifferent, or from difference collapsing into the sameness of the every day.
To live a life of seaming is to struggle to find ways to hold together what drifts apart and
Hold apart what drifts together" (Mark C Taylor)
excerpts from **Sturm der Ruhe - What is Architecture?** Az W (Architekturzentrum Wien

Anca Petrescu, chief architect of the building: the objective meets the European requirements for institutions working long hours… it is almost completed
2005 (The building is not ready yet…)

* * *

Spatial Narratives - interpretation, translation
"There is no mute architecture… all buildings 'tell stories" with varying degree of consciousness. It is constituted within a field of discourses and economies (formal, psychological and ideological) we will find inscribed within the architecture a complex array of mentalities and practices - between inside and outside, between

of strategical planning. More exactly at that chapter at which Romania is still failing, in a country that missed so far its modernization and where the isolationist fixation on a bi- or even a multimilenary tradition is a substitute for a systematic construction.
Ministry of Culture hasn't reformed yet. Its staff kept or temporarily indexed, in key-positions, people still animated by the communist stalinism's spirit, even some office workers longing for Ceauşescu.
The Ministry of Culture should concentrate on a few precise positions concerning the image (the promotion of the creations and the important cultural figures…) and also the infrastructure - subventions for programs of public interest. Only the creators and the public are competent to judge of the essence of culture. The state should modestly interfere, only when the consumption society's force threatens the substance of culture… (…) The culture includes humanities, natural sciences, technology, political spirit, political culture, civic culture…(…) Romania is a very modest presence on the international market of cultural assets. (…) We need to have our specialists … **many cultural institutions are making compromises for money. How far can the compromise go?** Donations must be prudently accepted, their source and use must be transparent, the conditions imposed by the donor need to be negotiated… (in the West - the big companies, the foundations, the individual donors, the loteries, the casinos – culture, education, research).
The Academy must also be reformed… some of the members have no body of work. What's worst is that the research institutes, sponsored by the Academy, have also preserved themselves…(…)
Creation unions – instruments of the party providing shameful advantages, in which even some tenors of our democracy found satisfaction."

2005
2.03
Vlad Nanca
Tuberman project
It is said that those from MNAC are for. So, if anybody wants to settle a match, then **It's possible!** Prepare your tubes, roll up your cornets and shoot!

2005 may 5
The freedom of expression celebration day.
Among other things (music concertos, public meetings) some graffiti activities have been organized on the wall around the Parliament Palace.
(actually on some woden panells and with the permission of The Chamber of Deputies. Graffiti as a life style and not at all counterculture. freedom?)

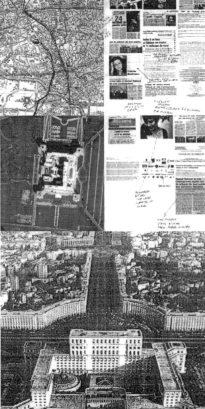

PSD (*almost a mafioso party... led Romania between 1990-1996, 2000-2004*)

MNAC as a political demand
MNAC directors:
Ruxandra Balaci - since 1995 director of the Contemporary Art Department from the National Museum of Art

Mihai Oroveanu - since 1990 the director of the National Office for Art Exhibitions

Context
2002
22 Magazine, july
Dan Perjovschi
Where we are now
For about 12 years I have sometimes been meeting **Andrei Ursu**, when he comes from Chicago at the trial of his father's Securitate assassins. We change a few words and then I look for my problems: miners' revolts, electricity bill, financial engineerings, rates, self-made billionaires. I'll meet him again in a week, in a few months or maybe in a year. Meanwhile, political leaders or contracts for Romania appear and disappear, general public prosecutors, presidents, governments, prime-ministers, the FMI (International Monetary Fund) rapporteur or the civil society are changing. For 12 years Andrei has been attending the trial, like a clock, amazing both the guilties and the juridical system that tries to blanch over those guilties.
We'll be a real country when Andrei comes only for the awarding of Gheorghe Ursu Foundation's essay prizes for highschool competitions like "The Culture of (in)tolerance" or "Why would I (not) leave Romania?"

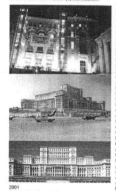

Andrei Ursu

2004
December
http://contracoruptie.ong.ro
The members of the Coalition for a Clean Parliament
Catavencu Agency-Media Monitoring Agency (Mircea Toma)
Civil Alliance (Ioana Arnǎutoiu)
The Association for Human Rights' Defence – Helsinki Committee (Monica Macovei)
Pro Democracy Association (Cristian Pârvulescu)
Students' Association from the Faculty of Political Sciences (Doina Tǎnase)
The Centre for Independent Journalism (Ioana Avǎdani)
Freedom House Romania (Cristina Guseth)
Open Society Foundation (Renate Weber)
The Group for Social Dialog (Radu Filipescu)
Romanian Academic Society (Alina Mungiu-Pippidi)
The Coalition for a Clean Parliament elaborated lists based on norms of ethical integrity founded by the civil society, based on standards necessary to a clean policy and to an honest administration.
Alina Mungiu-Pippidi in dialogue with Eugen Istodor:
For politics, lists do exactly what the Romanian society should have done long ago, in all fields - they state what's good and what's bad.
E I The lists are taken from the press. Well, the press is paid either by the state power, or by the opposition. You shouldn't have given also the lists of media owners and their relations with the politics?
AMP The main source is the press, that's true, but not only a newspaper article. And besides, we asked people to contest. We eliminated the articles based on no document.
The lists show that there are lots of parties, but a single network.
If you are in the network, everything comes to you automatically.
They are the first quantitative proof that everything is monopolized by the devouring elite, which, of course, has its nest in PSD.
The corruption map and the development map are strictly colligated, the poorest counties, with villages where everybody depends on social assistance or on coupons, have the biggest lists. Ialomiţa, Giurgiu, Argeş...
The most developed counties from Transylvania, with a higher standard of life and a more independent population, like Sibiu, Alba, Arad, have only a few names on the lists.
We accepted not to take into consideration the party leaders who promote their integrity norms and who clean the lists by themselves.
2004
Jurnalul National,
27 May 2004
Lavinia Tudoran
Romania, ploughed in the human rights examination
Amnesty International Organisation
The human rights are not respected, corruption is everywhere, "big fishes" are free...from the yearly report
2004
Evenimentul Zilei
No 3925, 24 November 2004
The shorthand records of PSD's secret meetings from the beginning of 2004
PSD is looking for political analysts
Adrian Nǎstase: "Everyone must name ten analysts that he recommends for the TV channels, radio and so on"
The party target: as many ONGs subordinated to PSD as possible
Misinformational strategies about political opponents
The leader of the Student's League named by PSD. How do the PSD leaders play the fool
The campaign strategist of D.A. Alliance accuses PSD of preparing a fraud at the

elections. The methods of electoral theft – the falsified polls and exit-polls, but also the cheats with the voting papers...
2004
Evenimentul Zilei 10 November 2004
55 new billionaires in top 300
Ovidiu D. Popica
13 billion dollars – the most attractive businesses were the investments in the capital market and in the real estates market.
Their past explains the present
On the whole, the group of the top ten has increased its fortune. About the majority of them it is known, at least, that they are still having cordial relations with the leading party PSD.
Doctor Roger Schoenman, professor at University of Santa Cruz, California – The dynamic in Romania, where it seems that 10 or 11 of the first 20 businessmen had had something to do with the Security...The majority of them is trying to maintain good relations with PSD. PSD has the most numerous billionaires candidate

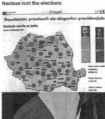

October 2004 The second opening of MNAC. This time for the General Elections. Adrian Nastase the PSD candidate for the Presidency did the opening speech

2004
Although PSD controlled the country Nastase lost the elections

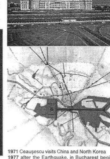

Traian Bǎsescu President

Prime Minister Cǎlin Popescu Tǎriceanu

Monica Macovei Minister of Justice

Where the Museum is located?

House of the Republic and the ensemble Socialism's Victory Boulevard...
Civic Centre, House of Science and Technology, the Ministry of the Interior, The State Archives and National Library.
Evicting 40,000 people with a single day's notice...
The construction was started and raised while many Romanians experienced a period of privations (1980-1989), great cost, effort and sacrifice...

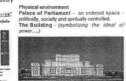

1971 Ceausescu visits China and North Korea
1977 after the Earthquake, in Bucharest begin massive demolitions. (in the oldest areas of the city photo).

1984 construction began ...
(foto Ion Grigorescu)

foto: Archive of Pain

c a s e s t u d y

MAC in Bucharest Romania is MNAC located in the Parliament Palace (?) incredible!!!

2001
A rumor turn into reality
(we need a museum... but not there... not built in secrecy... without debates, without a project...the methods remind me of communism... who's afraid of dialogue and why?)

Artelier Magazine, no. 7/2001
Magda Cârneci (art historian) spreads a questionnaire about a possible Museum of Contemporary Art (but no location was specified)

Questionnaire
1. What decade of the 20th century should a museum of contemporary art's exhibiting begin with?
2. What directions and trends shouldn't we issue from such an exhibiting? What fields, genres, technics?
3. How could be the relation between national and international in such a museum?
4. How do you see the subjacent cultural policy of such a museum? Only public? Only private? Both public and private? Both national and international? A policy involving art critics, curators, juries both from Romania and from important biennials and international events?
5. What national and international authorities or institutions could contribute to the creation of a viable project for a museum of contemporary art?/ What Romanian and foreign names?
6. Is there a museum of contemporary art in Europe or elsewhere that you especially appreciate?
7. Other suggestions?
In the Artelier magazine – surprise... you can find opinions about the National Museum of Contemporary Art (MNAC) located in the Palace of Parliament...
"A chat almost serious about a work in progress MNAC at its very beginning between Mihai Oroveanu director MNAC, Ruxandra Balaci chief curator MNAC, Irina Cios director CIAC and Adela Vaetis art critic editor Artelier"
MO (...) considering the time pressures due to the phasing of the financial investments in the construction, it was impossible to set up a

competition, as it would have been natural, and we made a projects'selection. From three proposals, the jury chose the most realistic formula,which has nothing eccentric in it. We chose a formula with "large spaces, a lot of techniques, high speed". In the army I learnt that these are the characteristics of the modern war.
(*A competition? I think this is about an architecture competition*)
MO We must get down some ceilings, break and remove some walls, build stairs and entries between floors, project again the climatic, the heating and the lighting systems. That means more than 12,000 sqm.
RB I would have preferred to call Gehry to make a funny intervention at the front side.
AV But after all, what do you aim at? There will be a collection? Will the acquisitions be made from the beginning or everything will be set up on the fly?
MO Of course there will be a collection, I hope we start making acquisitions, because we heard some promises.
IC until now we have a building under construction, which must be finished. What shall we do afterwards?
MO We'll certainly have difficulties at the beginning – one of the reasons is the lack of artists' civil practice. There are people who, from the first, refuse to exhibit their works in this museum because of its location.
(we were friendly pointing out that accepting that place was compromising for the contemporary art, for the culture in general... we decided never to exhibit there...)
RB It's clear, if we have problems with our artists (yes, we were friends...)
- do you have in mind those artists who refuse to exhibit in House of the People for political reasons, but they easily exhibited in Ludwig Museum in Budapest, the ex-residence of Museum of the Communist Party?), we would better turn to Chapmans, to other gentlemen and ladies. (!!!)
(for some years, Ludwig Museum in Budapest functioned in the residence of Communist Party former Royal Palace... shall I add this isn't a similar situation?)
MO We make a flow chart proposal. There will be four departments: one for curatoring and research, one for on-line and off-line research, one for education and international relations and one for economy. We'll have a consultative board (independent specialists) and an international one.
IC Theoretically, everything is separated from the political part (?)
MO Practically too, not only theoretically. We also intend to organize some small commercial activities, shop-galleries, coffee bars. These "recreation" areas could become another reason for which the parliamentarians frequent the museum. (?)
2001
30 July, Cotidianul (the daily newspaper)
(...) a piece of news from Mediafax transmitted the decision of Prof. Dr. Rǎzvan Theodorescu, the Minister of Culture, in which he named Mihai Oroveanu director of MNAC (...)

(the rumors proved to be true)
MO - "according to the decision of the prime minister (...) a wing from Palace of Parliament is made available for the future museum's disposal

Ilinia & Adrian Nǎstase

(...) We'll choose the dialogue with the professionals (...) (?)
(i wasn't invited to any dialogue...)
The spine of this museum will be an active electronic documentation service, with data basis ready to be accessed and even exposed by specific means
(center for art analysis as model...?)
(...) We intend to recruit (and to train) young professionals for the museum's structures (...)
The museum will also administer the current spaces of the ONDEA National Office for Exhibitions (?)

National Theatre

3/4 Floor Gallery

Dalles Hall

(and Dalles Hall...?
We were publicly announcing our dizzydence (dizzy because of the context)
2001
Mircea George Cârstea
Palace of Parliament will exercise itself through MNAC
Gardianul - the 20th of May
"Yesterday, Ministry of Culture and Religious Affairs organized a meeting in the residence of the future MNAC... 25 billion lei were spent – 13 billions for works'acquisition... less than 10

What kind of project is MNAC in the Palace of Parliament?

Mihai Oroveanu (museum's manager - in a 22 magazine interview, no. 664 , November – December 2002)
"The proposal to use spaces from House of the People came from the Prime Minister Adrian Nǎstase (?)
I don't know if he really thought of all connotations of this proposal (?)
The propaganda
"There was a political will and I hope it will have a certain consistency. A sum was allocated from the state budget, and that sum won't be given in a single year, but it will be phased almost for three years, in order not to become a burden for the general budget or to weaken the culture's budget. **This sum is directly given and administrated by the government**, through its institutions."
Stereotypes, clichés
"in monster's house" (allusion to the fact that it was built by Ceausescu)
cultural... "revenge" (a false problem ...Ceausescu is dead shot in '89)

The two directors' passport for trips in the West.
For the artists and art critics – it is the image of dependency, of opportunity...of lack of engagement, the image of the communist mentality of subordination in order to obtain a profit (to be the chosen one from the hungry crowd)... the lack of professionalism.
For the public – the message is clear: obedience and "no comment", the ones who rule know what they are doing – they have the intellectuals' support..., the culture's support...
Critical theories, cultural studies, institutional critique...conceptual art... the recent postmodern theoretical studies – unstudied in universities - these are necessary readings.
Measures
A critical analysis... the articulation of a critical space
Human being and society
Society - generically - civil association and distinct social relations system
"The permanent contemporary amnesia - the (postindustrial) hyperactivity and the anxiety generated by the unemployment and the Japanese alternative, "management by stress" – mobility - reality's crisis, a kind of permanent present with no organic relation with the past - a present time running at maximum speed - the society of the show... Adorno – administrated society... Marcuse – unidimensional man – Charles Baudelaire Le flaneur - a stranger among strangers."
To understand and to explain the social reality, you cannot avoid the evaluation and the criticism

Today the subject is the Power and the Culture and Art relations

Emotional factors
"The most difficult part is gone and, from now on, according to the sums which we'll gradually receive, in normal conditions we can start to build something (?)
But a museum is more than just a financial investment, it also needs understanding, civil and

class solidarity" (?) (nowadays, everyone who controls a business regrets the communism because then everybody obey and nobody criticise...that's why I imagine many people think like that, for them, change means getting to the power...)
Opinions
An error...
Certain events cause, or bring others events...
The autonomy of art/culture
The museum in this location is the visiting card of the Power, an official space for exhibitions, in the service of "democracy"

of the social representation - (Critical Theories)
Culture/Power
"Every society has its own shape, target, meaning... expressed in institutions, art, education... search for the common sense, directions, under the pressure of experience, contacts and discoveries" Raymond Williams
People learn culture
Culture shape behaviour and consciousness.
Culture is seen as political:
Raymond Williams – "a particular way of life, whether of a people, a period or a group - a whole way of life",..."not a determined field, but a site of social differences and struggle" (Green)
"Culture is dialectical in nature – we make culture and we are made by culture, just as there is individual agency, there is external structure – involve power and help maintain and create inequalities within and between social groups.
Resistance is always present – a dominant cultural process will generate its own critical response"... (Cultural Studies)
The power – Michel Foucault – "from the knowledge's angle, as a thought system gaining the control, it is legitimated socially and institutionally."
Ideology - Althusser – "operates not explicitly but implicitly - it lives in those practices, those structures, those images we take for granted... it is unconscious"
Roland Barthes "Everything that is culture may be decodified."
Who
Biological, psychological, social, economic, cultural backgrounds

Adrian Nǎstase - The Prime Minister of a party (PSD) which controlled Romania since the 1989 "Revolution".
1984 International Institute for Human Rights from Strasbourg (?)
1990-'92 Minister of Foreign Affairs
1992-'96 President of the Chamber of Deputies
1996-2000 vicepresident of the Chamber of Deputies
2000 - 2004 Prime Minister...

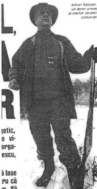

Adrian Nǎstase, un demn urmas al marilor vanatori comunisti

8-11

springer

postproduktion

shopping doublelife

THE DISCURSIVE MUSEUM

VIENNAWIEN

EINE BAROCKE PARTY

caa
caa
contemporary art archive/
center for art analysis

Lia Perjovschi presents

Formats

curated by
Georg Schöllhammer

in the frame of
Viena Days in Bucarest

may 2004

subjective
Art History

From Modernism to present day.
Art and its context

Timeline

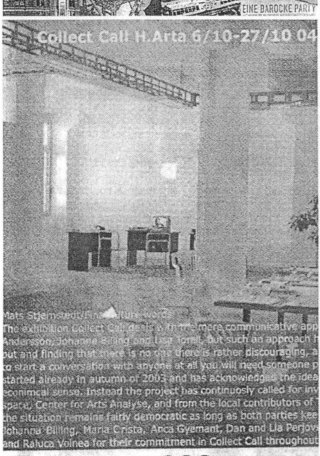

Collect Call H.Arta 6/10-27/10 04

Mats Stjernstedt/Final future 2004

caa
caa
center
for art
analysis

DETECTIVE DRAFT

2005

Si.
Svenska institutet

caa
caa
caa

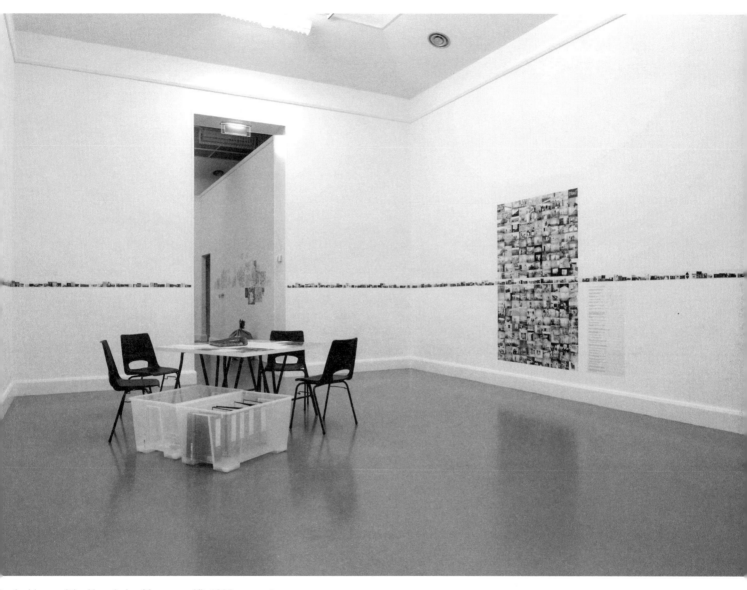

...e Archive and the Knowledge Museum – Kit, 1985–present

...chnique: timelines, diagrams, images, posters, objects

...ay Van Abbe Deel 3 : De principes van verzamelen, het verzamelen van principes/Play Van Abbe – Part 3:

...e Politics of Collecting – The Collecting of Politics

...n Abbemuseum, Eindhoven, The Netherlands, September 25, 2010 – January 30, 2011

...A/CAA publications/newspapers, No 9, 10, 11 and 12, 2004–2005

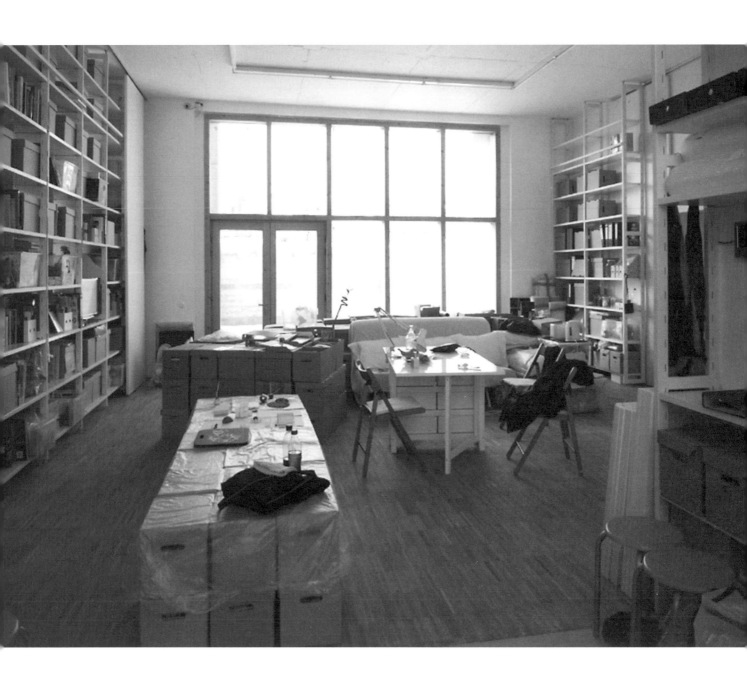

CAA/CAA new space, Sibiu, 2011

Cabaret Voltaire, Zurich:
© Cabaret Voltaire, 2010, pp.14-5, 48-9

Dorottya Gallery, Budapest:
Sándor Bartha, pp.12 images 6 & 7, 23, 38, 39

Duke University, Durham:
States of Mind: Dan and Lia Perjovschi/Nasher Museum of Art, 2007/Jack Edinger/Duke University, Durham, NC, USA, inside cover, pp.4, 46-7 top, p.85

Generali Foundation, Vienna:
Courtesy Generali Foundation,Vienna/Werner Kaligofsky, p.10 image 4. top and bottom, pp.24-5, 26, 27

Christine Koenig Galerie, Vienna:
Courtesy Christine Koenig Galerie, Vienna
pp.30, 31, 57, 59, 69, 72
pp.30, 31 Courtesy Kunstmuseum Liechtenstein/
Christine Koenig Galerie, Vienna

KulturKontakt, Vienna:
Courtesy KulturKontakt, Vienna, pp.20-1

Kunstmuseum Lichtenstein:
Stefan Altenburger, pp.32-3, 34-5, 36-7, 65, 68
pp.30, 31 Courtesy Kunstmuseum Liechtenstein/
Christine Koenig Galerie, Vienna

MACBA, Barcelona:
Museum of Parallel Narrative, Museu d'Art Contemporani de Barcelona (MACBA), May 14, 2011– October 02, 2011
Photo: © Rafael Vargas, p.56

Nasher Museum of Art, Durham:
Peter Paul Geoffrion/Nasher Museum of Art/Duke University, p.7 pic 2

Pavilion Journal:
Courtesy: www.pavilionjournal.org p.81

Dan Perjovschi:
Courtesy of the artist, p.6 image 1 top and bottom

Lia Perjovschi:
Courtesy of the artist
Cover, pp.3,11 pic 5, 13 pic 8 , 20, 21, 28, 29, 40, 41, 42, 43, 45, 46-7 top, 46-7 bottom, 50-1, 54-5, 60-1,

62, 63, 64, 66, 67, 68, 70, 71, 73, 74-5, 76, 77, 78, 79, 80, 81, 82, 83, 86, 87, 88, 89, 90, 91, 92, 93, 94, 96

State of mind without a title, Timişoara:
Tudor Vreme, p. 8

Sydney Biennale:
Installation view of works by Lia Perjovschi in the 16th Biennale of Sydney (2008) at the Art Gallery of New South Wales, Sydney Courtesy of the artist
Photo: Jenni Carter, pp. 52-3

The Test of Sleep, Oradea:
Dan Perjovschi, p. 6 image 1 top and bottom

Van Abbemuseum, Eindhoven:
Peter Cox/.Archives Van Abbemuseum, Eindhoven, The Netherlands, p. 95

Wilkinson Gallery, London:
Courtesy of Wilkinson Gallery, London pp.8, 16-7, 18-9

Bloomberg SPACE, London:
Commissioned as part of the COMMA programme, Bloomberg SPACE, 2009, pp.44, 45

British Library, London:
© The British Library Board. (Harley 3487 f. 22v)
p.8 pic 5

CIV (Center for Visual Introspection), Bucharest:
Catalin Rulea, pp.17, 32-3, 34, 35, 36, 37

Cioran dans la Rue, the artist and French Cultural Institute, Bucharest:
Razvan Braileanu/courtesy galerie Michel Rein, Paris, pp.24, 25

Culturgest, Porto:
Blues Photography Studio
Front cover, inside cover, pp.56, 57, 58, 59, 60, 61

Corbis:
Radu Sighetil/Reuters/CORBIS
pp.14-15 pic 12

Duke University, Durham:
States of Mind: Dan and Lia Perjovschi//Nasher Museum of Art, 2007/Jack Edinger/Duke University/
States of Mind: Dan and Lia Perjovschi//Nasher Museum of Art, 2007/Jack Edinger/Duke University Courtesy of private collection, pp.105, 111
Courtesy of Revista 22, pp.13 pic 9, 115

EACC, Castelló:
Pascual Mercé/courtesy Espai d'art contemporani de Castelló, pp.116-117, 118-9, 120-1, 122-3, 124-5

Franklin Furnace, New York:
Courtesy of the artist and Franklin Furnace, New York, p.6 pic 1

Dan Perjovschi:
Courtesy of the artist pp.6 pic 1,11 pic 8, 48, 49, 50, 52-3, 54, 55 top & bottom, 64, 73, 74-5, 76-7, 92, 93, 94, 95, 96, 97, 98, 103, 110

In the Gorges of the Balkans, Kunsthalle Fridericianum, Kassel:
Nils Klinger, pp.15 pic 11, 85

Istanbul Biennial:
Wolfgang Träger, Volxheim, pp.68-9, 70, 71

Kokerei Zollverein, Essen:
Wolfgang Günzel, pp.78-9, 80, 81, 82, 83

Kunstverein Lingen Kunsthalle:
Roman Mensing, pp.20-1, 22-3

Lille 3000:
Les Frontières Invisibles, Europe XXL,
Maxime Dufour Photographies/courtesy galerie Michel Rein, Paris, pp.4, 38-41, 42 top & bottom, 43

Live! From the Ground, Chișinău, Moldova:
Kristine Stiles, p.6 pic 2

Lombard Freid Projects:
Courtesy of the artist and Lombard Freid Projects pp.11 pic 8, 99, 100, 101, 104-108, 110

Ludwig Museum, Köln:
Olivier Kaeser/courtesy of the Ludwig Museum, p.72
Courtesy of the Ludwig Museum, pp.11 pic 8, p.73

MoMA, New York:
Installation view of *Projects 85: Dan Perjovschi,* The Museum of Modern Art, New York, May 2 – August 27, 2007
Photo: Jonathan Muzikar, © 2007 MoMA, N.Y., pp. 9 pic 4, 19
Robin Holland/www.robinholland.com pp.62-3, 65, 66-7

Michel Rein:
courtesy the artist and galerie Michel Rein Paris, pp.4, 9 pic 10, 24,25, 38-9, 40, 41, 42 top & bottom, 43, 86, 87, 88, 89, 90, 91

Revista 22:
Courtesy of the editor, *Revista 22*
pp.13 pic 9, 113, 114,115

ROM, Toronto:
Brian Boyle © Royal Ontario Museum, 2010. All Rights Reserved.
pp.10 pic 7, 26-7, 28-9,30-1

Schnittraum, Köln:
Courtesy of schnittraum, pp.74-5, 76-7

Tate Liverpool:
© Tate Liverpool, pp.3 pic 3, 46, 47, 51

Venice Biennale:
Giorgio Zucchiatti/La Biennale di Venezia – Archivio Storico delle Arti Contemporanee, p.58

Lia Perjovschi:
Courtesy of the artist, p.14 pic 10

Courtesy of the artist and Franklin Furnace New York, p.6 pic 1

First edition published in the United Kingdom in 2012 by University of
Plymouth Press, Roland Levinsky Building, Drake Circus, Plymouth, Devon,
PL4 8AA, United Kingdom.

ISBN 978-1-84102-277-2

A CIP catalogue record of this book is available from the British Library

Publisher: Paul Honeywill
Publishing Assistants: Charlotte Carey and Maxine Aylett
Art Director: Sarah Chapman
Consulting Editor: Miranda Spicer
Picture Researcher: Prue Waller
Photographic Technical Assistant: Helge Mruck

Typeset by University of Plymouth in Helvetica 10/16pt
Printed and bound by Shortrun Press, Exeter, United Kingdom

Published with the support of the Romanian Cultural Institute

david crowley

Professor David Crowley runs the Critical Writing in Art and Design programme at the Royal College of Art in London. He is an authority on modern and contemporary art and design from Eastern Europe. His books include *Style and Socialism* (Berg, 2000, co-edited with Susan E. Reid), *Warsaw* (Reaktion; 2003) and *Pleasures in Socialism* (Northwestern University Press, 2010). He regularly writes for the art and design press. He has curated major exhibitions including *Cold War Modern. Design 1945–1970* at the V&A Museum in London in 2008–2009 and the *Power of Fantasy. Modern and Contemporary Art from Poland* at BOZAR, Brussels, 2011. He is currently writing a book on the intertwined histories of photography and communism.

acknowledgements

The publisher is grateful to all those who have contributed to this publication and for their patience as we worked together through the editorial processes. We warmly acknowledge the pictorial research undertaken by Prue Waller and thank her for her diligence and willing support over many months.

publisher's note

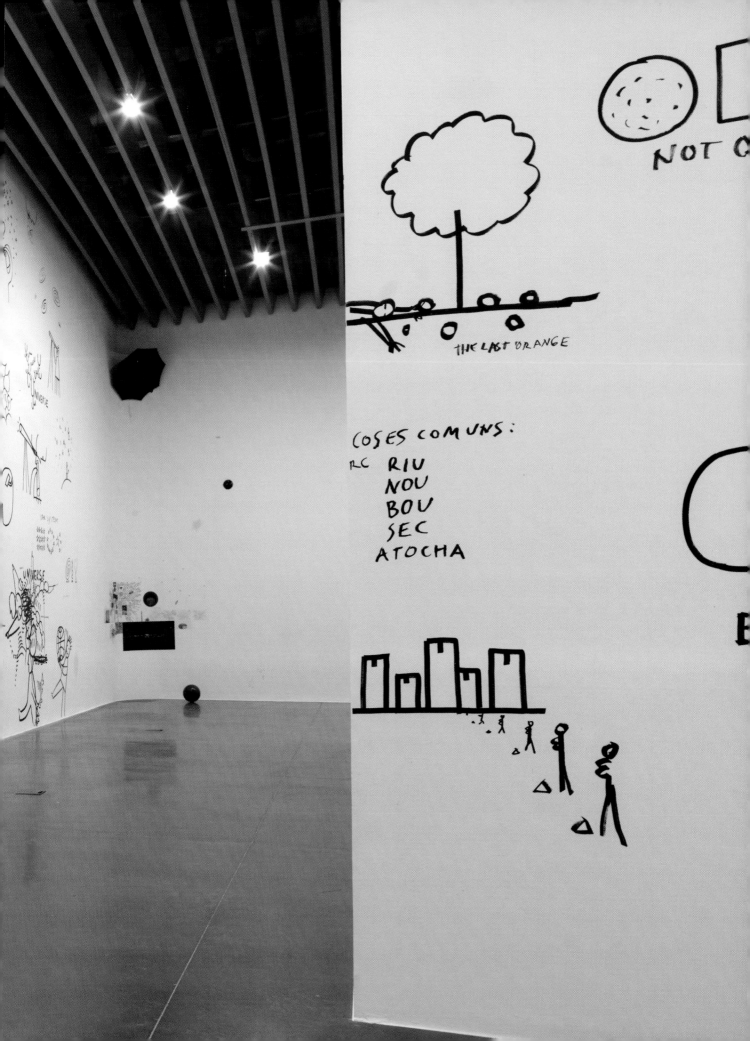

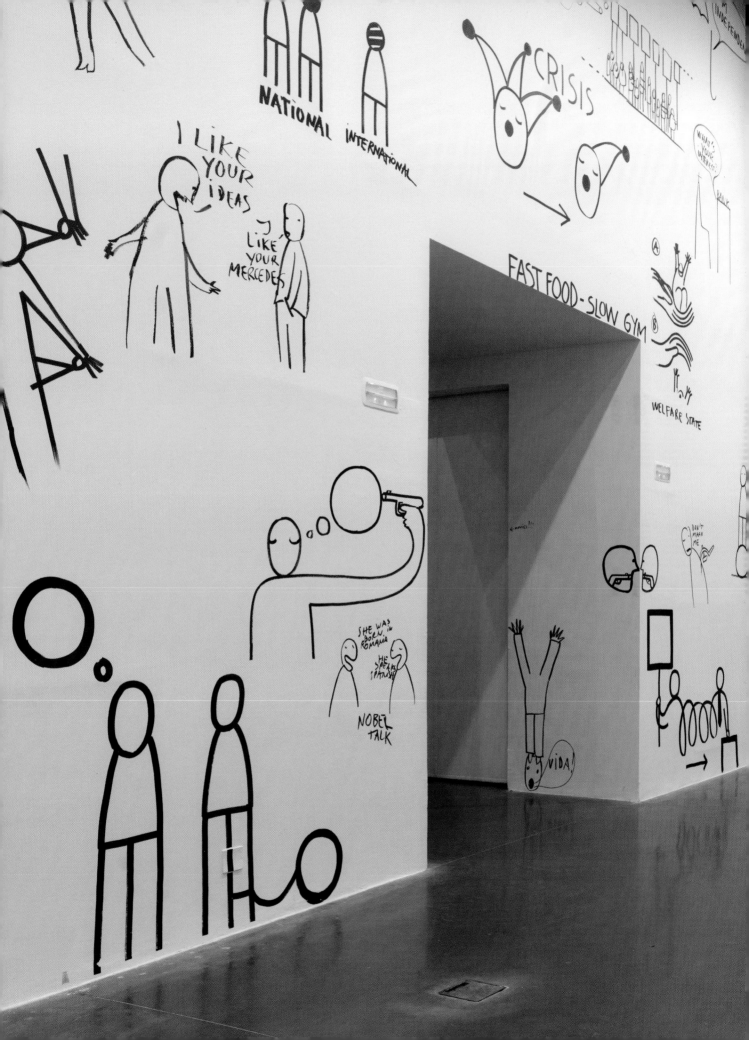

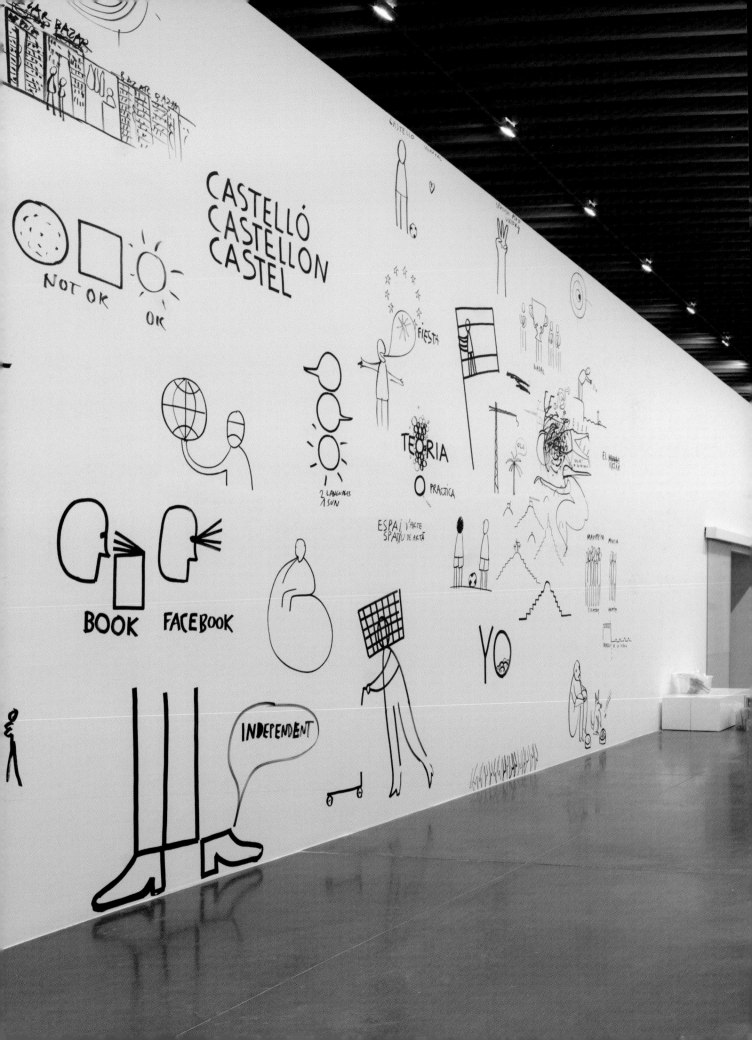

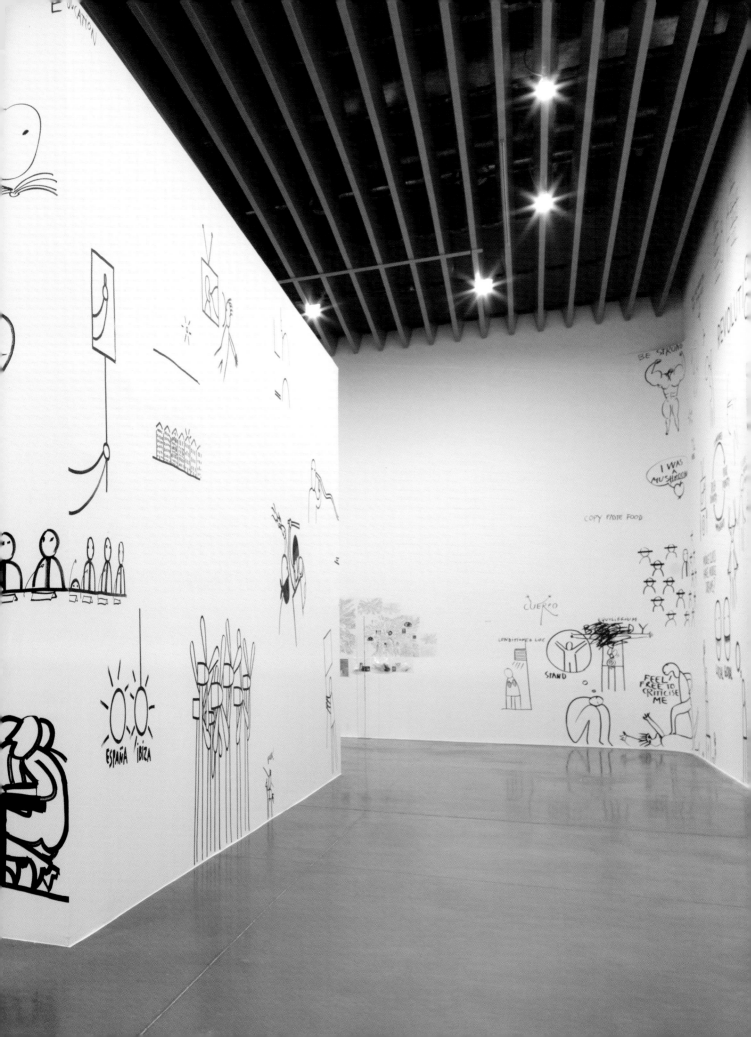

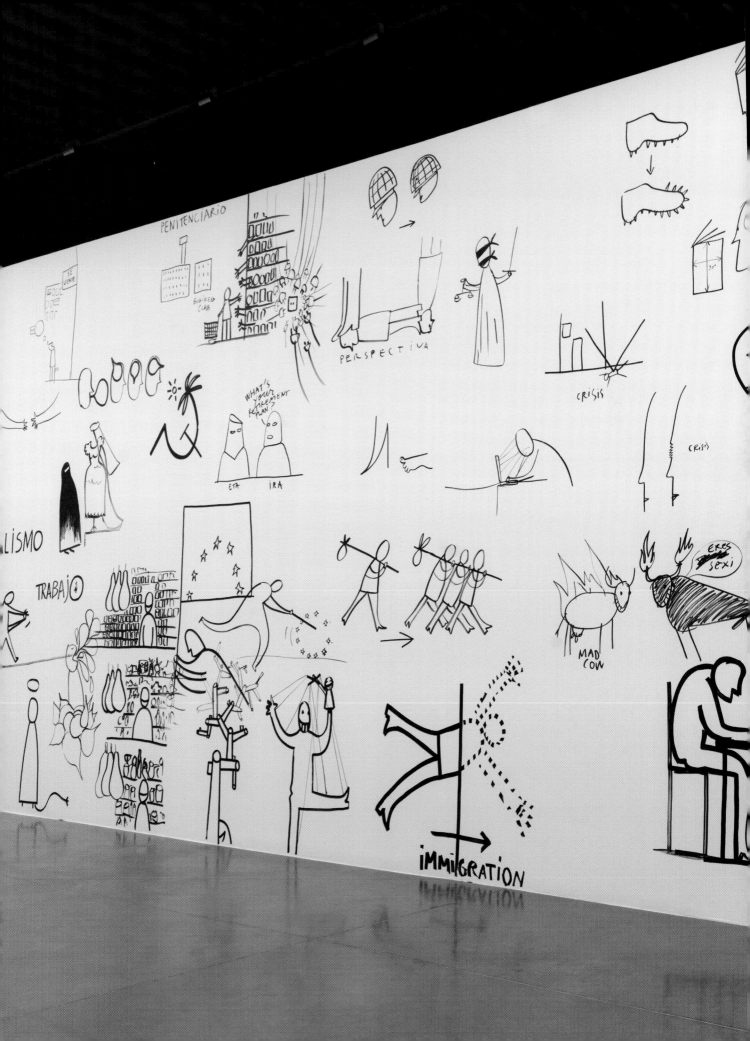

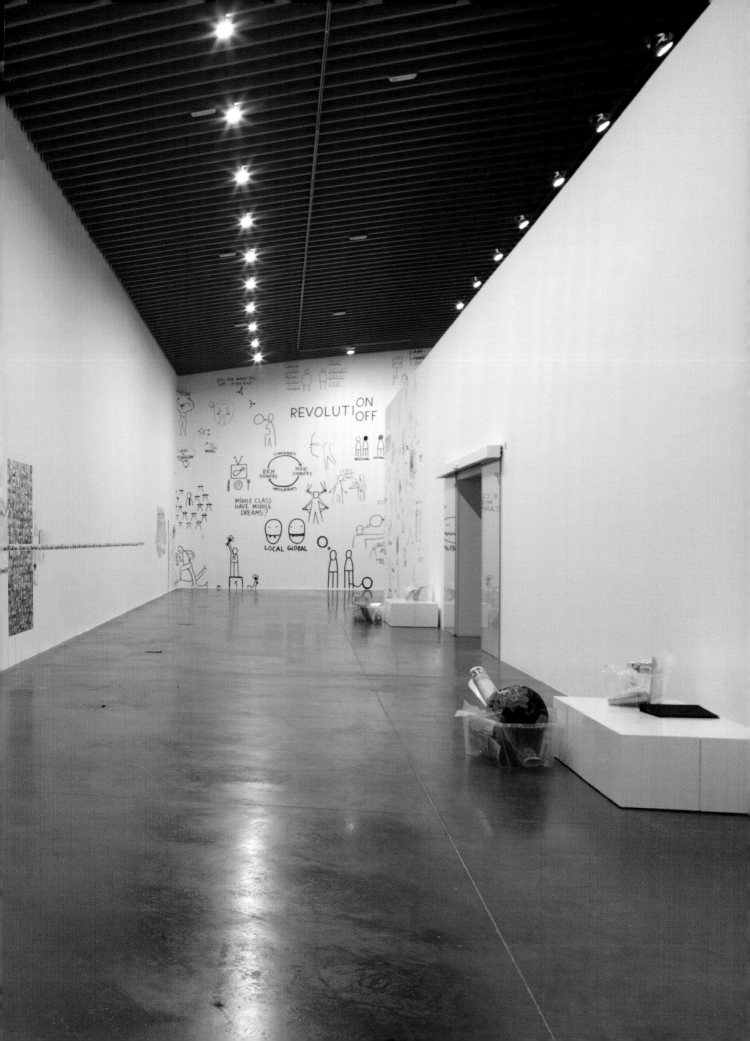

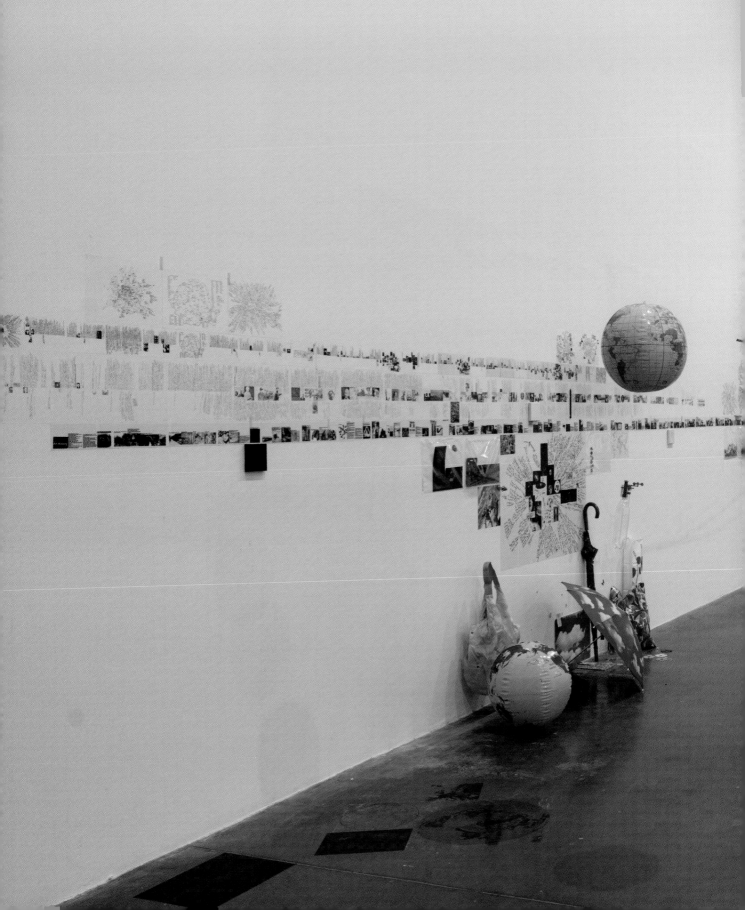

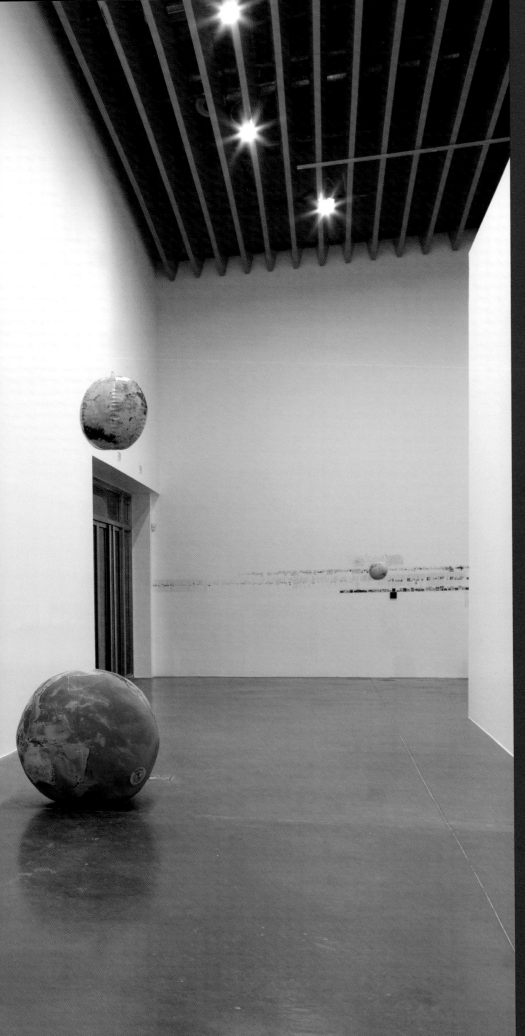

Perjovschi and Perjovschi

In autumn 2010 Dan and Lia Perjovschi exhibited together at the Espai d'art contemporani de Castelló. This was not only the first opportunity for both artists to exhibit in Spain, it was also a rare joint show. The exhibition included documentation of early works in their careers. Lia Perjovschi's performance entitled 'I Am Fighting For My Right to Be Different', performed at the Art Museum in Timişoara, Romania in 1993, was screened as well as her 'Knowledge Museum' project (2007), a new version of which was installed in the show. Dan Perjovschi's work appeared under the title of 'Time Specific'. As the title suggests, some of his drawings reflected on the period spent in Spain during the three weeks he spent preparing the exhibition. They included plays on Spanish words and national symbols: a mad cow, for instance, attracts the eye of a Spanish bull. Other works referred to the fragile state of the national economy.

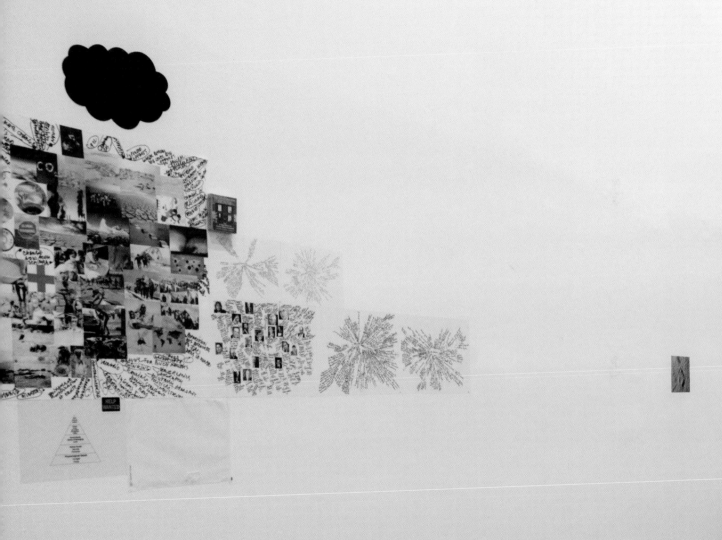

Dan and Lia Perjovschi,

Time Specific by Dan Perjovschi and *Knowledge Museum* by Lia Perjovschi,

Time Specific: black marker on walls,

October 15th – December 26th, 2010, Espai d'art contemporani de Castelló,

Castelló, Spain

22

PUBLICATIE
SĂPTĂMÎNALĂ
EDITATĂ DE

GRUPUL
PENTRU DIALOG
SOCIAL

NUMĂRUL
100
O SUTĂ

ANUL II • Nr. 50 (100) • 20 - 27 DECEMBRIE

• 16 PAGINI - 20 LEI

Gabriel Liiceanu

IARNA 1991

[text handwritten by Gabriel Liiceanu]

115

revista 22

Editor: Grupul pentru Dialog Social

ANUL XIX • Nr. 52 (981)/1(982) • 23 dec. 2008 - 5 ian. 2009

www.revista22.ro • 32 pagini • 2,5 lei

LA MULŢI ANI! 2009

ARMAND GOŞU

Situaţie imposibilă pentru preşedinte

Întrebat, într-o emisiune de televiziune, de către Emil Hurezeanu care sunt realizările mandatului său de preşedinte după consumarea a 4/5 din el, Traian Băsescu s-a grăbit să enumere creşterile salariale, ridicarea nivelului de trai, mărirea pensiilor etc. Neinspirat răspuns. Acestea pot fi trecute în contul guvernului Călin Popescu Tăriceanu, şi nu al preşedintelui. Şi, oricum, nimeni nu aştepta de la Băsescu creşterea pensiilor. Nu pentru salarii şi pensii a fost el votat, ci pentru ca „să ne scape" de Adrian Năstase şi PSD. Lupta anticorupţie şi împotriva abuzurilor „partidului-stat" PSD au fost principalele teme de campanie ale lui Băsescu. De altfel, anticorupţia va rămâne subiect major şi în primii patru ani de mandat prezidenţial. Cu toate acestea, rezultatele au fost departe de aşteptări, însă nu preşedintele este vinovat de eşecul anticorupţiei.

Mai mare succes a reportat Traian Băsescu îmbrăţişând temele anticomuniste, prezentate de către organizaţii ale societăţii civile ca un proiect de reformă morală a clasei politice. În contextul prefigurării conflictului cu PNL şi cu premierul Tăriceanu, preluarea temelor clasice ale Pieţei Universităţii, mai puţin lustraţia, a fost o mişcare tactică inspirată a preşedintelui Băsescu, care şi-a transformat în aliaţi, adesea necondiţionaţi, persoane publice care, prin educaţie, trecut personal, sunt mult mai aproape de liberali. Predarea arhivei Securităţii către *CNSAS* şi condamnarea comunismului sunt – chiar dacă preşedintelui îi este greu să accepte – realizările mandatului său prin care va rămâne în cărţile de istorie. Ambele au primit o încărcătură anti-PSD. Livrarea dosarelor, chiar periate de către serviciile secrete, a bulversat întreaga elită a României şi a generat „coaliţia 322" care a votat suspendarea preşedintelui. Nu condamnarea comunismului şi nici bileţelul roz al controversatei Elena Udrea au dus România în pragul unei grave crize politice, ci dosarul lui „Felix" Voiculescu. Din acel moment, niciun politician din România n-a mai putut dormi liniştit, oricine i-ar fi dat în trecut asigurări. Un raport, o notă informativă, un plan de măsuri, fotografia unei amante din tinereţe, transcrierea unei convorbiri telefonice pot oricând să ia calea unei redacţii, în ciuda restricţiilor impuse de lege. Din acel moment a început campania de presă împotriva lui Băsescu. Din acel moment, Traian Băsescu a devenit inamicul public nr. 1 al elitei României, care-şi are rădăcinile în nomenclatura comunistă şi în combinaţiile operative ale Securităţii.

Vârful de lance împotriva lui Băsescu a fost PSD, care s-a folosit de idiosincrasiile preşedintelui la Dinu Patriciu şi la alţi liberali pentru a rupe Alianţa D.A., a săpa o prăpastie între PD-L şi PNL şi a-l împinge pe Traian Băsescu în braţele principalului său inamic politic.

Ca să nu devină astăzi prizonierul PSD, Băsescu ar fi trebuit să forţeze reapropierea de PNL, după succesul reportat la referendumul pentru suspendare. N-a făcut-o, pentru că n-a înţeles miza Alianţei D.A., pentru că este un tactician, şi nu un strateg.

În noul context, dacă vrea să obţină al doilea mandat de preşedinte, el trebuie să se reinventeze ca om politic. Dacă va continua cu discursul anti-PSD, după ce a agreat coaliţia PD-L–PSD, riscă să consolideze imaginea de generator de crize politice, într-o vreme în care electoratul dă semne de obo-

(Continuare în pag. 3)

 plus — Libertate şi securitate

114

revista22.ro

RODICA CULCER
Reforma educației
și pânza Penelopei
PAGINA 3

DAN SUCIU
Canonul BNR și
scăderea dobânzilor
PAGINA 10

ALEXANDRU MATEI
Pentru un alt discurs
intelectual
PAGINA 15

REVISTA GRUPULUI PENTRU DIALOG SOCIAL // ANUL XX // NR. 3 (1036) // 12 – 18 IANUARIE 2010 20 PAGINI // 2,5 LEI

Reforma partidelor

Reforma statului ar putea deveni o temă confortabilă, tocmai bună de traversat perioada tulbure de după câștigarea alegerilor. Nu ar fi prima oară în perioada postdecembristă. Împănată cu vorbe mari, așteptări și, de ce nu, proiecte care să țină trează atenția publicului avid de schimbare, reforma statului conține în esența ei eșecul, dacă ea nu vizează clasa politică. Deci, partidele. Rămase captive în sistemul clientelar, al valorii conferite de numărul de voturi sau de sponsorizarea din campanie, dependente de oligarhia de la vârf și refuzând schimbarea regulilor și criteriilor, partidele s-au transformat în cluburi cu circuit închis. Porțile se întredeschid doar în perioada alegerilor, dar chiar și atunci biletul de acces conține multe zerouri în coadă și o demagogie direct proporțională. Așa-zisul vot uninominal nu a rezolvat mare lucru, din simplul motiv că mentalitatea și năravurile au rămas neschimbate. Doar vorbele par a fi aceleași. În fapt, totul se reduce la aceeași acerbă luptă pentru putere.

Desigur, alegerile sunt și au fost cel mai bun moment pentru schimbarea garniturilor de la vârful partidului, mascată în modernizare. Diferă situația de acum de cea din 2004, de exemplu? Da: prin dimensiunea și calitatea înfrângerii și a victoriei. Dacă PSD nu ar fi fost despărțit de funcția supremă în stat de doar 70.000 de voturi și dacă acestea nu ar fi cântărit, la nivelul simbolisticii, greutatea lor în aur, înlăturarea echipei responsabile cu înfrângerea ar fi rămas la nivelul masacrului ritualic și nu ar fi resuscitat discuția despre reforma partidului. Situația este similară și la PD-L. Vocile care cer modernizarea vin din aceeași zonă extrem de subțire a intelectualilor înregimentați. Cristian Preda sau Vasile Dâncu vorbesc însă o limbă necunoscută pentru majoritatea activiștilor și pun probleme greu de digerat pentru conducerea partidelor. Modernizarea structurilor, relația cu cetățeanul, valorile stângii sau ale dreptei, principii de accedere în funcții și demnități, înlăturarea oligarhilor, raportarea la resurse, meritocrație, și nu clientelism și bani. Este o discuție în funcție de care partidele pot evolua sau nu. Și, împreună cu ele, statul. Doar de la acest punct încolo reforma statului poate căpăta sens.

Inevitabila și necesara schimbare a liderilor ar putea avea o șansă să nu eșueze în sterila luptă pentru putere. Cristian Preda și Vasile Dâncu, ale căror interviuri le puteți citi în acest număr al revistei 22, pun chestiunea exact în aceste coordonate. Teodor Meleșcanu susține însă că PNL are o situație specială, importantă fiind doar schimbarea și eficientizarea conducerii.

ANDREEA PORA

12 – 18 ianuarie 2010

3

(1036)

113

Dan Perjovschi is often celebrated for bringing the inky political cartoon to the *Revista 22*
pristine walls of the white-cube Gallery. Nevertheless, he remains committed
to the demotic and critical tradition of print by publishing his drawings in *Revista
22*, a weekly magazine. Founded in early 1990, just after Romania threw off
Nicolae Ceauşescu, the title refers to December 22, 1989, the date when
the dictator fled the capital. It is published by the Group for Social Dialogue
(Grupul pentru Dialog Social), a non-governmental organisation established
to promote the transformation of Romania into a civil society.

Working for *Revista 22* from its early days, Perjovschi continues to
supply it with cartoons and occasional essays as he travels around the world
today. The conditions needed for democracy to thrive, such as freedom of
speech and the free circulation of information, continue to preoccupy the
artist. His sharply critical view of the rampant capitalism and cronyism which
operates in Romania today is often evident in his acerbic cartoons.

Postcards from America, 1994

ink on pastel paper mounted on cardboard

67 drawings

Postcards from the World (Emirates), Detail, 2009

ink and marker on paper,

4 x 6 inches: 10.2 x 15.2 cm

30 drawings

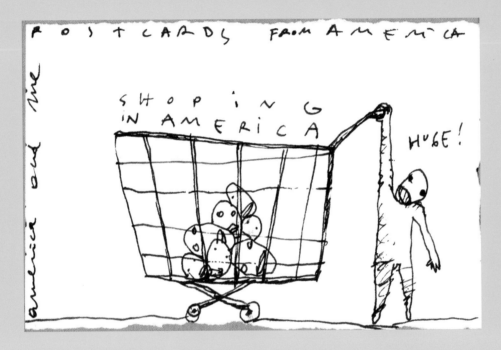

Postcards from America, 1994

ink on pastel paper mounted on cardboard

67 drawings

Postcards form the World (Sydney), 2009

ink and marker on paper,

4 x 6 inches: 10.2 x 15.2 cm

18 drawings

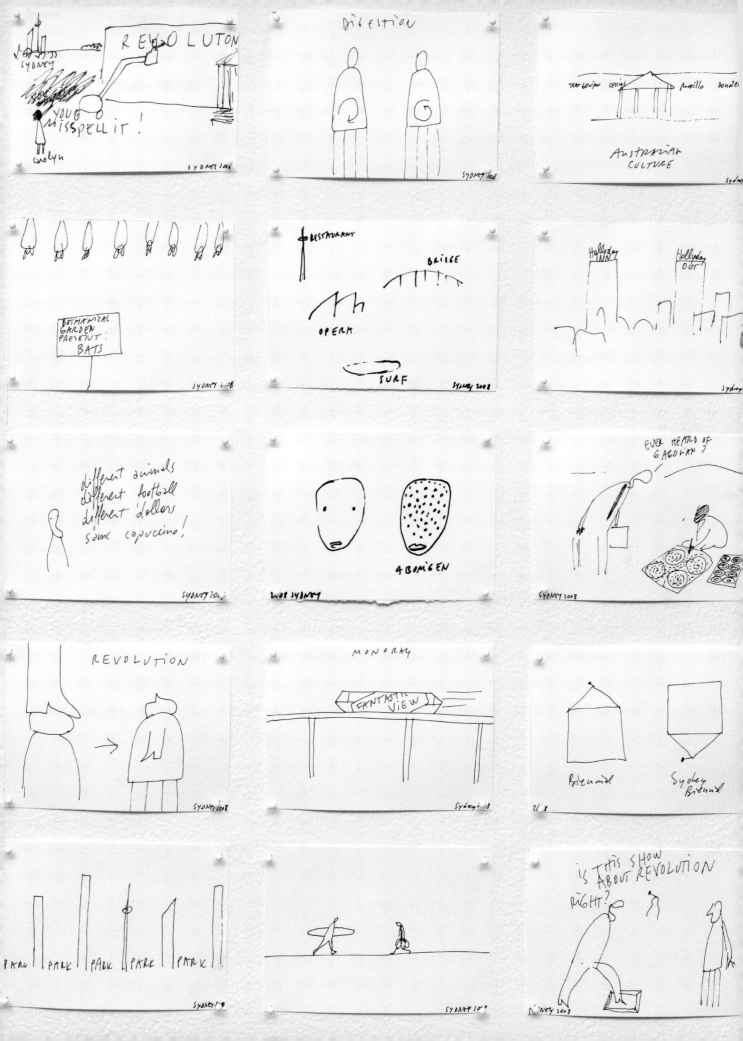

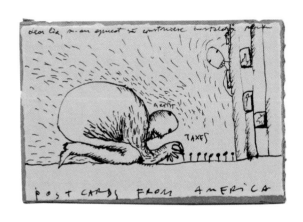

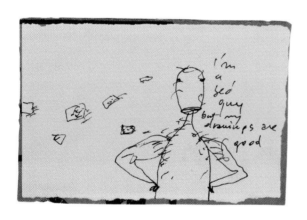

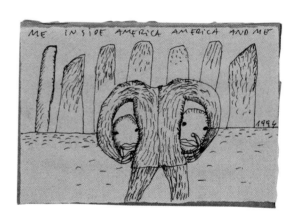

Postcards from America (500), Detail, 1994

ink and pencil on paper mounted on cardboard

3 ½ x 5 ¼ inches each: 8.9 x 13.3 cm

500 drawings

Postcards from America (500), 1994, ink and pencil on paper mounted on cardboard, 3 ½ x 5 ¼ inches each: 8.9 x 13.3 cm, 500 drawings

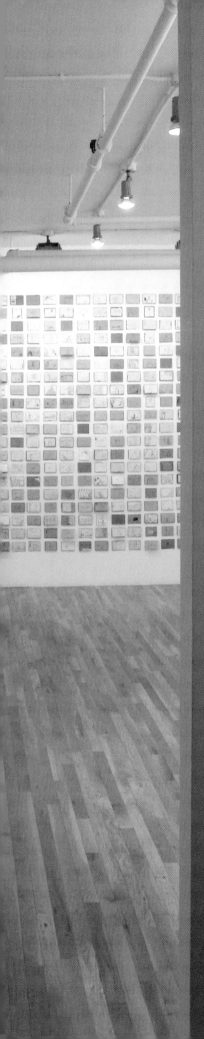

DAN PERJOVSCHI
Postcards from the World

NEW YORK, MINNEAPOLIS, SHARJAH, DUBAI, AJMAN, CHILE
MOSCOW, ESSEN, PLÜSCOW, ARC-ET-SENANS, LILLE, LYON
PARIS, SYDNEY, SIBIU, BUCHAREST, CHISINEW, SKOPJE
SOFIA, KÖLN, FRANKFURT, MARSEILLE, CLUJ, BELGRADE
ROANOKE, SCOTTSDALE, WORPSWEDE, ODENSEE, COPENHAGEN
STOCKHOLM, MALMÖ, AMSTERDAM, BASEL, GENEVA, LISBON
GÖTEBORG, GÖTTINGEN, HELSINKI, MADRID, BARCELONA
LIVERPOOL, LONDON, SALZBURG, VIENNA, TORINO
ROVERETTO, VENICE, EDINBURGH, SEVILLA, KASSEL, ATHENS,
LIMERICK, ISTANBUL, BRUSSEL, PARIS, BERGAMO, BERLIN
ALTENBURG, EINHOVEN, HALLE, QUIMPERE, BRISTOL, PHOENIX
REGINA, SIBIU, BUDAPEST, PRAGUE, DUBROVNIK, HAIFA,
JERUSALEM, WUHAN, GUANGZHOU, BEIJING, IAŞI, CETINJE
SPLIT, HAVANA, NIKOSIA, CHICAGO, SAN FRACISCO, SAN DIEGO,
BOGANSA, LOS ANGELES, NEW ORLEANS, ORLADO, RALEIGH,
DURHAM, BALTIMORE, WASHINGTON, CHARLOTTE, GAINSVILLE
NEW SMYRNA BEACH,

postcards from abroad

In 2010, Dan Perjovschi had a retrospective of his drawings entitled 'Postcards From the World' at Lombard Freid Projects in New York. This exhibition offered a chance for the artist to revisit a key body of work, 'Postcards from America', produced in 1995–7 during his first stays in the country. This wall-mounted set of drawings was organised like a series of small flip-charts through which viewers could flick. These 500 drawings were accompanied by the same number of postcard-sized drawings made in recent years as he travelled the world. (Images made in China, Australia and the Middle East are reproduced here). Compressing 15 years and displayed in large numbers, the Lombard Freid exhibition presented a chance for the viewer to reflect on Perjovschi's 'journey' as well as the artist's acute ability to function like a barometer measuring the effects of globalisation.

Postcards from the World
Installation view at Lombard Freid Projects, New York, USA, 2010

The 'Postcards from America' were made only a few years after the end of communist rule in Romania. Effectively a visual diary, they capture his reflections on his encounters with the both the real spaces and myths of the 'new world'. One cartoon is captioned with a phrase which might be adopted to describe the entire series, 'Me Inside America and America Inside Me'. Another – in which a face seems to have relocated to a flexed bicep – captures the cult of the body in the USA. A few years earlier, another European intellectual, Jean Baudrillard, called this phenomenon the "hedonism of the 'into'". "The 'into' is key to everything. The point is not even to *have* a body but to be *into* your own body".[1] Perjovschi's body builder seems quite literally to be into his body. By contrast, America seems to have produced bodily disorder in the artist: in his autobiographical sketches, his body sprouts additional arms to handle supersized food and his head leaves his body in bewilderment. →

The difference between places – whether between Romania and the United States or between China and Australia – will, however, never be as great as they were when Perjovschi first started travelling the world. Globalisation, as Perjovschi demonstrates in his recent drawings, brings the 'same cappuccino', the same skyscrapers and 'another gold mall' to the world. Nevertheless, he still has the eye of an outsider, sharing his puzzlement with 'normal' events and circumstances.

[1] Jean Baudrillard, *America,* Verso Books (London, 1993), 35.

Postcards from the World (Emirates), Detail, 2009

ink and marker on paper

4 x 6 inches: 10.2 x 15.2 cm

30 drawings

US EU BALKANS

Postcards from the World (Eastern Europe B), Detail, 2009
ink and marker on paper
4 x 6 inches: 10.2 x 15.2 cm
45 drawings

2008

Postcards from the World (Sydney), Detail, 2009

ink and marker on paper,

4 x 6 inches: 10.2 x 15.2 cm

18 drawings

International Artist, 2006

Bucharest, Romania, 2008

China Boom, 2009

BORDERS

95

WORLD ART SCENE

NEW YORK ART SCENE

DAN PERJOVSCHI

HISTORY CONTEXT

POLITICS

TRADITION

ARTIST

ART

Review-Marathon-New York, 2009
ink on paper, 4 drawings
11.61 x 8.27 inches each
29.5 x 21 cm

invitation card project for *Free style*

galerie Michel Rein, Paris, France, 2009

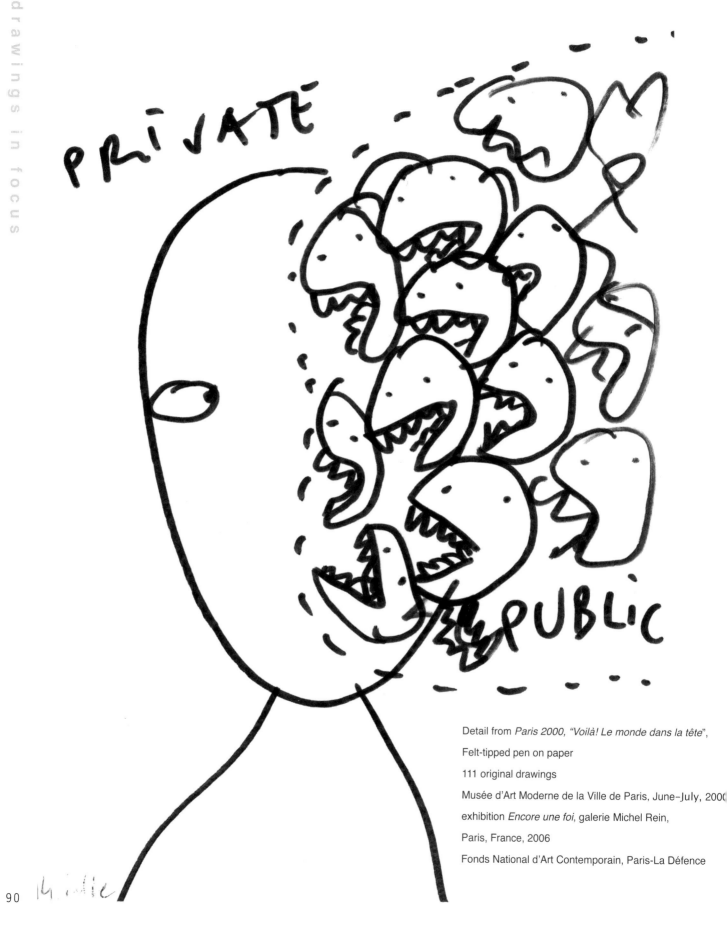

Detail from *Paris 2000, "Voilà! Le monde dans la tête"*,

Felt-tipped pen on paper

111 original drawings

Musée d'Art Moderne de la Ville de Paris, June–July, 2000

exhibition *Encore une fois*, galerie Michel Rein,

Paris, France, 2006

Fonds National d'Art Contemporain, Paris-La Défence

MAIN STREAM ALTERNATIVE

invitation card for *Free style*

galerie Michel Rein, Paris, France, 2009

invitation card project for *Free style*
galerie Michel Rein, Paris, France, 2009

Detail from *Paris 2000, "Voilà! Le monde dans la tête"*,

Felt-tipped pen on paper

111 original drawings

Musée d'Art Moderne de la Ville de Paris, June–July, 2000

exhibition *Encore une foi*, galerie Michel Rein,

Paris, France, 2006

Fonds National d'Art Contemporain, Paris-La Défence

GLOBALISATION
MONDIALISATION
ON

invitation card project for *Free style*
galerie Michel Rein, Paris, France, 2009

drawings in focus

In seeming to offer the viewer immediate effects, cartoons escape the accusations of elitism which are often levelled at other forms of contemporary visual art. They have the appearance of a 'natural' idea, close to thought and not slowed down by craft or technique. Dan Perjovschi's drawings are not, however, quite as immediate as they first seem. He always carries a sketchbook to capture ideas and impressions. Some of his sketches are observations triggered by the places he visits to create his exhibitions, and others are stimulated by news stories in the international press. He usually pares these impressions into the telegraphic form of the cartoon when working on the walls of the gallery or museum or for *Revista 22*, the weekly magazine to which he contributes. His sketchbooks are a kind of working archive. The same figures and symbols reappear in different exhibitions, with modifications of form or changes of context. The scale of 'Recession' was marked in a drawing for an exhibition in Porto in a former bank by the exaggerated size of the wire mesh in a shopping trolley and, a year later, in another drawing in Liverpool by the number of disappearing pints of beer.

The format and style of his drawings do not automatically make them 'simple'. In fact, they often expose the ways in which complex political and social themes are themselves simplified in the media or in which political opponents trade in clichés. They deliver their ideas by inserting a space of doubt between word and image, often with the effect of undermining the pumped-up rhetoric that employs phrases like 'Western Values' or 'Freedom'. Whilst they are undoubtedly comic, some of his drawings feature a kind of dark, biting humour which, perhaps, owes much to his Eastern European background. In his book on jokes under communism, *Hammer and Tickle*, Ben Lewis shows how humour was used to resist illegitimate power.[1] He reserved the top prize for comedy, however, to the dictator Nicolae Ceaușescu. His regime responded to food shortages not by improving production but by establishing a special 'nutritional commission' to demonstrate that Romanians required fewer calories than other people. →

Urban Drawings, street graffiti, chalk, *In the Gorges of the Balkans*, Kunsthalle Fridericianum, Kassel, Germany, 2003

Communism has now been cast into the dustbin of history but the political role of humour has not disappeared. Lewis could well have been describing Perjovschi's output when he wrote "If you question communism, you end up with democracy. If you question democracy, you end up with – more democracy".

Ben Lewis, *Hammer and Tickle*, Weidenfeld & Nicolson (London, 2009)

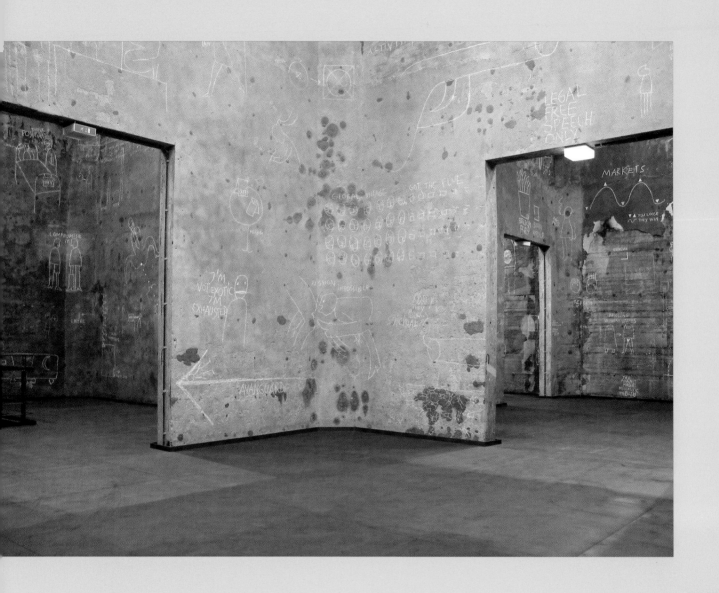

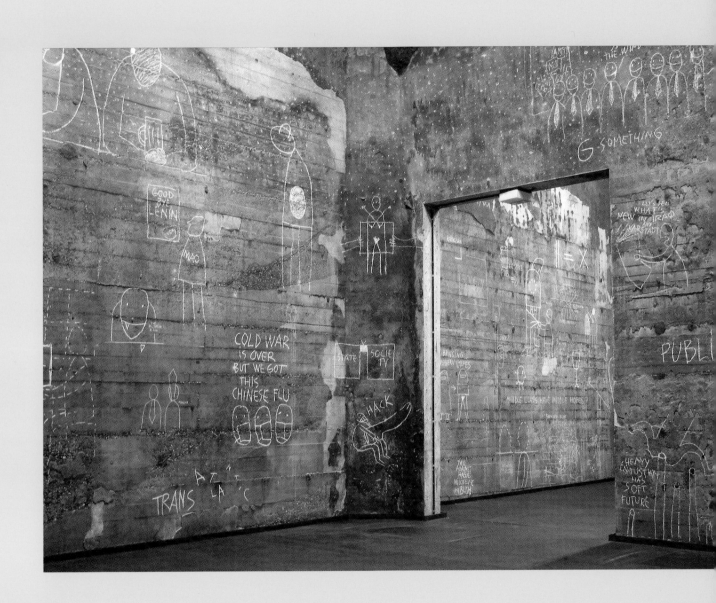

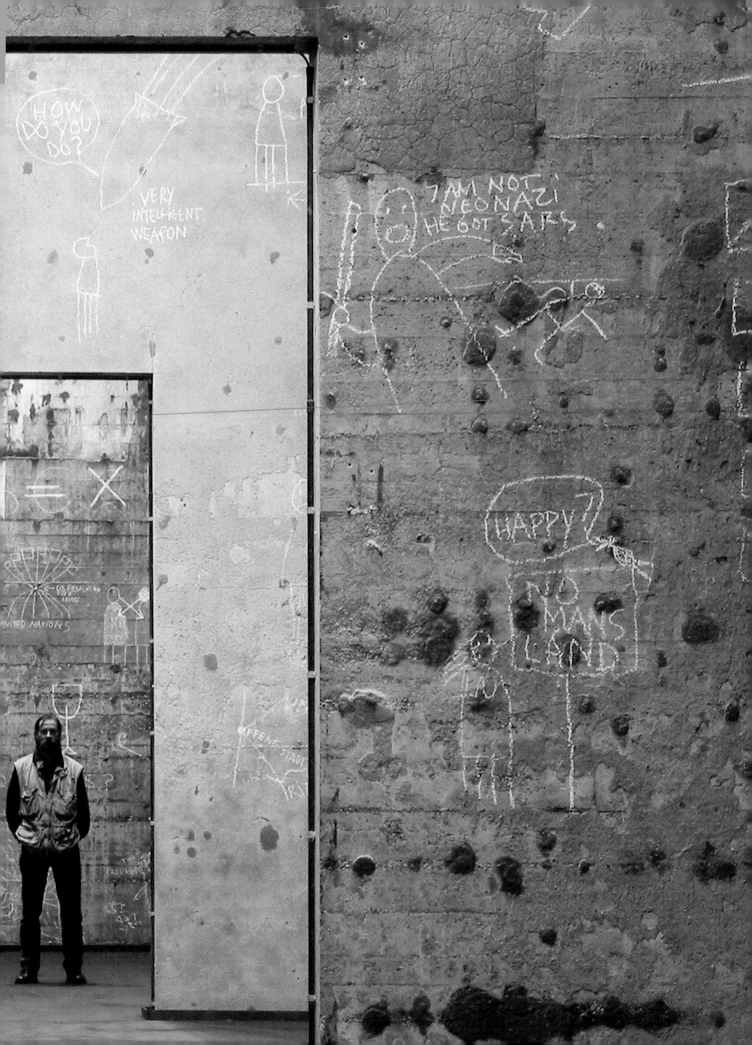

BE FIT FOR RECESSION

NO
YES

THE FIVE

LOOSE
WIN

PUB

LICSPACE

WIFE
HI

WIFE
OF
PEOPLE

White Chalk – Dark Issues
Open City Models for Use, chalk drawing on walls, 6 rooms

Kokerei Zollverein, Zeitgenossische Kunst und Kritik

Essen, Germany, 200

MIDDLE CLASS

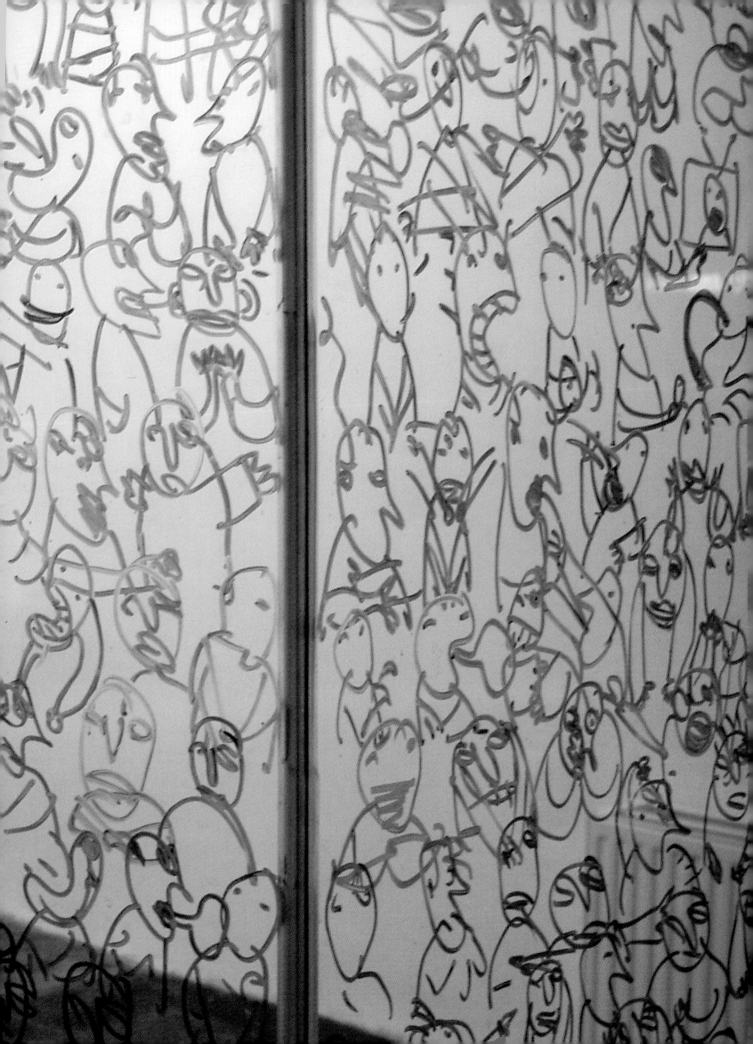

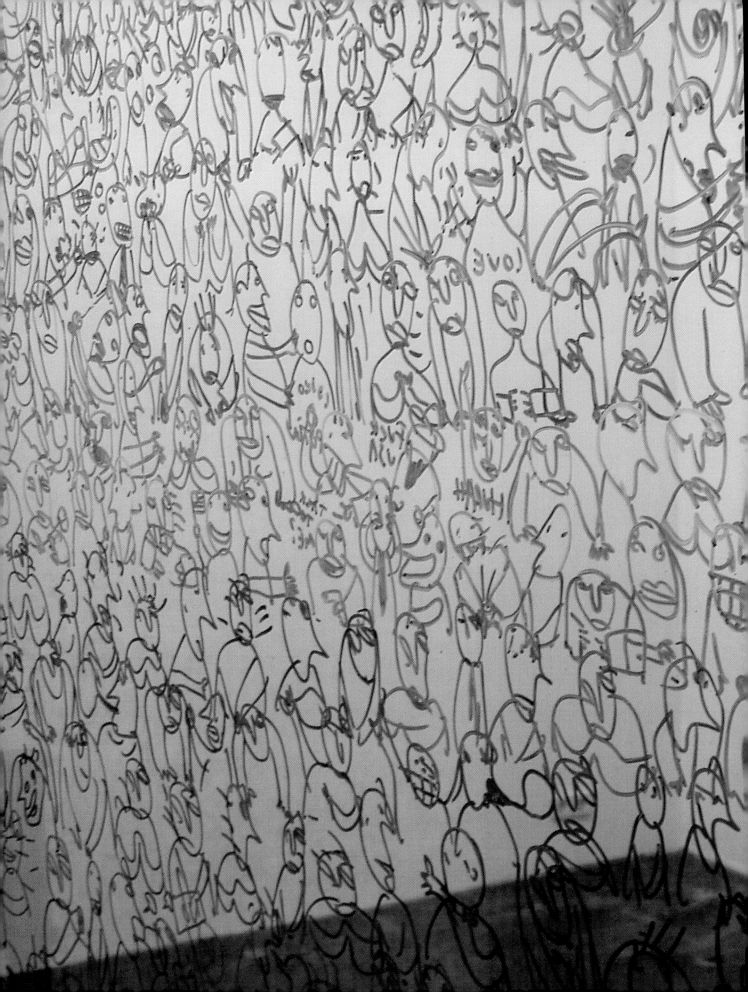

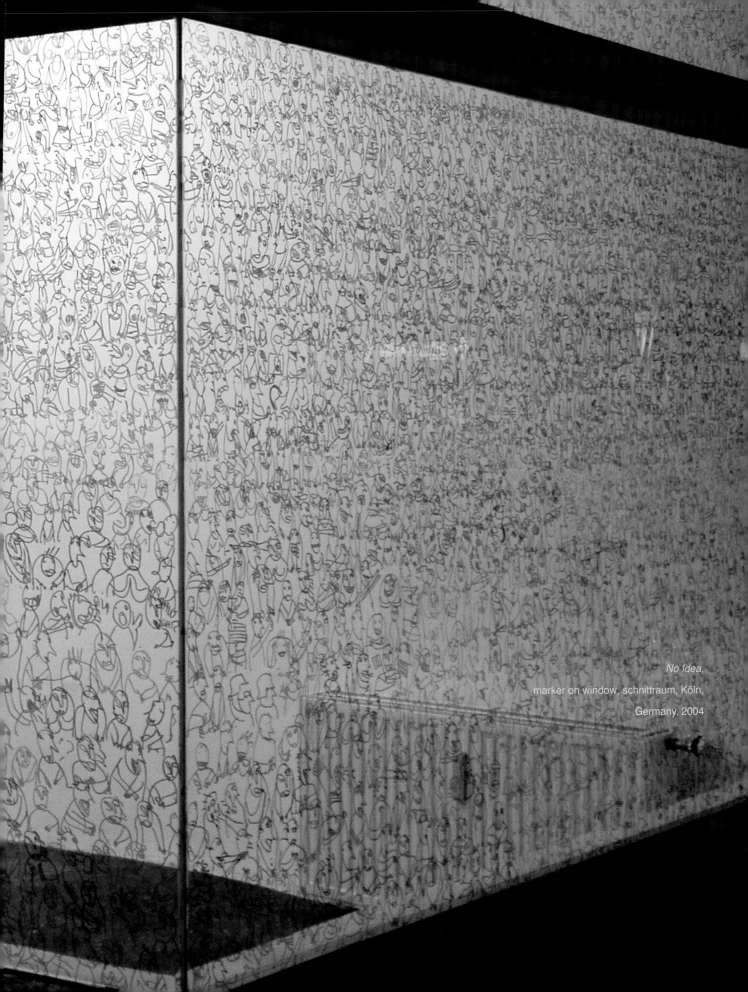

No Idea,
marker on window, schnittraum, Köln,
Germany, 2004

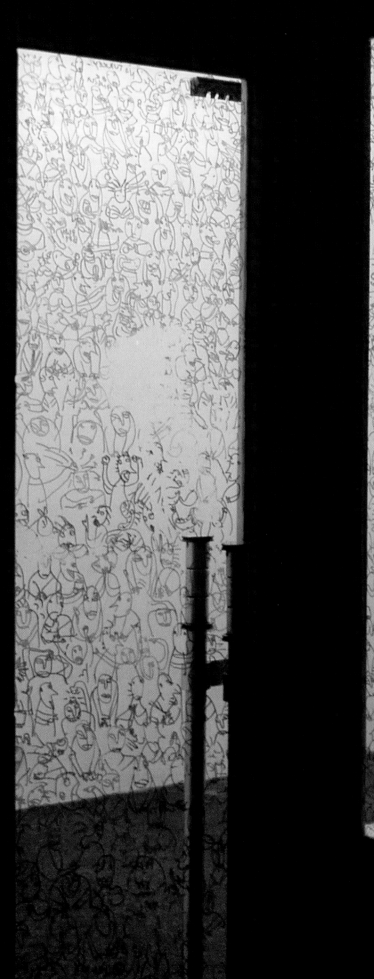
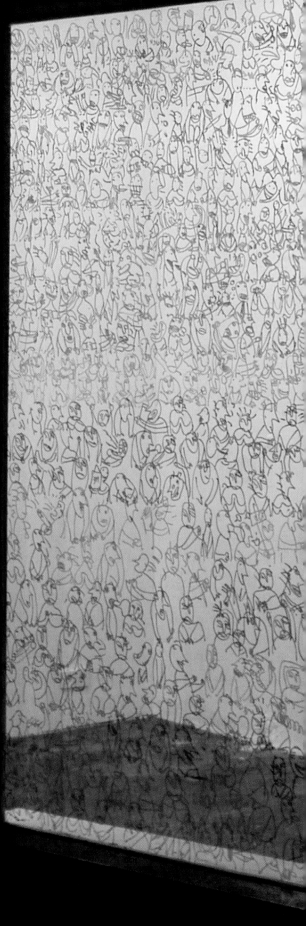

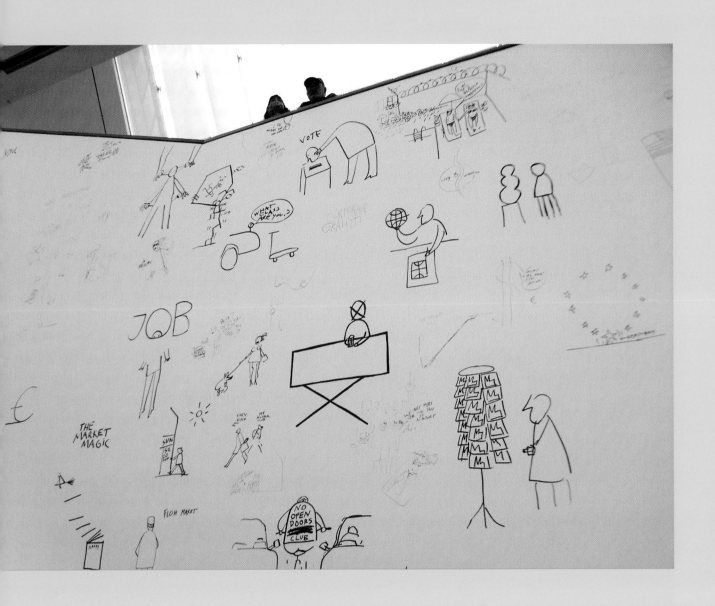

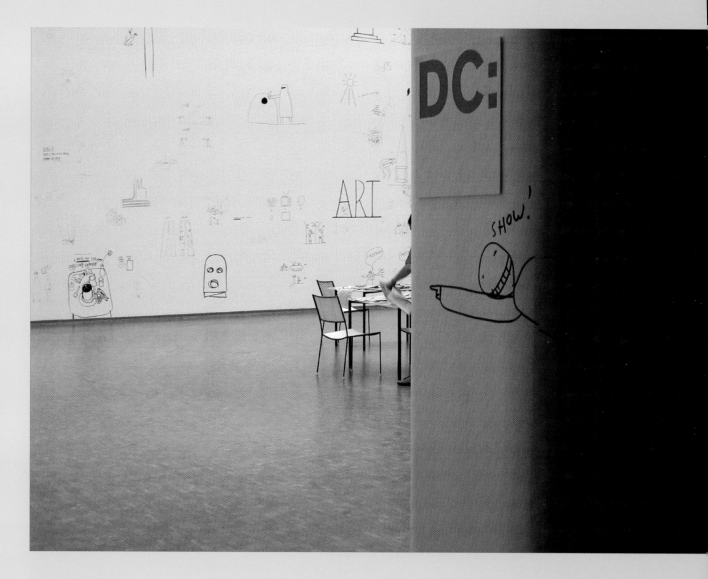

Naked Drawings,

permanent marker on walls, Ludwig Museum,

Köln, Germany, 2005

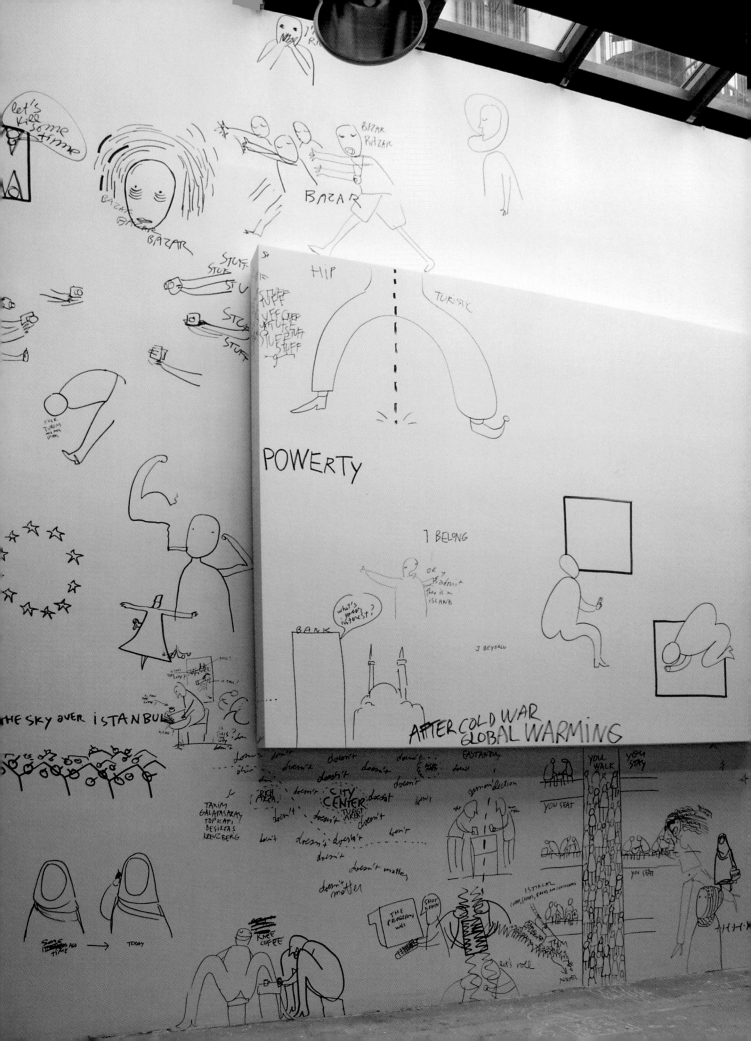

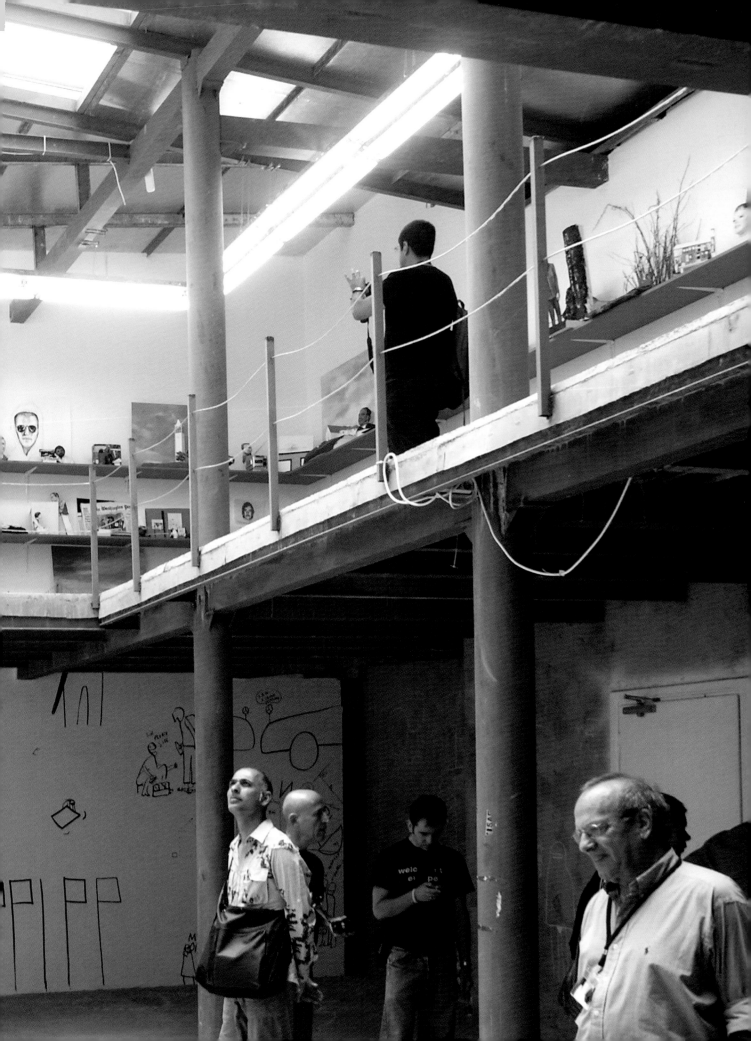

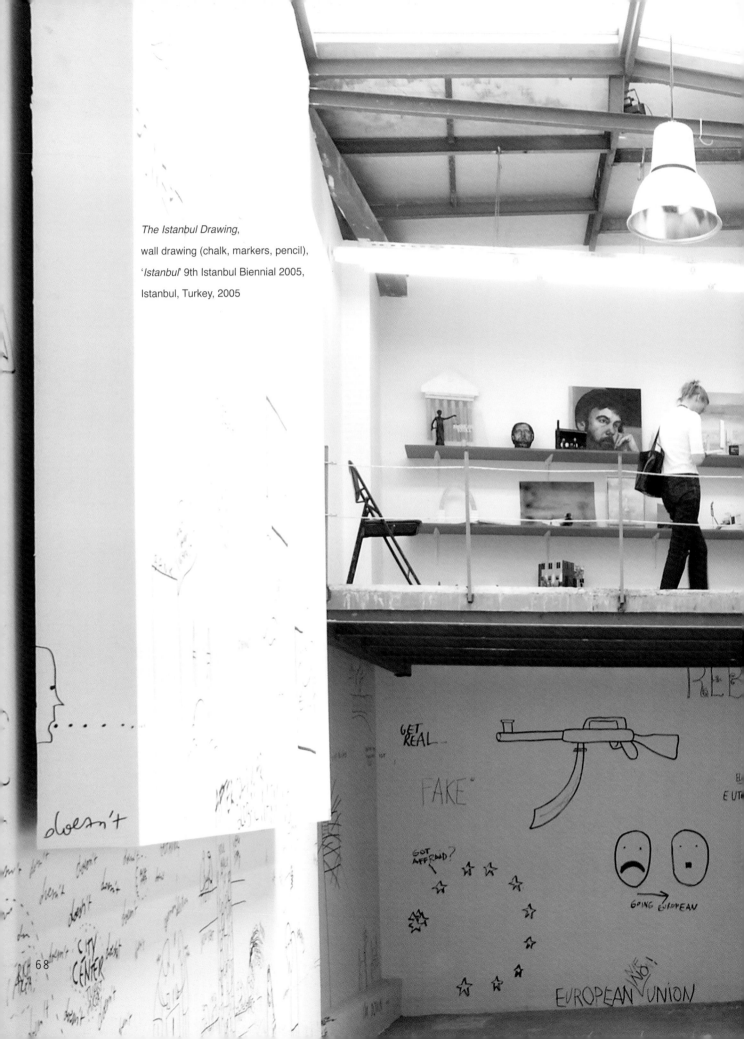

The Istanbul Drawing,
wall drawing (chalk, markers, pencil),
'*Istanbul*' 9th Istanbul Biennial 2005,
Istanbul, Turkey, 2005

68

MAJORITY MINORITY

RUSSIA CHINA UNITED STATES OF AMERICA

FREEDOM OF EXPRESSION

← FROM HERE ————————————→ TO HERE

GLOBAL WARMING

RADICAL

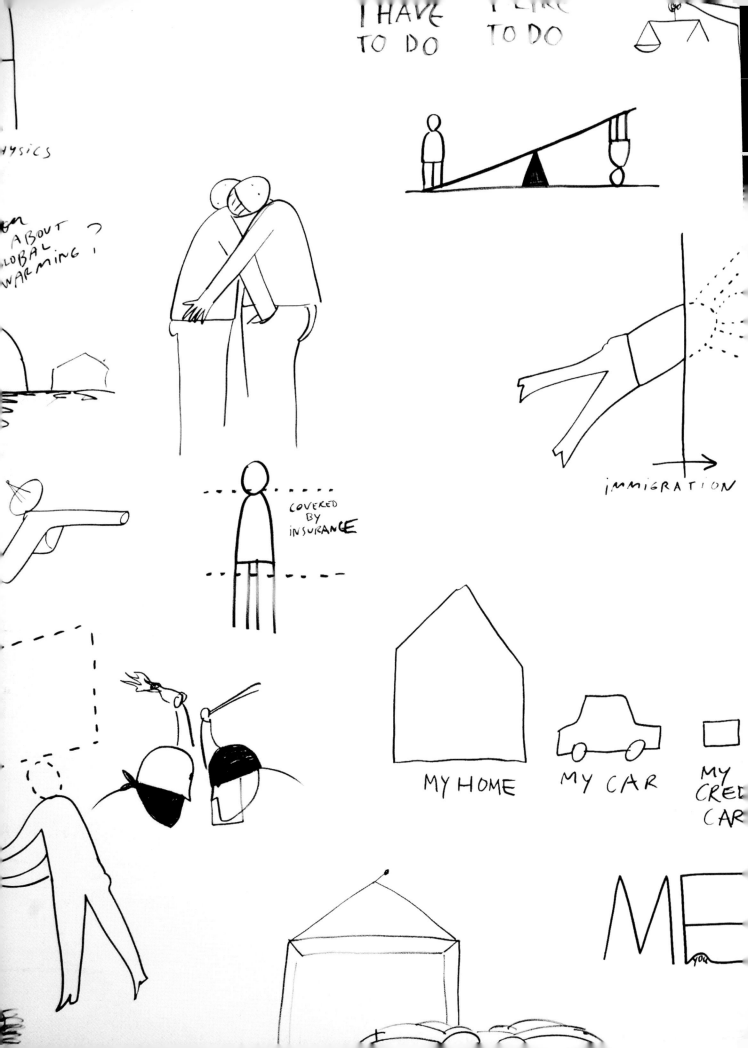

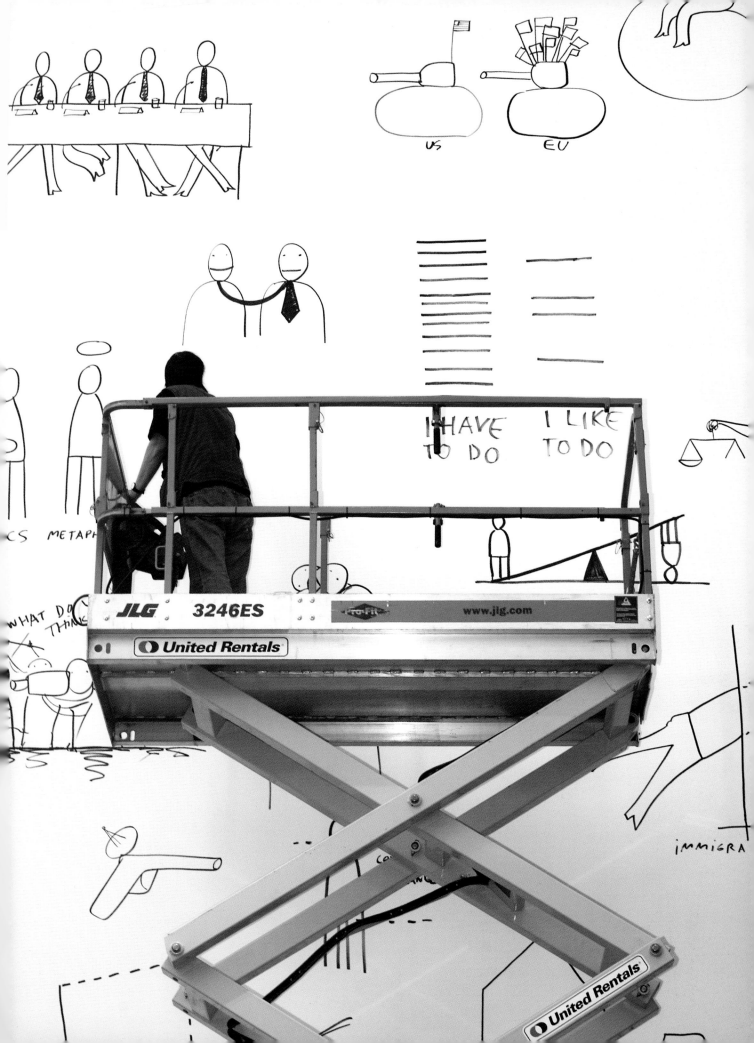

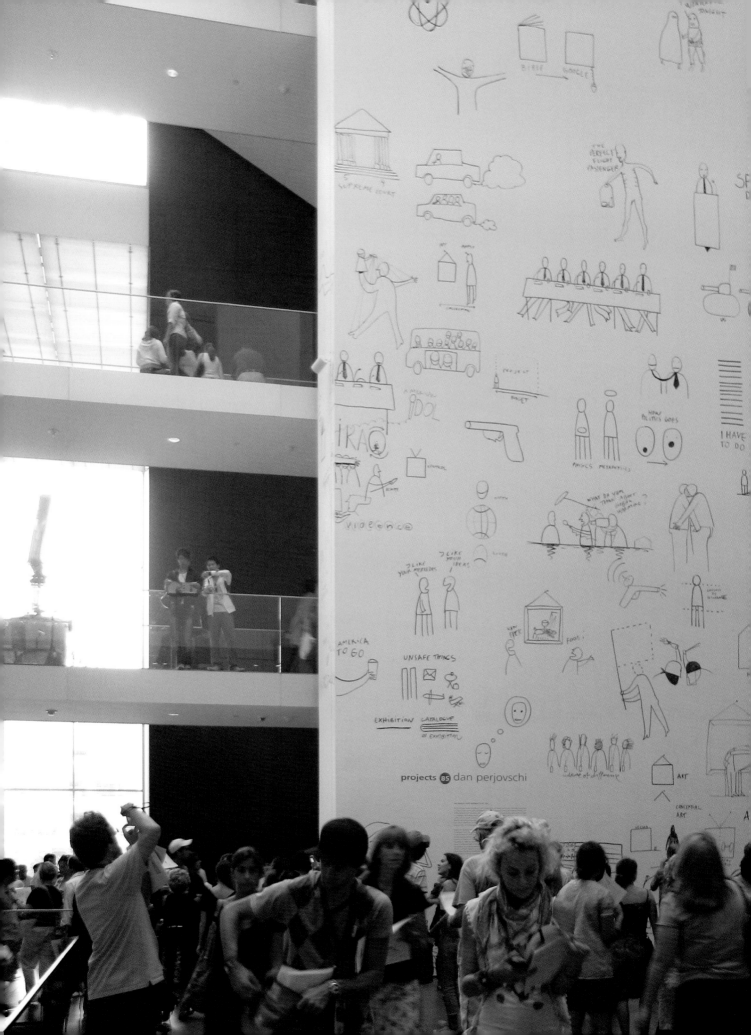

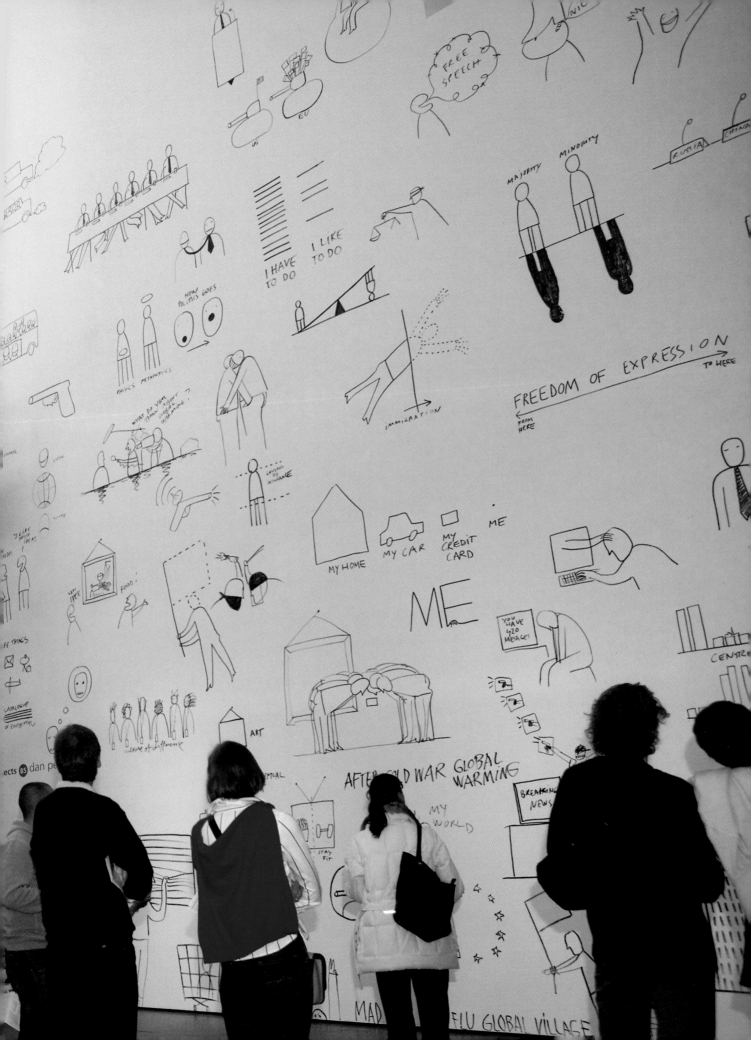

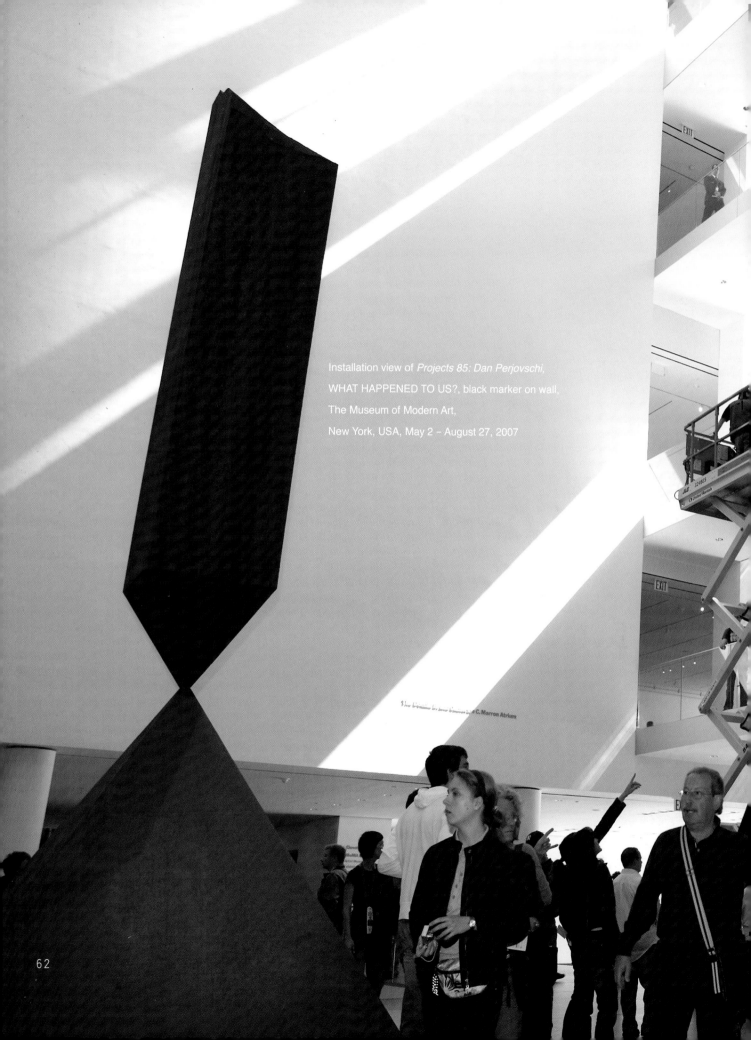

Installation view of *Projects 85: Dan Perjovschi,*
WHAT HAPPENED TO US?, black marker on wall,
The Museum of Modern Art,
New York, USA, May 2 – August 27, 2007

62

STRUCTURE OF POWER

ONE

MANY

STRUCTURE OF INCOME

MANY

ONE

IMMIGRATION

SOCIETY

DISIDEN-

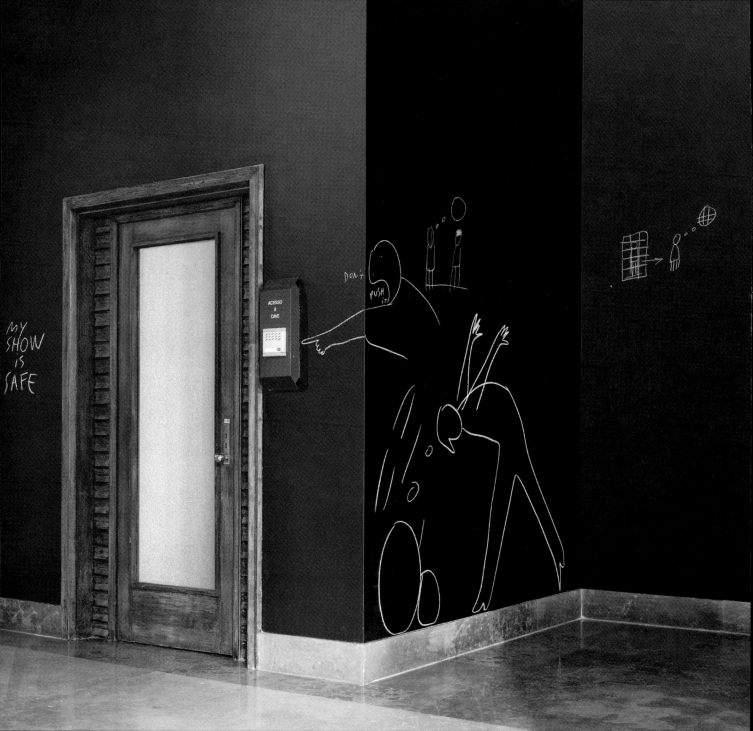

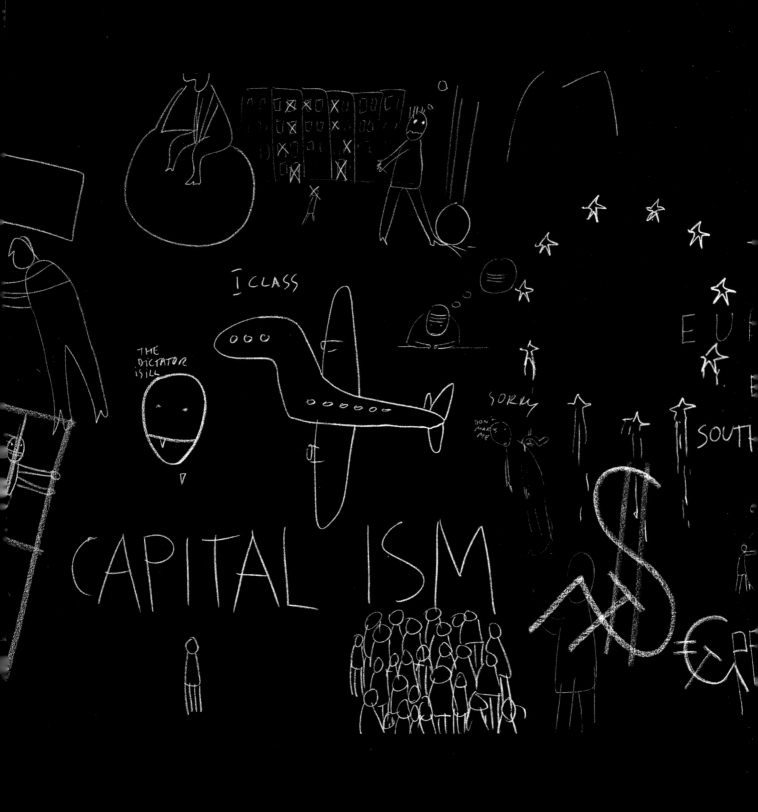

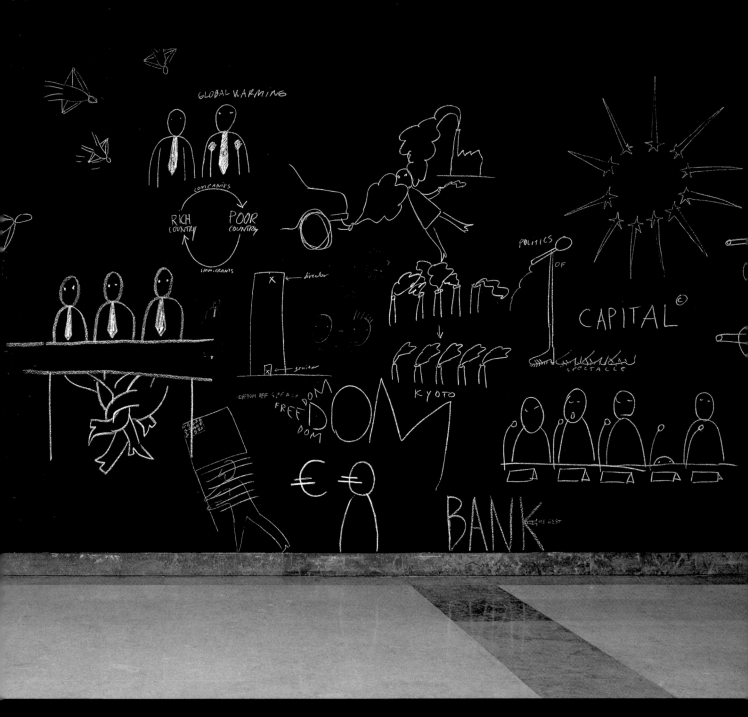

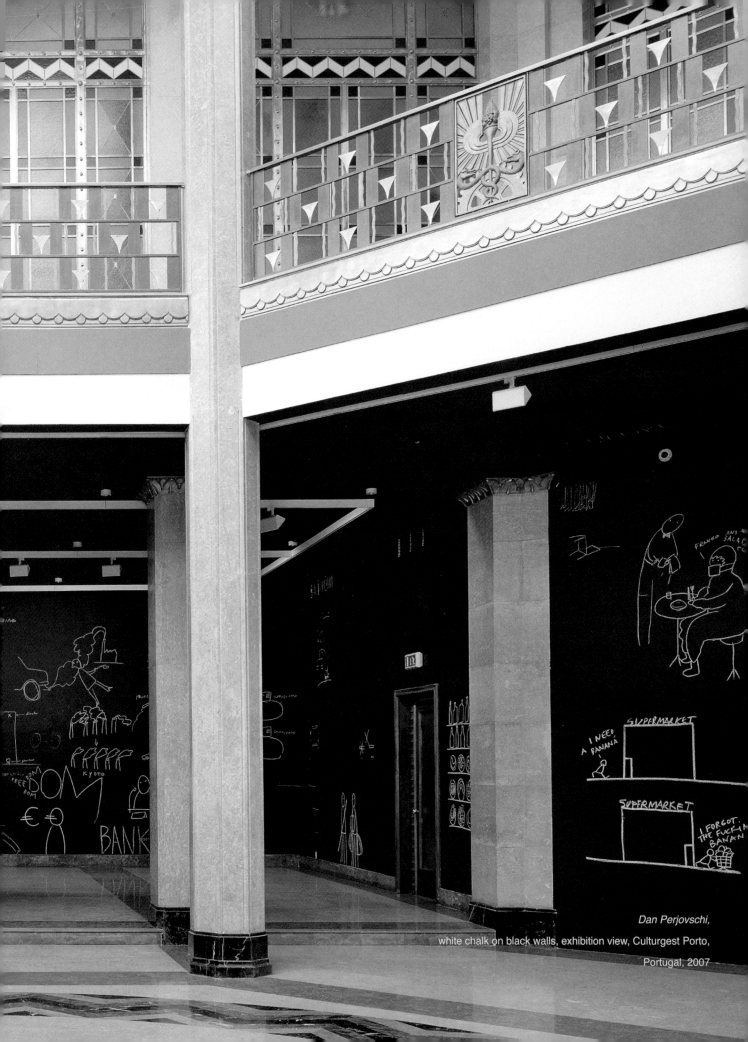

Dan Perjovschi,
white chalk on black walls, exhibition view, Culturgest Porto,
Portugal, 2007

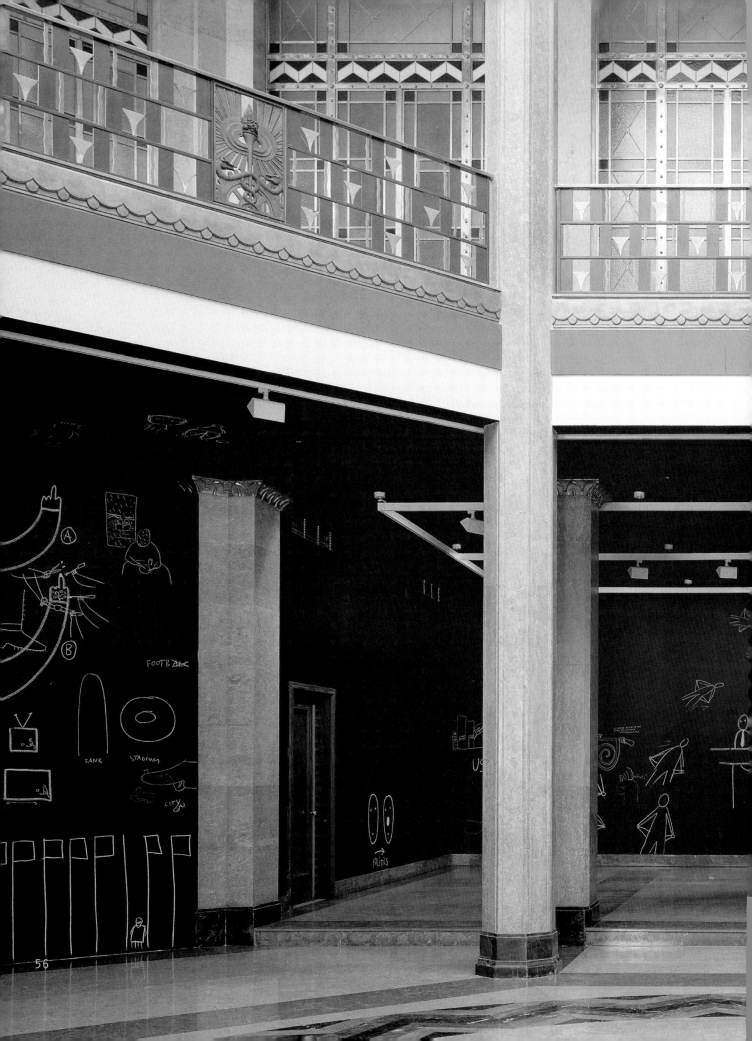

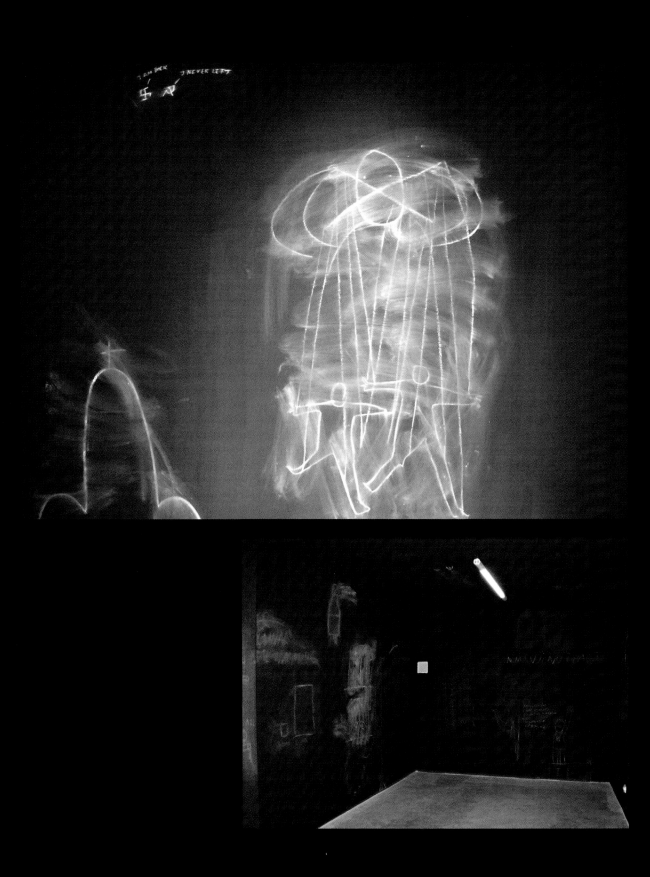

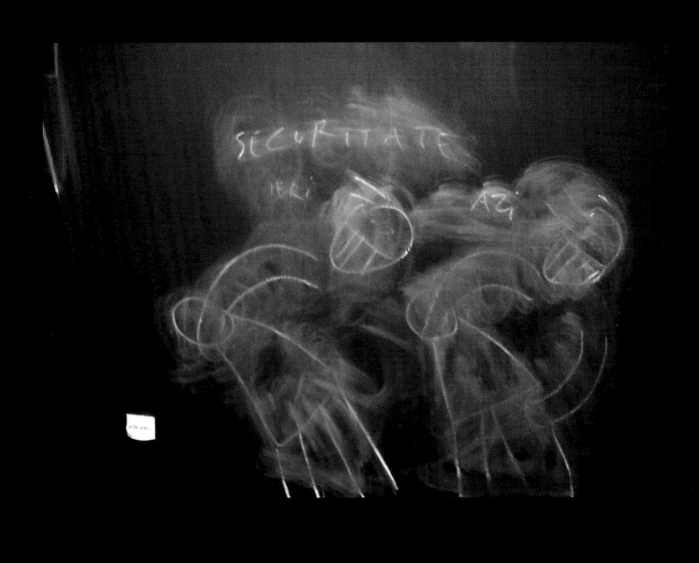

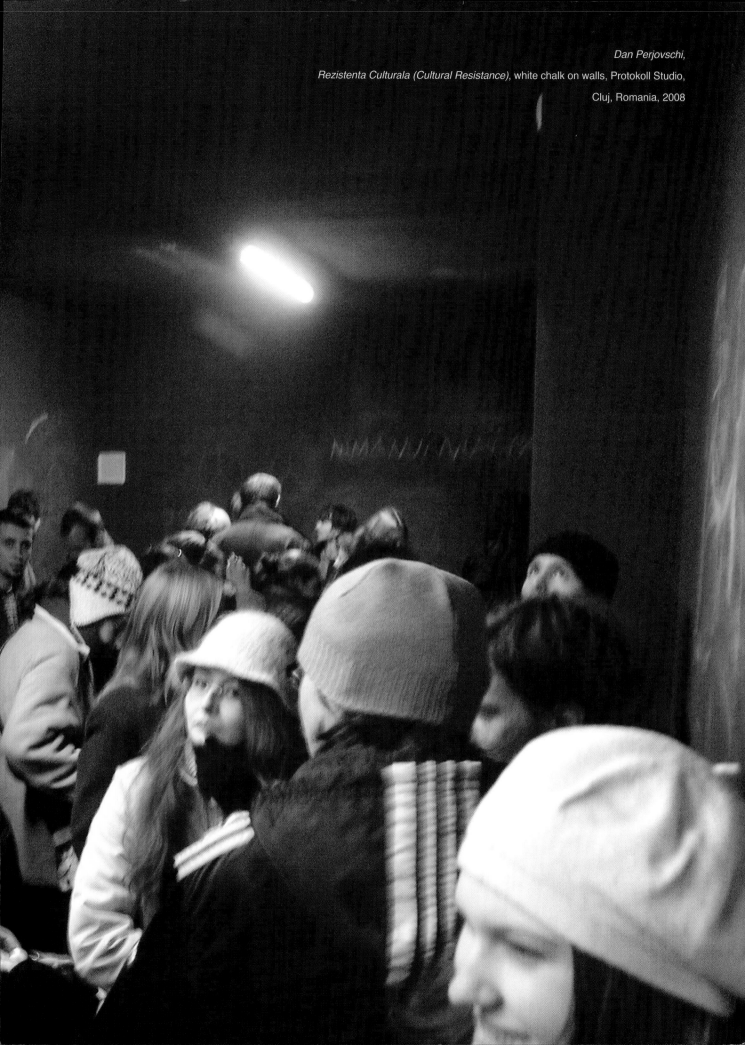

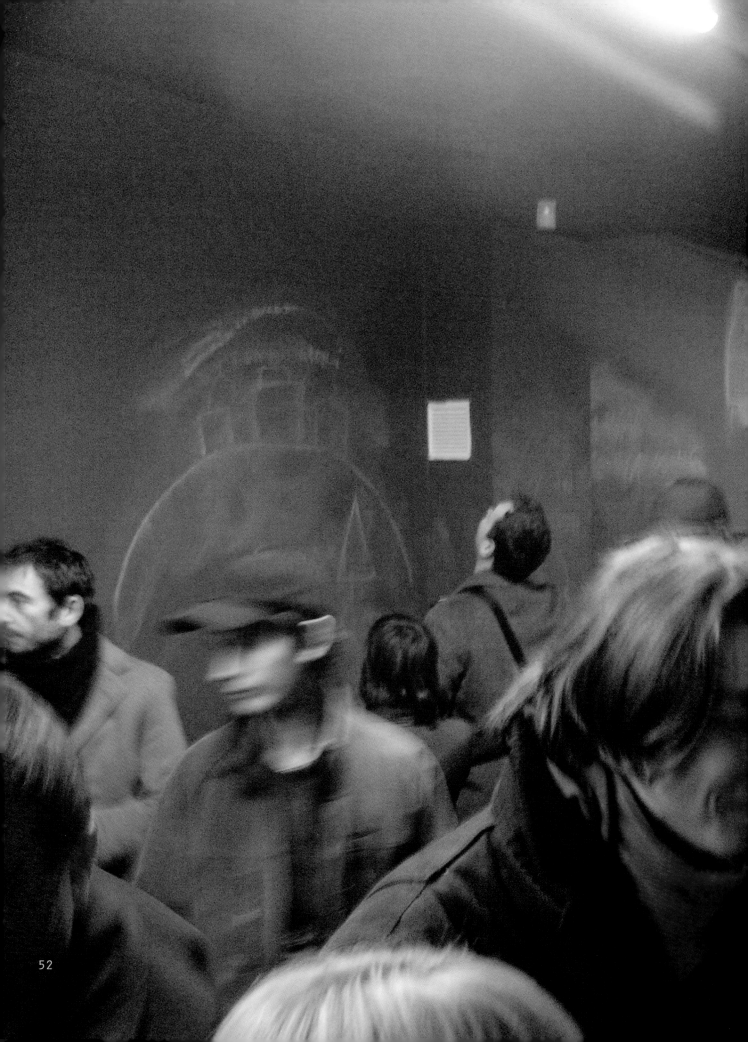

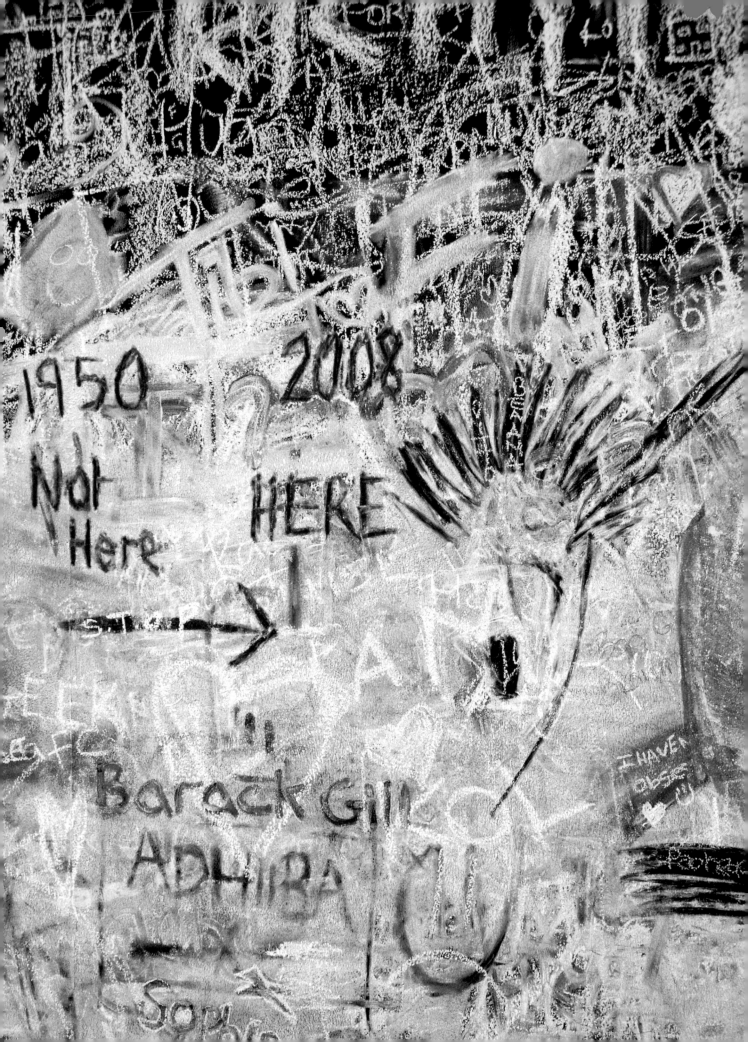

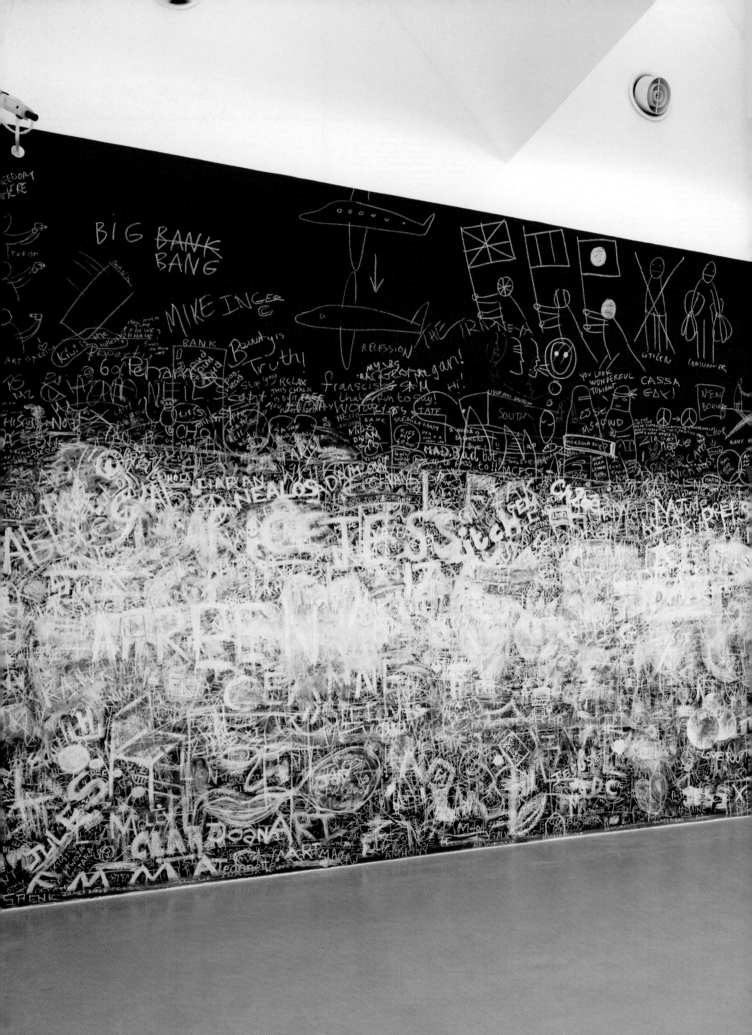

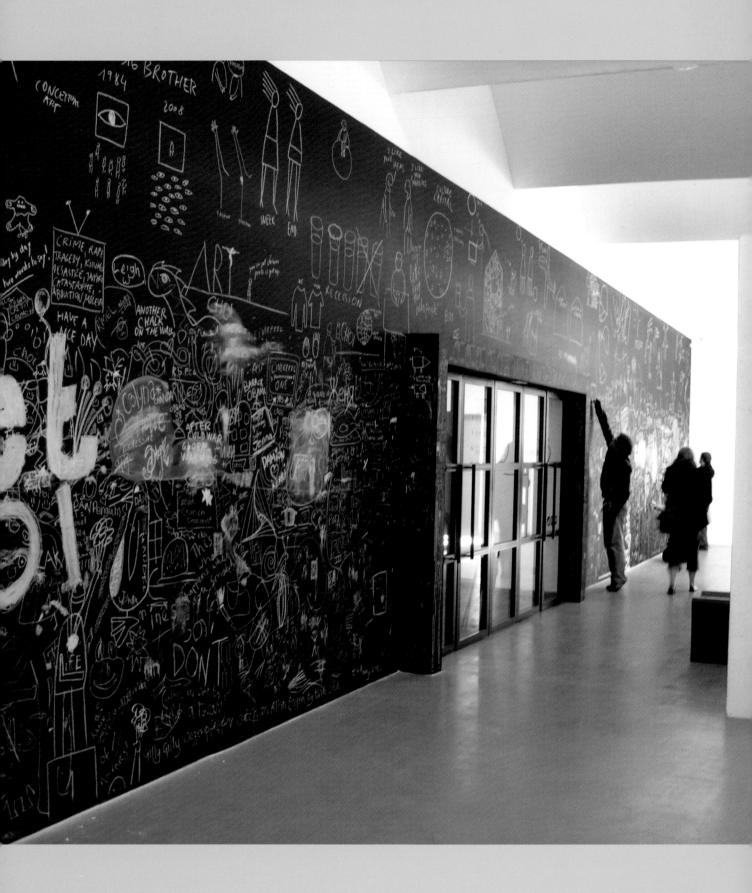

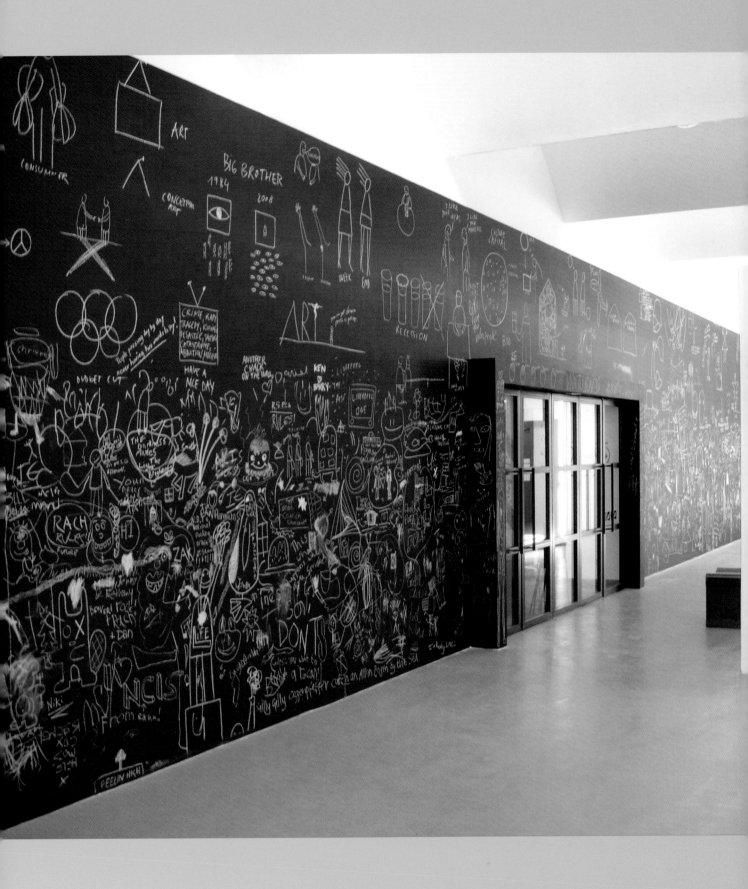

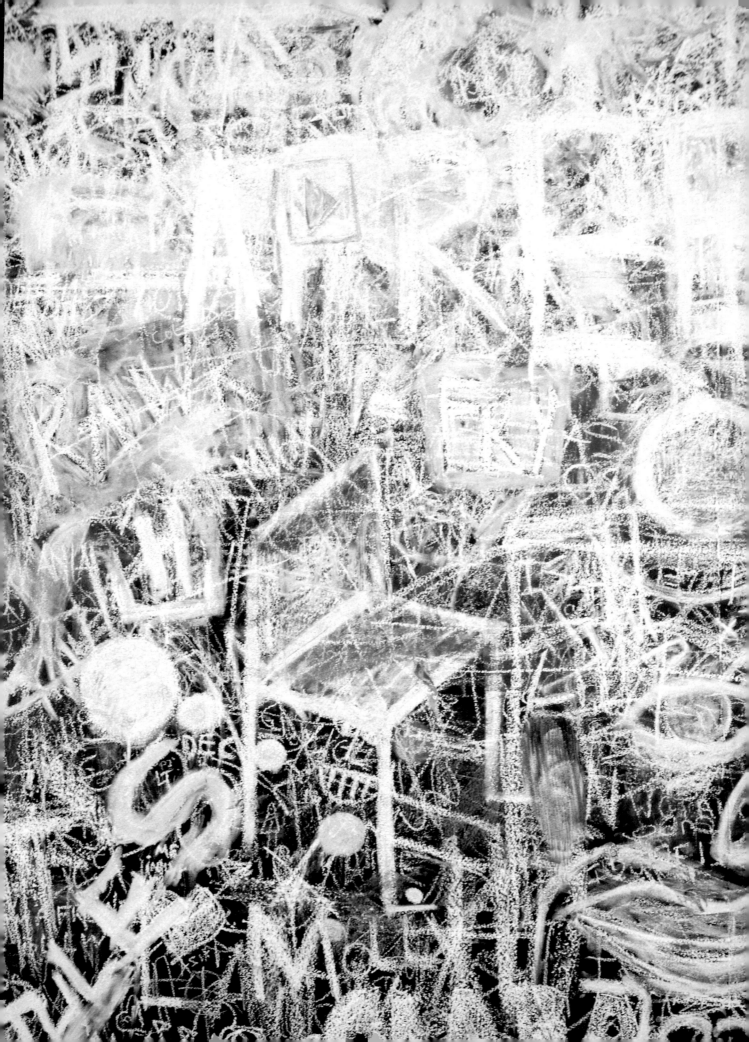

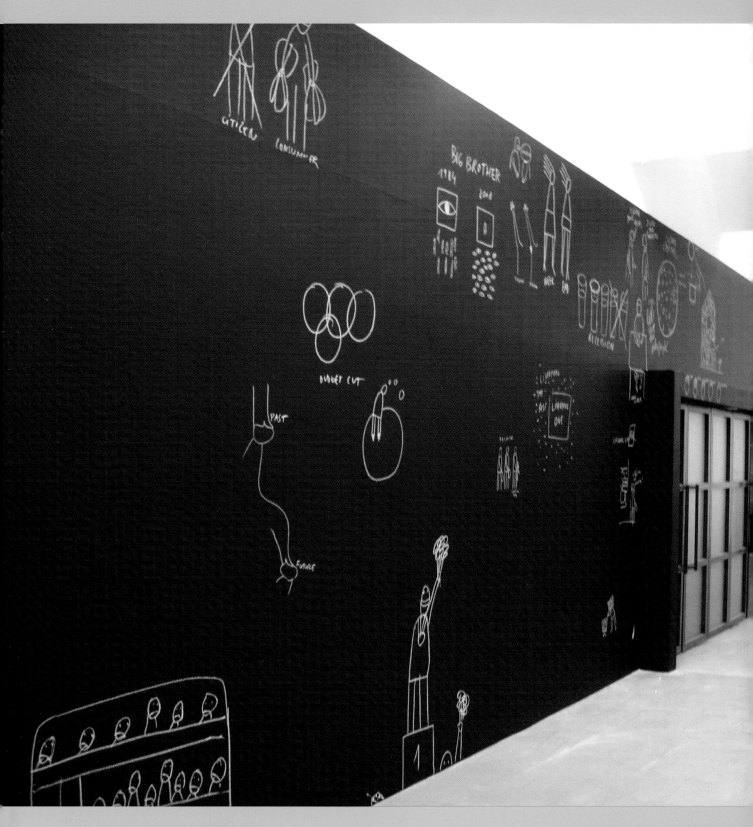

The Fifth Floor: Ideas Taking Space,
held at the end of 2008, white chalk on black wall, with visitor interventions, Tate Liverpool, UK

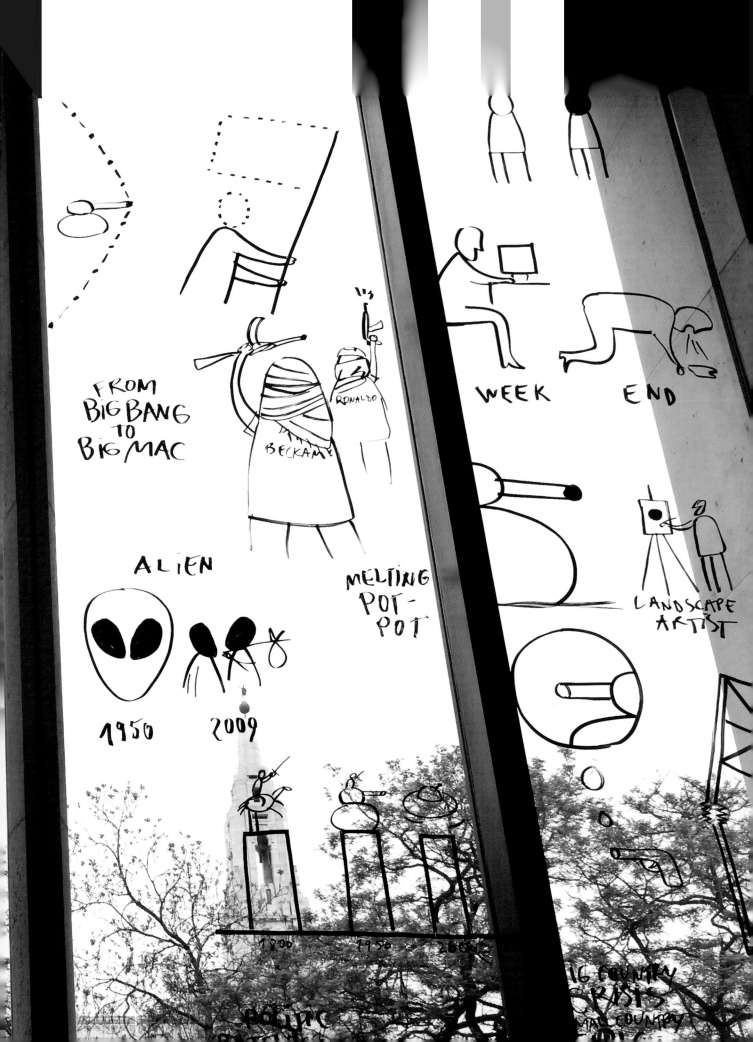

COMMA 05 Dan Perjovschi,
permanent marker on windows.
Bloomberg SPACE, London, UK.
May 2009

I HATE
MY JOB
I HATE MY
HOME
I HATE MY WIFE
LUCKY
YOU
A FREE
MAN

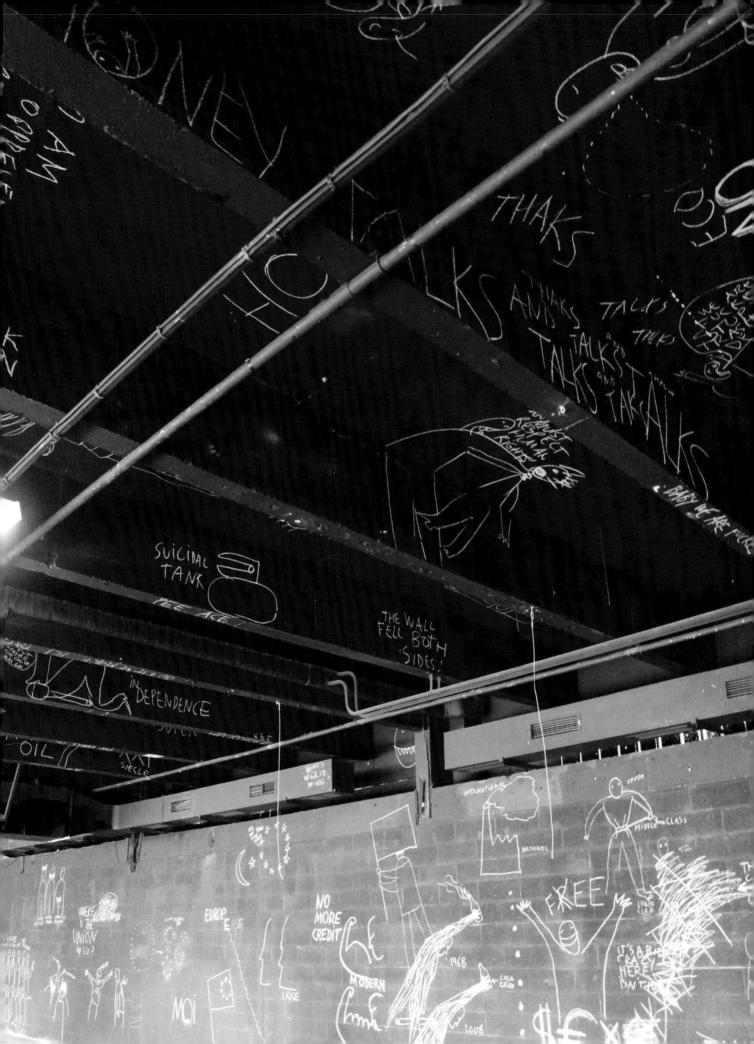

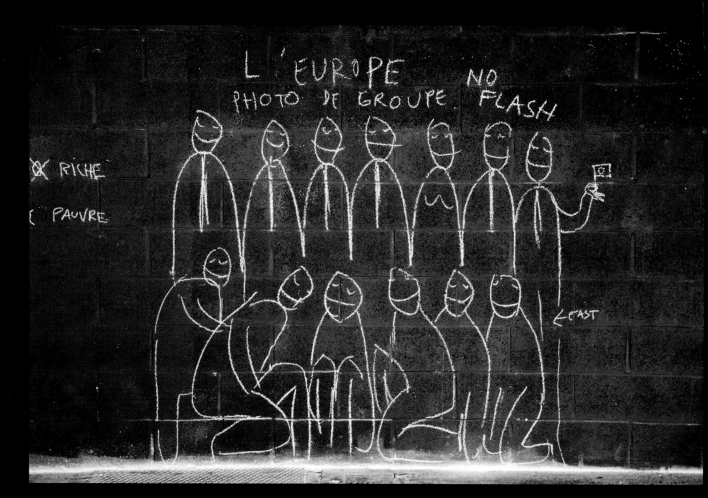

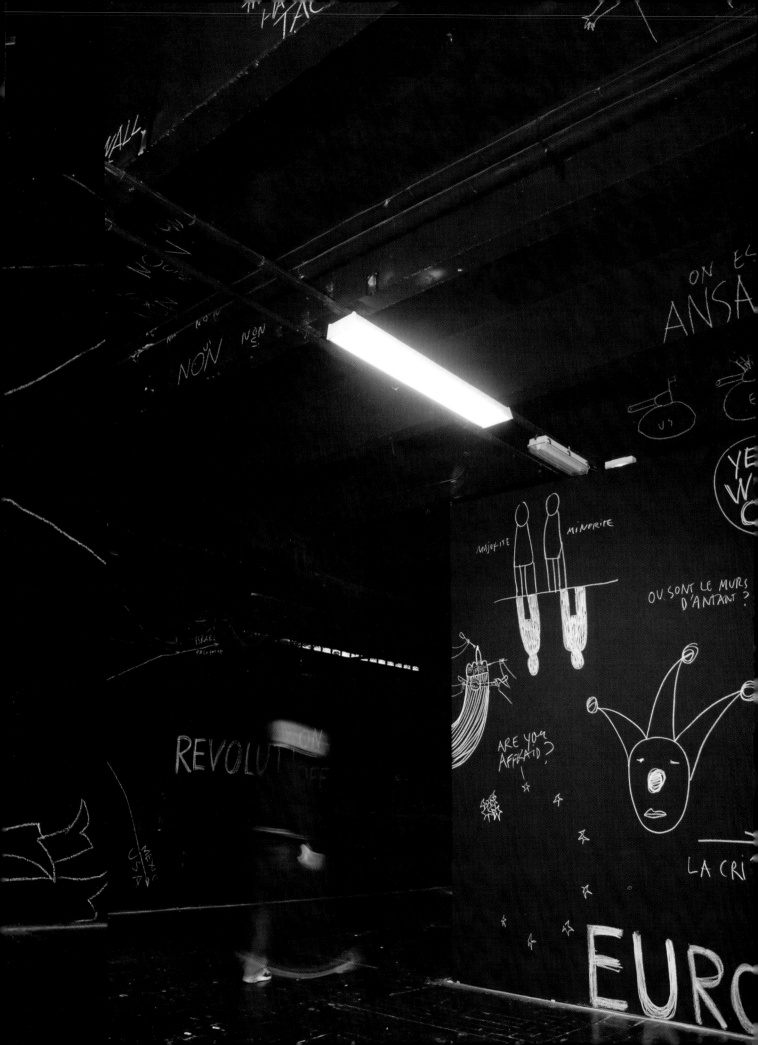

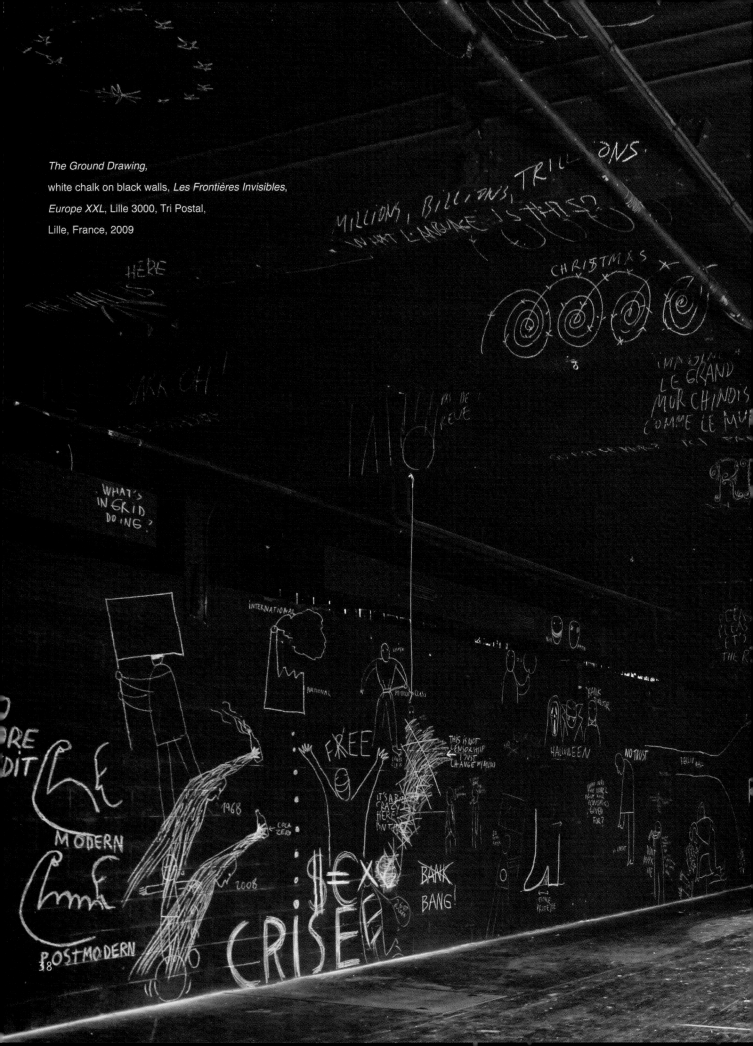

The Ground Drawing,
white chalk on black walls, *Les Frontières Invisibles,*
Europe XXL, Lille 3000, Tri Postal,
Lille, France, 2009

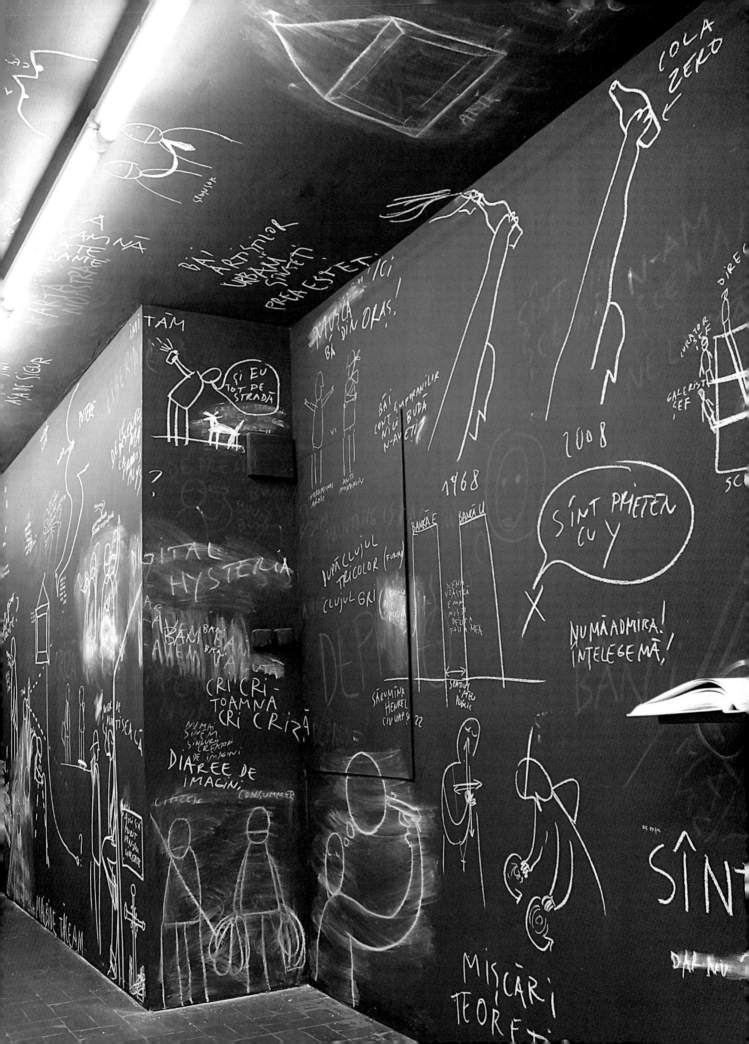

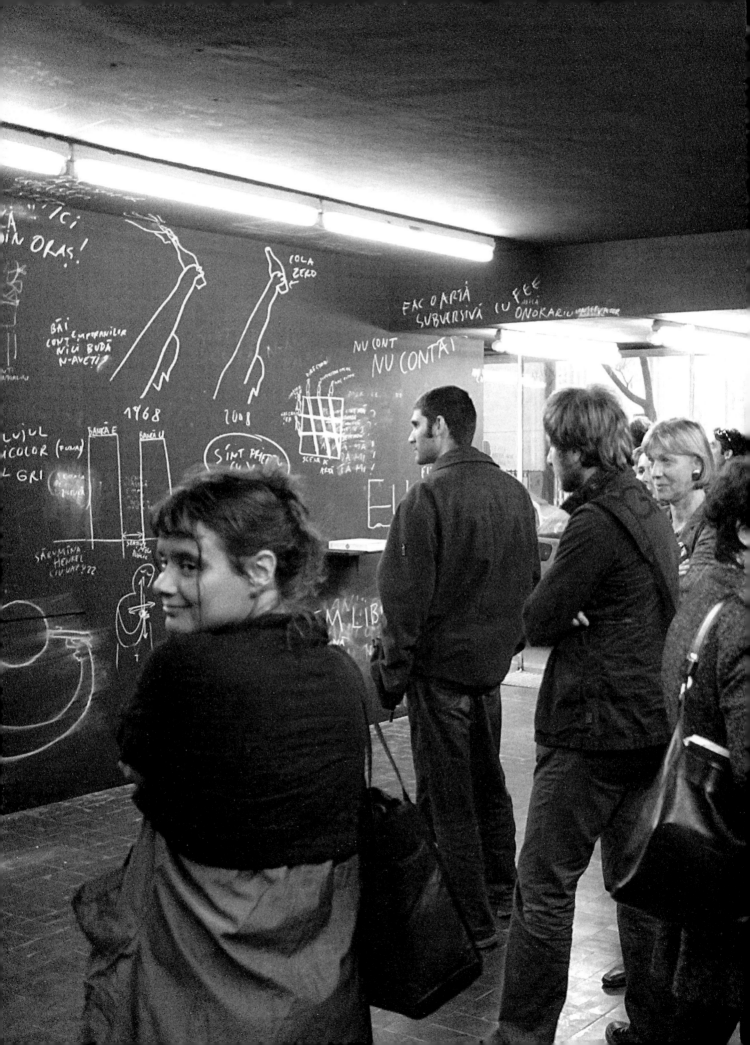

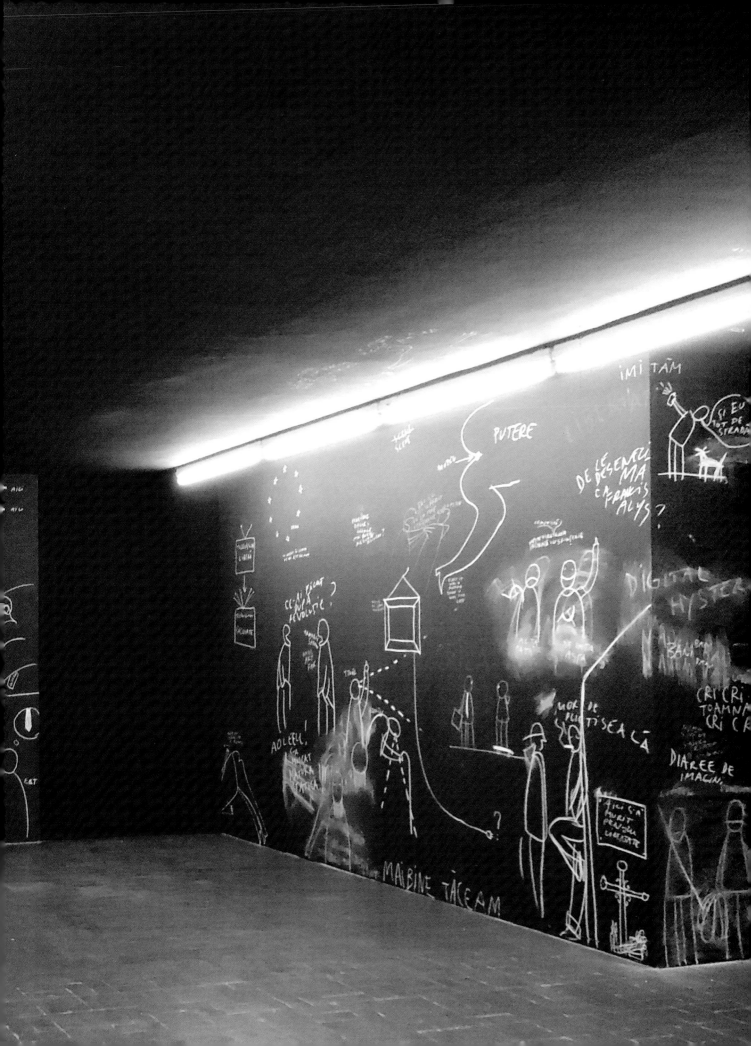

Dan Perjovschi S.A.,
white chalk on black walls,
CIV (Center for Visual Introspection),
Bucharest, Romania, 2010

I AM NOT
EXOTIC
I AM EXHAUSTED

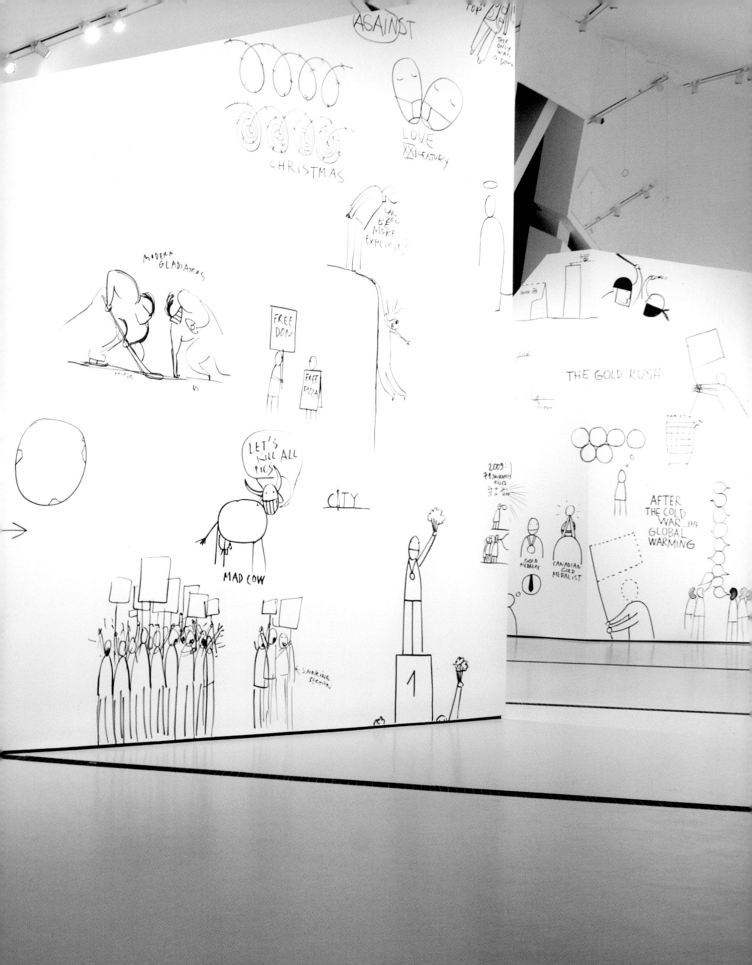

LIFE IS (FUN)DAMENTAL

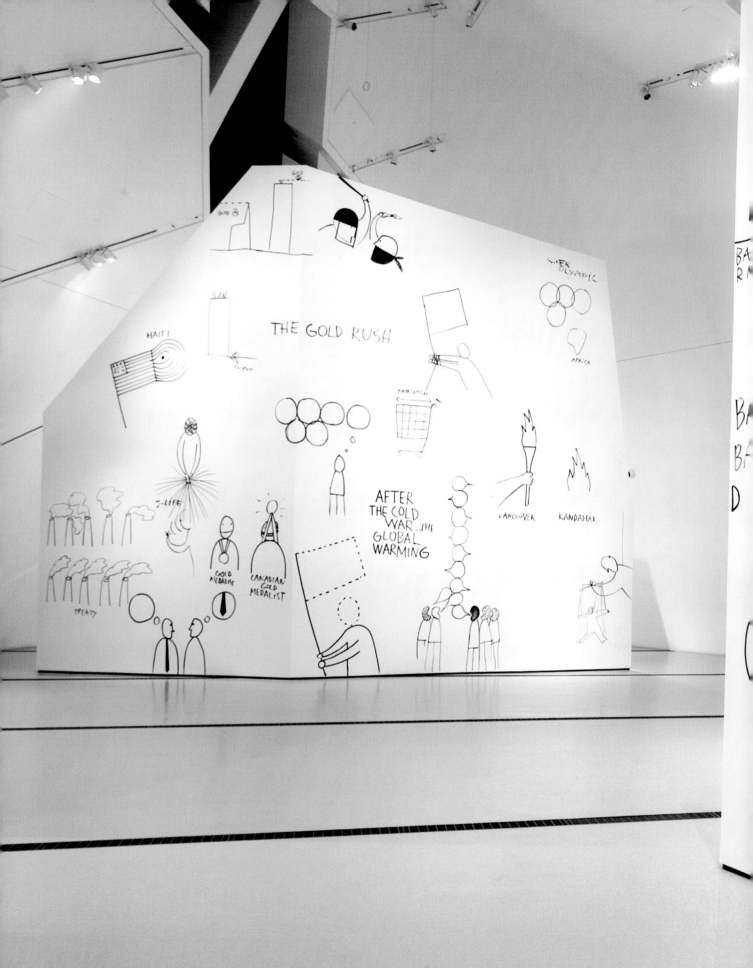

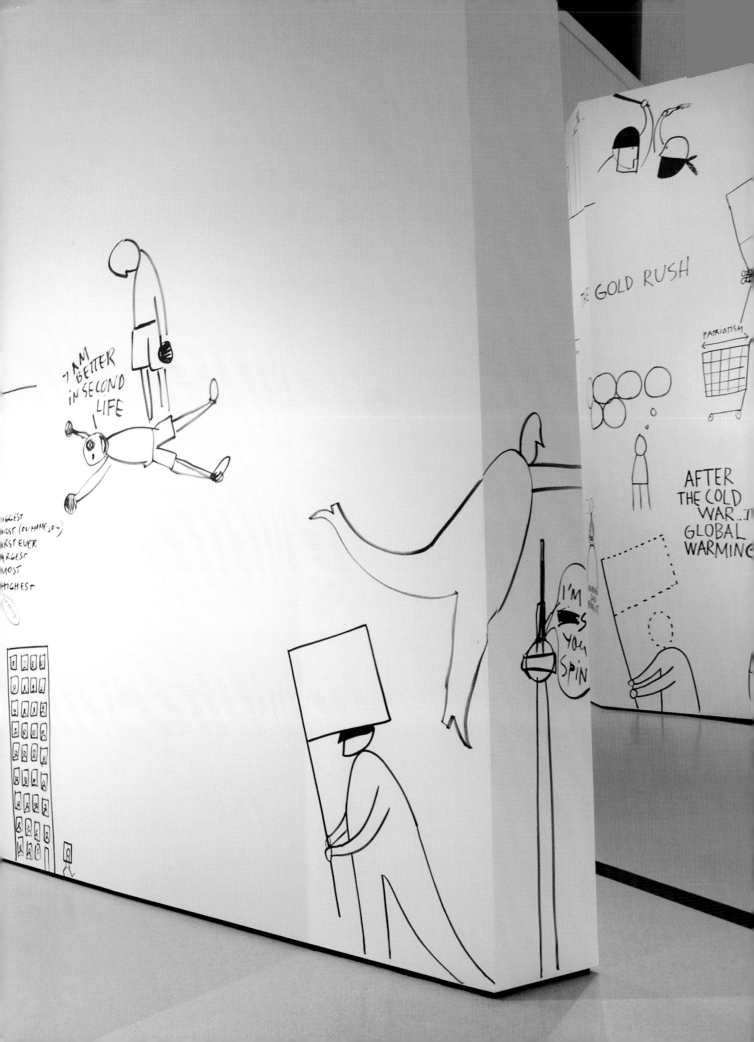

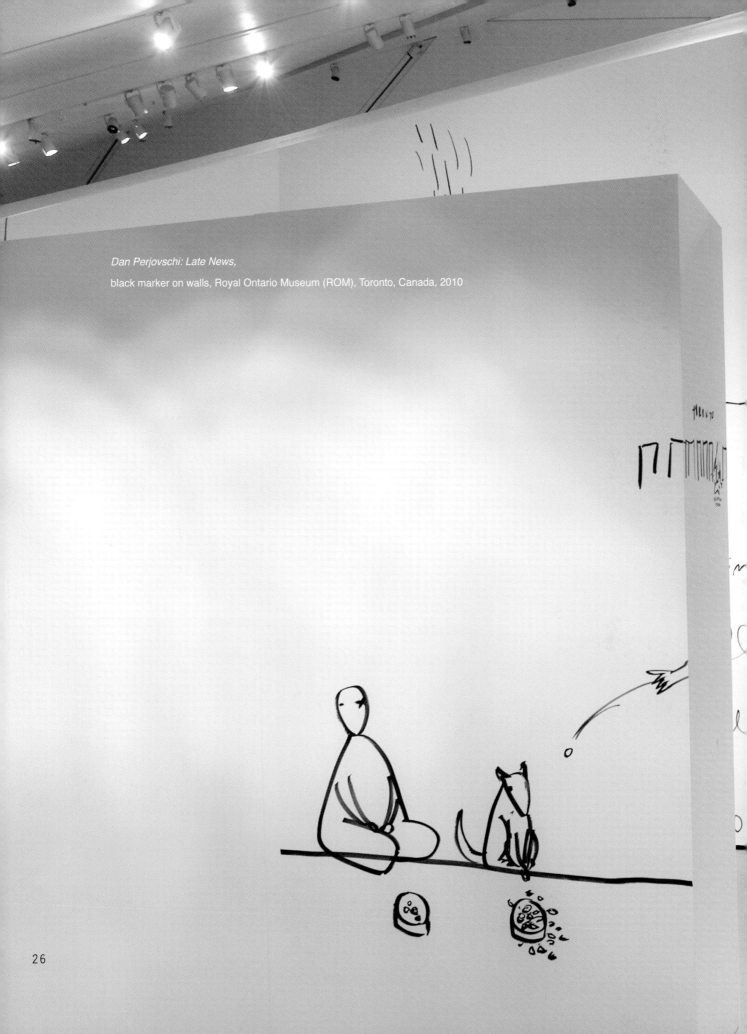

Dan Perjovschi: Late News,

black marker on walls, Royal Ontario Museum (ROM), Toronto, Canada, 2010

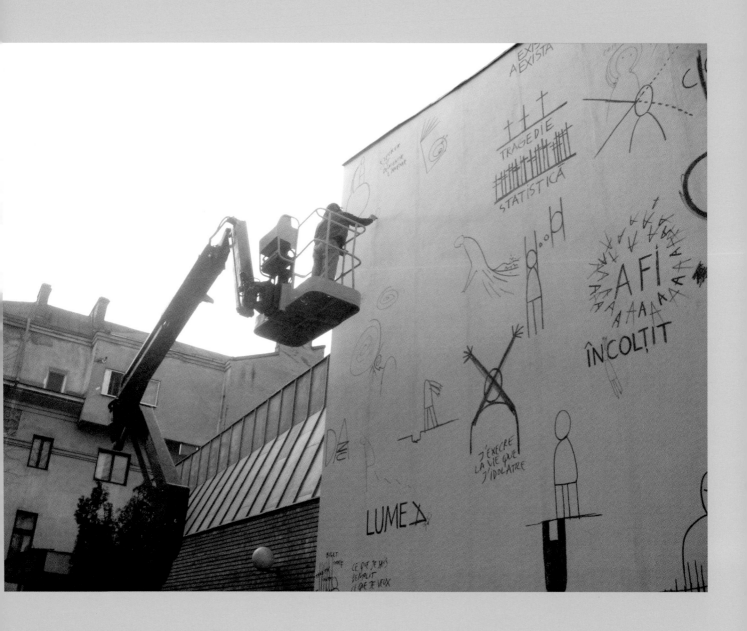

Cioran dans la Rue, black marker on walls,

French Cultural Institute, Bucharest, Romania, 7 April – 6 May, 2011

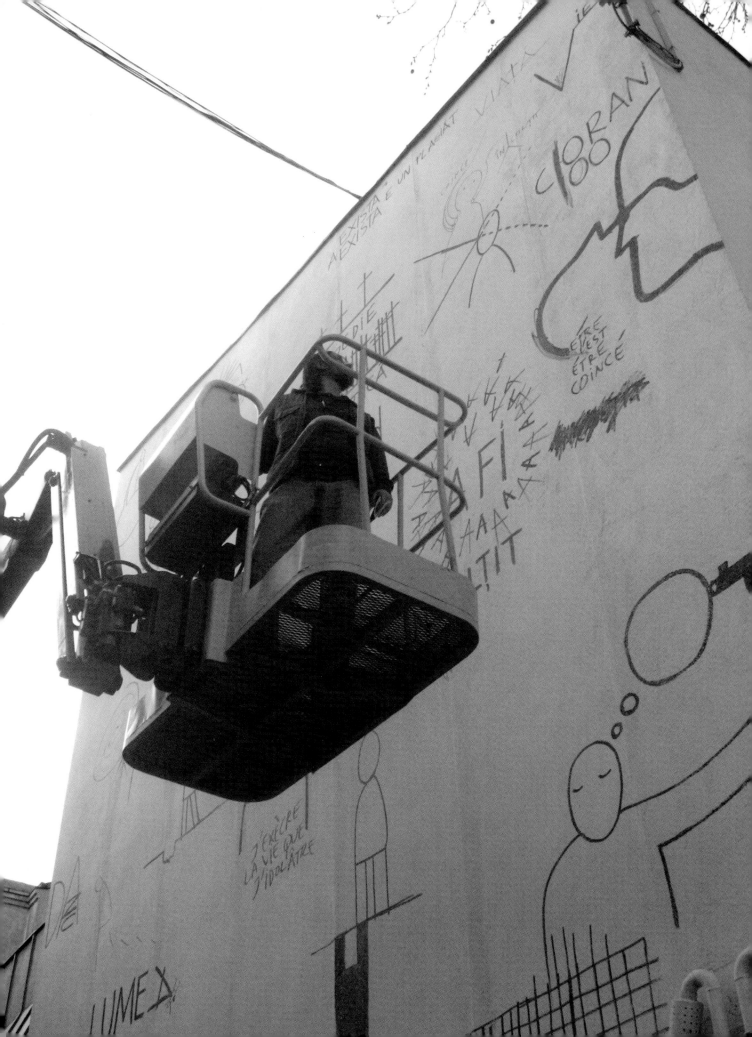

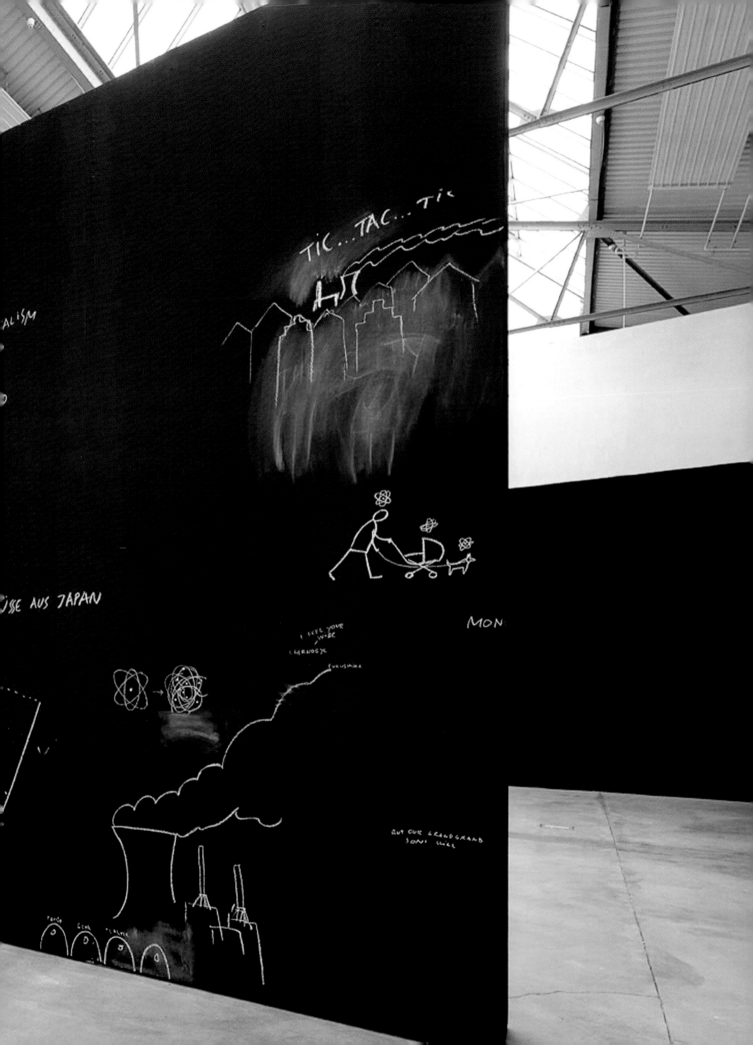

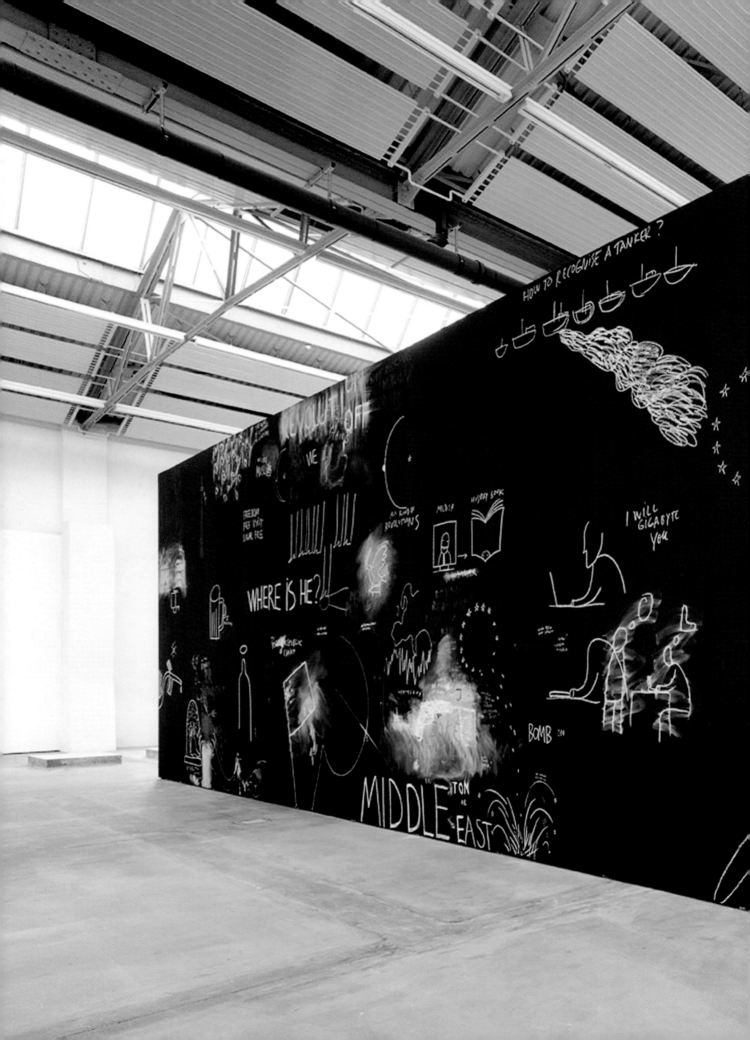

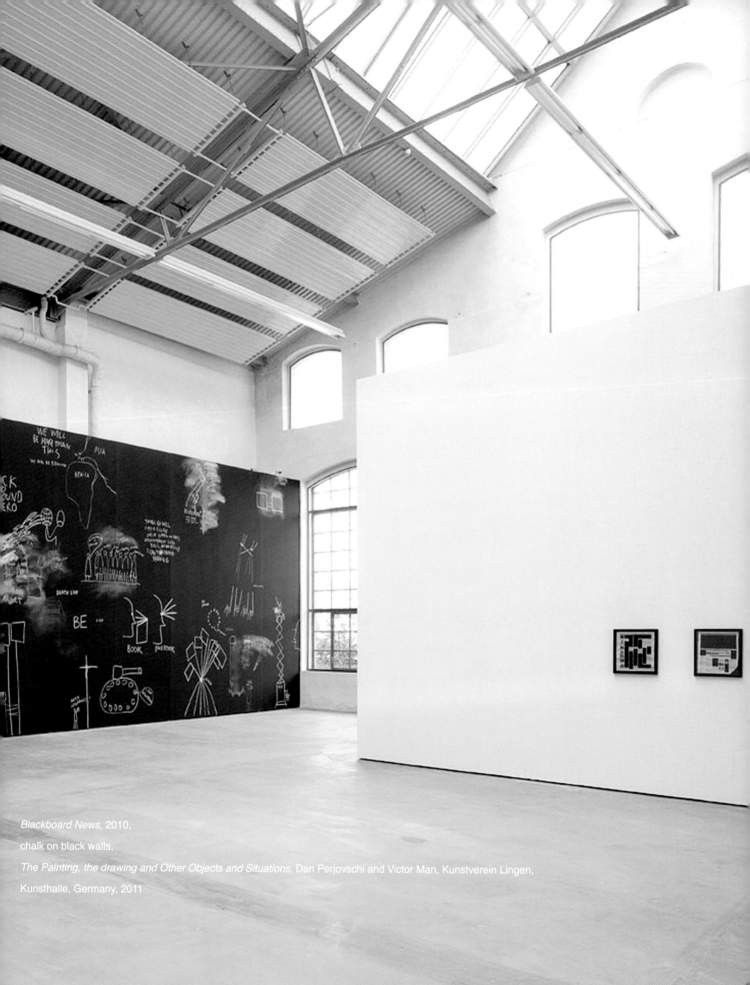

Blackboard News, 2010,

chalk on black walls,

The Painting, the drawing and Other Objects and Situations, Dan Perjovschi and Victor Man, Kunstverein Lingen,

Kunsthalle, Germany, 2011

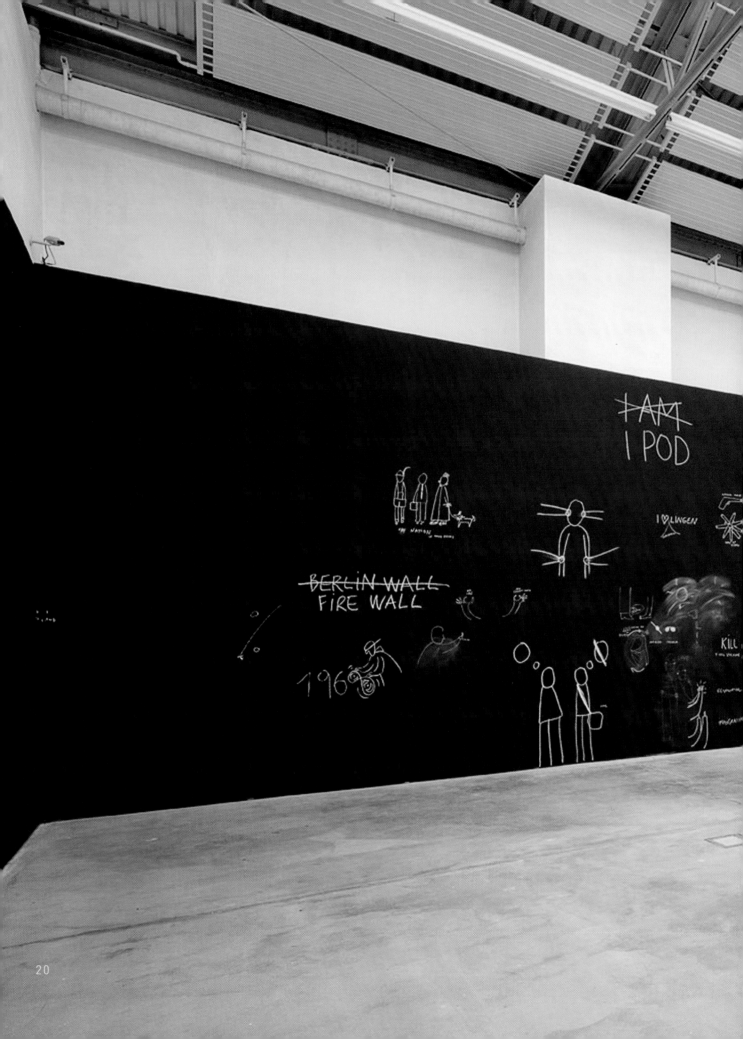

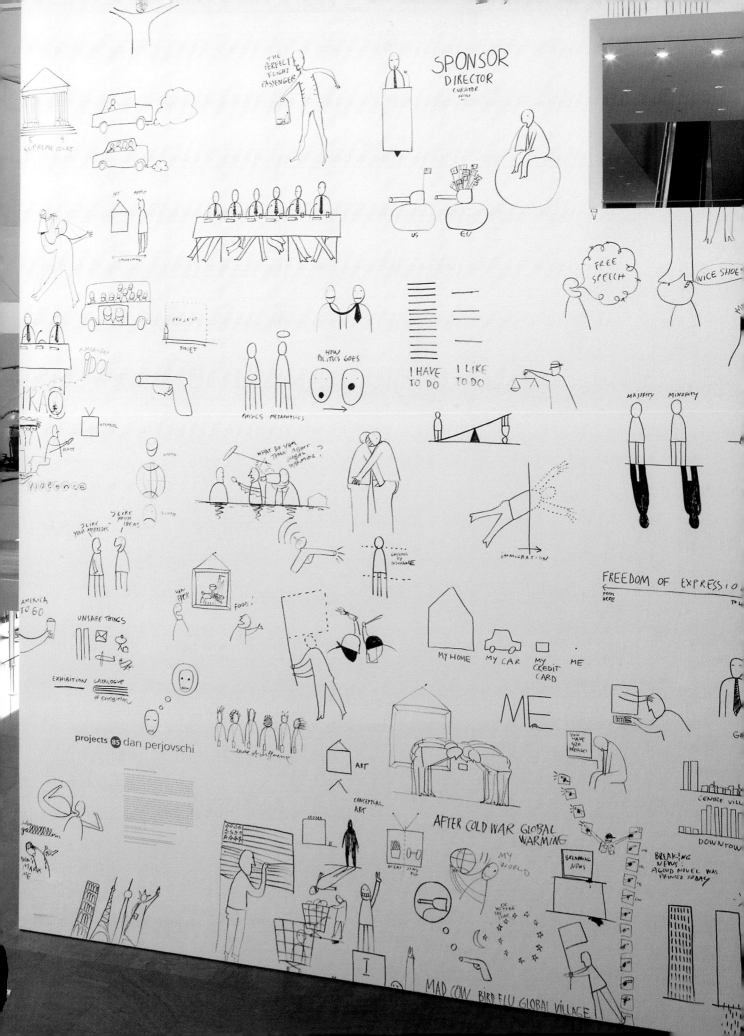

works on walls
2003 – 2011

Viewed separately, Dan Perjovschi's drawings are powerful 'one-liners', often capturing the complex effects of globalisation, economic crisis, religious fundamentalism, nationalism and consumerism in a few quick lines. By exploiting familiar symbols drawn from the iconography of the nation (flags or currency), signs of status (ties, cars or tower blocks) and a word or phrase, Perjovschi comments on the complex conditions of life today. He achieves maximum effect with minimum means.

The power of his work does not, however, lie in its economy. Its impact comes from the crowded agglomeration of drawings which he produces *in situ* in galleries and museums around the world. The nature of these spaces is important too. It is often the margins of the gallery which attract his attention. Viewers crane their necks following a line around a corner or onto a ceiling to make sense of an idea. Reflecting on his interest in breaking the tidy frame offered by the well-proportioned gallery wall, Perjovschi himself points to his own personal history in communist Romania, a country which narrowed the intellectual and personal horizons of its citizens.

Much in demand in the last few years, Perjovschi has worked virtually non-stop. He has developed new approaches 'on the road'. Creating WHAT HAPPENED TO US? in the Museum of Modern Art in New York in 2007, Perjovschi had to work on top of a moving platform while the public looked on. Drawing became a kind of performance for both the artist and the public: "My work is not only my work, the drawing on the wall, but also people pointing because they create a kind of choreography. They move their hands and they re-describe the drawings …".[1] At Tate Liverpool in 2008, Perjovschi worked in chalk, encouraging visitors – largely children – to pick up the medium and draw on the blackboard walls. Perjovschi welcomed the way in which their efforts 'ate' his own. Like a metaphor for the relentless communication of the age in which we live, the white chalky lines merged into a cloud of buzzing lines. →

Installation view of *Projects 85: Dan Perjovschi,* WHAT HAPPENED TO US?, black marker on wall, The Museum of Modern Art, New York, USA, May 2 – August 27, 2007

The Liverpool exhibition made evident the fundamental condition of all his work – its ephemerality. When an exhibition closes, his drawings are washed off or whitewashed over (Perjovschi calls them "a temporary project with permanent markers"). Impermanence is an advantage: revived and subtly revised for new locations, Perjovschi's drawings always stay current.

[1] Dan Perjovschi speaking to MoMA Multimedia at www.moma.org, Spring 2007.

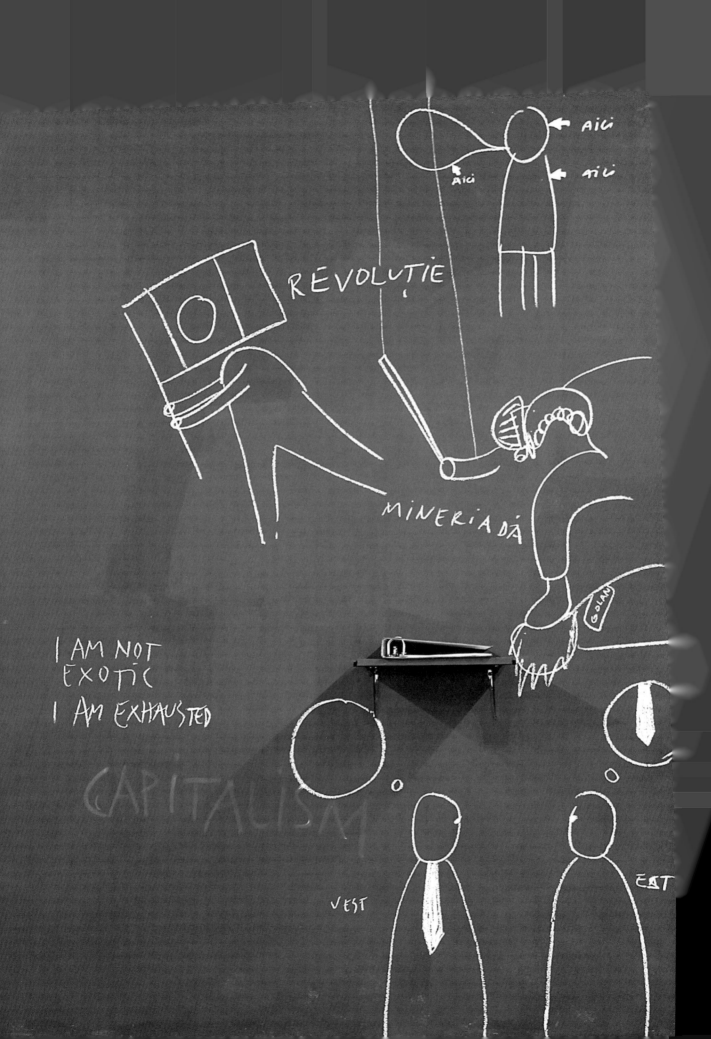

failures of the Revolution. One figure carries a national flag which has had its central motif excised. In 1989, Ceauşescu's enemies cut out the coat of arms which signalled the Romanian Socialist Republic, producing an icon of erasure. In Dan Perjovschi's 2010 image, the flag-carrying figure has placed his own face in the hole or, perhaps, the hole has become his face, a device which points to the arrogance and petty nationalism of the politicians who have led Romania in the last two decades.

Despite his strong criticisms of Romania today, Dan Perjovschi continues to make his home in Bucharest (and, as such, is unlike 10 per cent of the adult labour force who have left the country to work abroad).[13] The country remains a productive place for his art and for reflecting on the processes of globalisation underway in Europe. When, in 1989, communism collapsed, bankrupt and exhausted, many in the West predicted a future for the countries of Eastern Europe in terms determined by neo-liberal capitalism. This was the 'natural' and incontestable face of modern society. What Dan Perjovschi's art exposes is the hubris and injustice in the 'New Global Order'. One cannot help but think that his perspectives on the political, social and economic interests shaping the world are more sharply focused because of his Romanian vantage point. This is the powerful view from the margins.

Dan Perjovschi S.A., white chalk on black walls, CIV (Center for Visual Introspection), Bucharest, Romania, 2010

[13] See Tom Gallagher, 'Romania and Europe: An Entrapped Decade' (March 2010) http://www.opendemocracy.net/tom-gallagher/romania-and-europe-entrapped-decade – accessed July 2010.

Removing Romania tattoo performance, *In the Gorges of the Balkans*, Kunsthalle Fridericianum, Kassel, Germany, 2003

popularity of his work around the world, his art has a universal appeal which transcends such narrow categories. Nevertheless, Dan Perjovschi's relations to Romania – past and present – are complex and ultimately productive. In 1993, he staged his commitment to the country by having a tattoo of the word Romania on his shoulder as a public performance at Zone 1, a festival in Timişoara. An ambiguous gesture, the tattoo implied both choice (this I chose to do) and compulsion ('my' national identity is marked on me). In 2003 he had this tattoo removed in three public sessions at the 'In the Gorges of the Balkans' exhibition in Kassel, Germany, a gesture which marked a break with the nation. Kristine Stiles, in her landmark study of Dan and Lia Perjovschi's art, identifies this action with a renewal of their vows of dissent. Thereafter, they became increasingly critical of the activities of the political and cultural elites.[11]

There is reason to be critical. Despite the violence that was unleashed during the 1989 revolution, it channelled tremendous hopes for democracy, freedom of speech and dignity which comes from an improved quality of life. Those who took power in 1990 – and their successors – have been keen to hold on to it, often with little regard for the actual workings of democracy. The bodies responsible for 'decommunisation' – the process by which those who supported or benefited or supported the Ceauşescu regime are denied power or influence – have been neutralised. Capital is concentrated in the hands of a small number of oligarchs, many closely connected to political cartels. The courts and the media seem to serve the interests of the elite. Meanwhile, Romania remains one of the poorest countries in Europe, with broken roads, schools and hospitals.[12] Dan Perjovschi has been highly critical of the political culture in Romania, refusing to be swept up in the populist nationalism which stirs the country periodically. His 2010 CIV exhibition in Bucharest offered brilliantly incisive commentaries on the

[11] Stiles, *States of Mind*, 79.

[12] See Tom Gallagher, *Theft of a Nation: Romania since Communism* (London, 2005).

Dan Perjovschi has restored this low-tech medium, reviving its critical, comic and unruly energy. Preparing 'The Room Drawing' at Tate Modern in London in 2006, he took the views of the museum staff, Members and representatives from Tate Modern's Council. The drawings which filled the Members' Room – a clubbish space for fee-paying affiliates, open to the public for Dan Perjovschi's exhibition – incorporated their comments and views of local and international events and 'personal issues'.

Romania tattoo performance in Timișoara, Romania, 1993

Offering a distinctly critical perspective on the interests at work in the world without the heavy hand of propaganda, Dan Perjovschi's work is often described as ironic. Irony is a form of dissimulation: an ironist says one thing but means another. Dan Perjovschi's images are irreverent but they feign nothing. They show the world exactly as he sees it, albeit often in its most incongruous forms. When his drawings are absurd, it is because life is absurd. Looking at his wall-drawings and slogans we see what we already know: communities living on fault lines (East-West/Christian-Muslim) fail to understand each other; politicians are ruled by their egos and their libidos; and advertising makes us unhappy. In an age infected with the plague of irony (sometimes glossed as 'postmodern irony') Dan Perjovschi's direct humour seems to point to an earlier, though no less sophisticated, way of viewing the world which exposes the vanity and conformity of people and the irrationality of systems which organise life. In this regard, he seems closer to existential skepticism than the postmodern taste for irony. "No society has been able to abolish human sadness, no political system can deliver us from the pain of living, from our fear of death, our thirst for the absolute," wrote playwright Eugène Ionescu 50 years ago. 'It is the human condition that directs the social condition, not vice versa.'[10] These words might be used to caption Dan Perjovschi's drawings today.

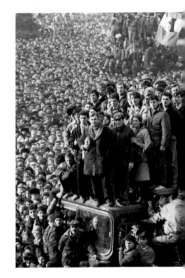

Revolution, Bucharest, Romania, 1989

Refusing to be anyone's representative, Dan Perjovschi has repeatedly expressed his dislike of the label 'Romanian artist' or even 'Eastern European artist', viewing both terms as limitations. To judge from the tremendous

[10] Eugène Ionescu (writing in the *Observer*, 29 June, 1958) cited in Martin Esslin, *The Theatre of the Absurd* (Harmondsworth, 1968), 126.

22

PUBLICAȚIE SĂPTĂMÎNALĂ EDITATĂ DE

GRUPUL PENTRU DIALOG SOCIAL

ANUL III ● Nr. 19 [120] ● 15-21 MAI 1992 ● 16 PAGINI ● 25 LEI

ANCHETĂ ASUPRA UNEI INSTITUȚII

SECURITATEA

— Mărturii; Anchete
Interviuri cu SORIN ROȘCA STĂNESCU
și FLORIN GABRIEL MĂRCULESCU

„Domnul Măgureanu ar trebui judecat, nu doar schimbat din funcție"

Interviu cu NICOLAE MANOLESCU, președintele P.A.C.

22 ● După doi ani și jumătate de la Revoluție, știți mai multe despre Securitate decît știați înainte ?

● Știu tot atît de puțin ca și înainte. (Și mi-e tot așa de puțin frică de ea, ca și înainte.) Dar cred că nu știm, deoarece este o instituție anume concepută ca să se știe foarte puțin despre ea.

● Ce vi se pare important să știm despre Securitate, numele informatorilor sau, de pildă, organigrama instituției ?

●● Important ar fi mai întîi să știm exact care a fost structura ei, care au fost direcțiile, care au fost responsabilii și să putem desprinde pe adevărații responsabili de plevușcă, pe cei ce erau doar funcționari în sistemul răului, de factorii de decizie. În al doilea rînd, ar trebui ca fiecare cetățean să aibă acces la dosarul lui propriu, după metoda din fosta R.D.G. Sigur, eu pot să mă duc să-l văd, sau pot să nu vreau să mă duc să-l văd : dar asta depinde de mine. Eu decid dacă îmi face bine sau nu consultarea propriului meu dosar. În al treilea rînd, în ce privește oamenii cu funcții de decizie (parlamentari, membri ai guvernului, șefi de partide), trebuie să li se aducă la cunoștință existența unui dosar compromițător și să li se permită ca într-un timp oarecare (mai lung sau mai scurt) să se retragă pașnic, fără vîlvă. Și atunci dosarul să nu fie făcut public. Sau dacă rămîn în funcție, să riște publicarea dosarului — ceea ce s-a propus și s-a făcut în Cehoslovacia. Oricît de neplăcută ar fi această deschidere a cutiei Pandorei pe care o reprezintă dosarele, mai devreme sau mai tîrziu ea trebuie făcută. Altfel nu reușim să ne vindecăm de suspiciune, să ne închidem rănile și să deschidem un alt capitol al vieții noastre. Cîtă vreme această cutie a Pandorei va sta cu capacul astupat, în orice moment se poate da drumul unei părți din răul de aici. Aș da exemplu cele întîmplate cu Măgureanu, care, după ce a fost atacat prin publicarea dosarului său, n-a găsit altceva mai bun de făcut, decît să publice el însuși niște dosare. Ceea ce a făcut Măgureanu mi se pare mult mai grav decît faptul că a avut un dosar din care a rezultat că a fost căpitan de Securitate. Că directorul Serviciului Român de Informații a putut proceda așa, nu mai ține de supărarea lui „pe lume" și nici de dorința lui de răzbunare. Domnul Măgureanu ar trebui judecat, nu pur și simplu schimbat din funcție, dacă se dovedește că din mîna lui au plecat acele dosare. A încălcat legea și și-a încălcat atribuțiile. Unde am ajunge dacă fiecare șef de instituție care are în mînă asemenea lucruri s-ar apuca să le publice împotriva dușmanilor lui ? Am ajunge în infern.

● Credeți că în timpul campaniei electorale ne așteaptă dezvăluirea altor dosare ?

●● Cu siguranță că se vor folosi toate mijloacele. S-ar putea întîmpla să vedem și dosare falsificate. Toată lumea se teme de confuzia pe care ar stîrni-o amestecarea unor lucruri valabile cu lucruri inventate. Dau de pildă cazul televiziunii : în timpul lui Ceaușescu absolut nimeni nu credea că măcar o miime sau o milionime din ce se spune la televizor este adevărat. Acum, cînd ceea ce se spune este mai mult sau mai puțin adevărat, lumea ar trebui să dea dovadă de un imens discernămînt ca să înțeleagă exact ce-i corect și ce-i mincinos din propaganda pe care o face televiziunea. Or, cîți sînt în stare de asta ? Într-un fel, o televiziune sută la sută mincinoasă e preferabilă unei televiziuni care în parte minte și în parte spune adevărul. Același lucru se va întîmpla și cu dosarele care ne așteptăm să apară. Și care ar putea fi falsificate, ceea ce ar crea o confuzie imensă. Toată lumea ar putea bănui pe toată lumea. Să sperăm că nu sînt în stare — nu din punct de vedere moral, ci din punct de vedere material — să facă aceste dosare. Nu e foarte ușor să falsifici un dosar. Eu încă mai nădejde că nu sînt capabili din punct de vedere material, tehnic, să fabrice dosare. Sau nu suficient de multe care să devină importante.

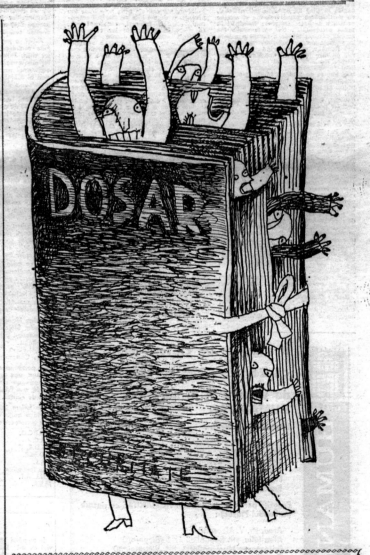

democratic rights in Romania. Loyal to the cause, Dan Perjovschi still sends cartoons to the weekly from around the world today.

Revista 22, no. 119
May 15–21, 1992

Resolutely anti-communist, Dan Perjovschi has, by an accident of history, fulfilled a communist vision of the radical newspaper. After the October Revolution in Russia in 1917, the young Bolshevik state encouraged the production of wall-newspapers or what in Russian are called *stengazety*.[9] Workers and school children were encouraged to paste up news, and cartoons, to 'publish' documentary photographs and commentaries on the transformation of their world. Soviet citizens were, as the Communist Party loudly trumpeted, living through the greatest social transformation in the history of mankind. Their reports, sketches and cartoons were displayed on the streets, in factories and hospitals as well as in schools and apartment blocks in Soviet Russia.

The wall-newspaper was not just a medium for the transmission of ideas: it was, according to its champions, a mechanism for the transformation of consciousness. In recording and reporting their world, not least on the walls of the *stengazeta*, the new Soviet man and woman would become conscious of their own progressive influence in the world. In other words, they would become real revolutionaries. The efflorescence of proletarian creativity was an illusion: in fact, considerable effort went into providing 'advice' about how and what to write for the *stengazeta*; all material required permission of the communist authorities. Although the wall-newspaper was exported into the newly formed Eastern bloc in the late 1940s, including to Romania, regulation and control eventually did for the format. The wall-newspaper became a moribund relic of revolutionary socialism. By the 1960s, state printers in East Germany were turning out wall-newspaper 'cut and paste' kits. Printed reports, logos and stencils turned the act of authorship into one of assemblage (like writing for the official communist press). The events of 1989 in Eastern Europe put an end to the wall-newspaper: in the years since,

[9] Catriona Kelly, "A Laboratory for the Manufacture of Proletarian Writers", in *Europe-Asia Studies* (June 2002), 573–602.

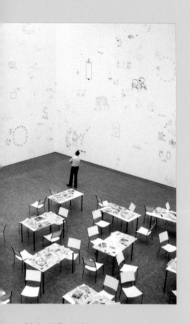

Naked Drawings,
permanent marker on wall,
installation view at Ludwig
Museum, Köln, Germany,
2005

even instinctive (and, as such, a suppression of all that he had learned at the conservative George Enescu University of Art in the 1980s). Occasionally, scratching out 'errors' in thick black marks, his lines are quick and bold. He writes in English in hasty capital letters, seemingly with little concern for penmanship. Figures, buildings and actions are reduced to a simple graphic lexicon of silhouettes and loose geometric shapes. National and political symbols are drafted in as graphic ready-mades. His wall drawings are not, however, always as spontaneous as they might seem. While some figures are conjured up on the spot, others are distilled from the sketchbook he always carries with him. Over the years Dan Perjovschi's sketchbooks function as a kind of archive of ideas, always ready when needed. The same figures and motifs appear in his wall drawings, still resonant 10 years or more after their first appearance. They pass from one context to another. The phrase 'I AM NOT EXOTIC I AM EXHAUSTED' often resurfaces, most recently at his show at the Centre for Visual Introspection (CIV) in Bucharest in 2010. Each time it materialises on a wall, it gathers new poignancy.

When commissioned to draw *in situ*, Dan Perjovschi absorbs himself in the press. This is not just a matter of expediency. When he was commissioned by the Ludwig Museum in Köln in 2005 to fill the white cube of its DC-Room over several weeks, copies of *Le Monde*, the *Guardian*, the *International Herald Tribune* and *Newsweek* were arranged on tables in the centre of the gallery. In effect, viewers were invited to reflect on the relation between the detailed reports in print and his telegraphic images. (The exhibition extended beyond the walls of the Ludwig when, each week during the exhibition, *die tageszeitung* printed a visual digest by Dan Perjovschi on current events). One conclusion to be drawn from the comparison is that he is a brilliant visual and textual editor. In English, his word-plays are often as sharp as any newspaper headline and his drawings deliver their message in a few telegraphic lines. These are skills honed over many years. When he joined the team of *22*, he was involved in all aspects of the press from layout to proofreading. Established by a group of dissidents and intellectuals called the Group of Social Dialogue, *22* continues to defend freedom of speech and

FREEDOM OF EXPRESSION
← FROM HERE
TO → HERE

potency (and, as Camille suggests, perhaps, as a result, the centre was made all the more secure and stable by the presence of fantastic images on the edge).[6]

What is the relation of Dan Perjovschi's graphic marginalia to the institutions on which they are quite literally inscribed? In many of his cartoons and slogans, Dan Perjovschi reflects on the condition of the museum and gallery in the 21st century, deprecating the commercialism and sponsorship on which these institutions increasingly rely. Like many Eastern European intellectuals, Dan Perjovschi possesses a sharp sense of freedom and so 'free' is a word which invariably raises suspicion.[7] The excess and profligacy of the international biennale, a seemingly unending cycle of bonanzas, is ridiculed too ('DUE TO GLOBAL WARMING THE VENICE BIENNALE WILL BE RELOCATED TO STOCKHOLM'). Curators are identified as minor dictators, in one drawing framing the eyes of a faceless artist. Dan Perjovschi does not exempt himself from his critical pen: the figure of the 'international artist' who lives his or her life from a suitcase appears regularly in his cartoon cast. In one image that featured in his 2010 Royal Ontario Museum show, two figures, hands in pockets, exchange small talk. 'WHAT YOU DID AFTER THE FALL OF THE BERLIN WALL?', asks one. 'BASEL ART FAIR' replies the other. Positioned next to the text panel describing Dan Perjovschi's art, this cartoon points to the art world's keen embrace of the Eastern European artist (as well politics as a commodity in the form of artworks with expensive price tags[8]). In fact, the curatorial statement on the wall nearby begins by describing Dan Perjovschi as "One of Eastern Europe's most sought-after artists."

Dan Perjovschi's wall drawings look unplanned, unfinished and

Invitation card project for *Free style*, galerie Michel Rein, Paris, France, 2009

Dan Perjovschi: Late News, black marker on wall, Royal Ontario Museum (ROM), Toronto, Canada, 2010

[6] Camille, *Image on the Edge*, 26.

[7] See Svetlana Boym, *Another Freedom: The Alternative History of an Idea* (Chicago, 2010), particularly chapter five.

[8] Of course there is nothing new in this. See Christina Kiaer, *Imagine No Possessions: The Socialist Objects of Russian Constructivism* (Boston, MA, 2008).

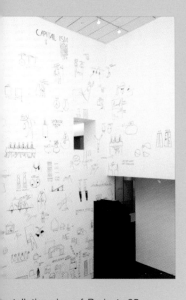

Installation view of *Projects 85: Dan Perjovschi*, WHAT HAPPENED TO US?, black marker on wall, The Museum of Modern Art, New York, USA, May 2 – August 27, 2007

Illuminated manuscript
Aristotle '*Libri Naturales*', with extensive glosses, 3rd quarter of 13th century, Latin, England, Harley 3487 f. 22v

floors, sometimes making a feature of the edges of the space. Occupying the dizzying atrium space in the monumental lobby of MoMA in New York in 2007, Dan Perjovschi's drawings were 'interrupted' by the floor and folded around the corners of the wall. Edges are not necessarily marginal spaces. In fact, they offer up ideal positions for critical perspectives.

Here, an analogy can be drawn from the past. In the Middle Ages, artists illuminating books would sometimes add mocking glosses and grotesque figures to the borders of the page. The anxieties which lurked in the dark spaces of the human imagination were given material form as dog-headed men, one-footed beasts and ape-angels. An illuminator might supplement his portraits of venerable saints and wise philosophers with profane acts and erotic fantasies. Off-centre and often humorous, these devices provided a kind of imaginative escape for the illuminator and the reader wearied by the orderly and uplifting content of the missal or Book of Hours. Some marginalia went further, seeming to offer a critique of the text itself. The British Library, for instance, possesses a late 13th Century copy of Aristotle's *Physics*, a controversial text when it was prepared for scholars in Europe's universities (to the extent that it was ordered to be burned in Paris as a text which might encourage heresy).[4] On a page discussing the Heavens, a scholar in his study stares into the space above the block of text. His vision of the starry firmament is, however, obscured by a scabrous fool being transported in a wheelbarrow over bumpy ground. In his analysis of this marginal image, Michael Camille suggests that it is a satirical commentary on the consequences of acquiring too much knowledge.[5] Had the body buckled under the weight of all the lofty ideas contained on the very same page? Irreverent and witty, illuminated marginalia were inevitably dependent on the centre. The fact that these unruly images appeared on the same page as the sacred Word or brilliant philosophical treatises is what gave them such

[4] Haig A. Bosmajian, *Burning Books* (Jefferson, NC, 2006), 49.
[5] Michael Camille, *Image on the Edge: The Margins of Medieval Art* (London, 1998), 22–23.

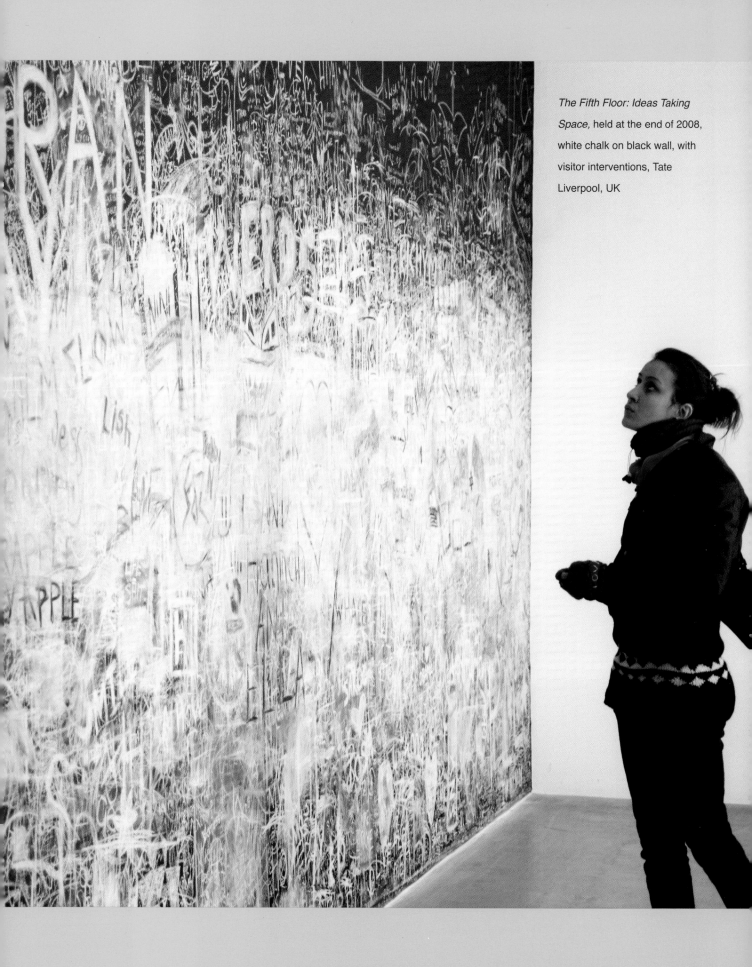

The Fifth Floor: Ideas Taking Space, held at the end of 2008, white chalk on black wall, with visitor interventions, Tate Liverpool, UK